CONTENTS

A PRINTMAKER'S
HANDBOOK

EDITED BY

SILVIE TURNER

estamp.

to my daughters

ACKNOWLEDGEMENTS Much appreciation must go firstly to Chelsea School of Art for the support of this project over the last year, with especial thanks to Tim Mara and the printmaking department.

Many thanks to the readers of my text for their comments and criticisms : Tim Mara, Steve Bury, Librarian at Chelsea, Sandy Linan from the ILEA Careers Office,Tim Challis on Safety & Health, Jane Hindley from Flowers East, Roslyn Innocent of Stephens Innocent, Michael Steel of Roffe Swayne, Godalming, Kip Gresham at Chilford Hall Press,Cambridge, David Case of CCA Galleries, Marc Balakjian and Peter Ford.

Thanks also to the artists in many countries around the world who have sent me news of printmaking activities, especially Sofus Rindel in Denmark, Dr.William S.Eickhorst in USA, Barto do Santos in Portugal, Dorothea Wight and Toril Krogh in Norway, Akira and Sakiyo Yagi and Mr Abe of Abe Publishers in Japan, The Print Council of Australia Inc., Maurice Pasternak and Gabriel Belgeonne in Belgium, Jill Faulkner in Athens.

Filling in and returning questionnaires is not a particularily rewarding occupation and I should like to thank all the people that did.

I am indebted for reference to the many articles concerning surviving and thriving published in *Artists Newsletter* each month over many years, and in which my own articles - 'Making Prints', 'Pricing Prints',' Marks on Prints', 'Export of Prints' - were first published.

For permission to quote directly I would like to thank the Crafts Council who published leaflets such as *Premises* and *Running a Workshop* which are now no longer available but are incorporated in their book *Running a Workshop - Basic Business for Crafts People, Artists Newsletter,* Tim Challis and Gary Roberts and the Curwen Gallery and Studio.

I should like to send greetings to the many Chelsea printmaking Masters students whom I have thoroughly enjoyed meeting and teaching and who have indirectly helped me with this project.

I should like to thank Jason White for his invaluable help and advice with my Apple.

I am grateful to Harriette Cunningham (who also collected the advertising) and Jo Rankin for their input into my computer.

Finally lots of love to my husband who has always given me generous support with this project.

Text : © Silvie Turner 1989
Design : © estamp 1989

Published by estamp 204 St Albans Avenue London W4 5JU
All rights reserved
Designed by Lone McCourt
Printed and bound by Westerham Press Ltd. London Road Westerham Kent TN16 IBX

British Library Cataloguing in Publication Data

A Printmaker's handbook
 1. Prints. Making. Manuals
 I. Turner, Silvie
760' .28

 ISBN 1-871831-00-8

PREFACE

Although I believe that printmaking is, in itself, a primary means of expression and that editioning is a by-product of the making of prints and not fundamental to it, printmaking is, nevertheless, generally involved in the production of a multiple. Multiple production implies publication. Publication implies distribution and distribution implies specialist knowledge allied to marketing and business skills. The making, distribution and marketing of prints is a complicated business which most artist printmakers have to handle themselves.

Several years ago ,when I first started running the Master's Degree Course in Fine Art Printmaking at Chelsea School of Art, I was very keen to introduce a business/ professional practice element into the course. I asked Silvie Turner to make several visits to Chelsea and to give our students all the information that she had about life after college for printmakers. Silvie did much more than this. She structured a course that looked in depth at handling work, approaching galleries, making sales, book-keeping, taxation, export, the law as it applied to artists and information on countless other professional areas. She gave the students documentation, ideas and leads. She encouraged the students to do a great deal of their own research. She observed, supported and evaluated the students' experiences. She invited their comments and suggestions, allowing the course to grow and evolve based on this real and tested experience.All this activity had an instant effect on the ethos of the department, creating a greater all-round professional awareness in the students. They gained a sense of a wider context for their work, a belief in its continuity after college, a greater degree of self-regard and even, in some cases where it was necessary, a greater care of and more positive attitude towards the making of their own work. These seminars were and are regarded as an important part of the course and an invaluable asset when taking the first steps into professional life as an artist printmaker. Silvie had shown them the possible and that, if they aimed for it armed with the knowledge, this then became the achievable.

From this course has evolved the book you now hold in your hands. It is timely, appearing at this point in the history of art education. It is remarkably comprehensive in the range and quality of its information and invaluably helpful in the clarity of its focus.

Tim Mara

Artist and Principal Lecturer in Printmaking, Chelsea School of Art
1989

INTRODUCTION

The practice of printmaking is active, it's alive and it's fresh. It has survived the gloomy markets of the 1970s, the influences of mass media, photography, new technology and much else to emerge strong; a separate activity from painting and sculpture, photography and video but with which it has obvious relationships. The activity of printmaking has also found a new home. Although much of the dealing is centred in London, the production has become firmly established in workshops all over Britain, many rooted in their own surrounding communities. It is no longer isolated or elite but in active contact with local artists and the public. With these changes has come a shift in acceptance of the print as a medium in its own right, heralded partly by the changes and interest in printmaking in art schools.

This is not a book about how to make a print. It is a comprehensive guide for artist and student alike concerning a profession. I have gathered often scattered, isolated facts and brought them together to present a picture that documents the print-making profession in Britain at the beginning of a new decade. This book aims to inform artists and, with the recognition of the need for support and contact with others in the same profession, to help artists become aware not only of the opportunities but also of the people and the professional practices that exist in the fine art original print trade today.

Every fact-finding project must stop somewhere leaving inevitable gaps in the information. Where I have left addresses without explanations, I have had no response to my inquiries and the user must then take up his/her own references. The changing of addresses is a perpetual problem for the editor of a directory and I should be happy to hear about omissions and corrections for a future handbook.

I have enjoyed this work. I have looked at the shape of British printmaking at grass-roots level. I have seen the changes and have recognised the energy that is in it. I welcome it and I hope this handbook will encourage its identity to expand.

Definitions of an original print

In 1956, Carl Zigrosser identified the term 'original' when referring to a print:

'When used as a noun , original refers specifically to a print...Every single copy of a woodcut, etching or lithograph is an "original", the final and complete embodiment of the artist's intention....The miracle of the process is that there are not one but many originals.' (Ref 1)

Ref 1 Carl Zigrosser *The Book of Fine Prints* rev. ed. New York, Crown 1956

The Vienna Congress of Plastic Arts in the 1960's recommended that the artist alone had to create the print from concept to finished print and Jules Heller, in1972, defined an original print :

'to include each successive impression created through contact with an inked or uninked stone,block, plate or screen that was worked upon by the artist alone or with others; it may be directly controlled or supervised by the artist and must meet his criteria for excellence.' (Ref 2)

Ref 2 Jules Heller *Printmaking Today* Holt Rinehart & Winston New York, 1972

An early definition by the Printmakers Council of Great Britain suggested that

'The artist printmaker has the inalienable right to decide himself on the methods he uses to make a print.These can be autographic,mechanical or photographic. He can use any process in existence today or which could exist in the future.He has the right to print or take an edition of his work in any method that exists today or could exist in the future.His work can be executed by himself in his home alone,or with the help of assistants, or he can work elsewhere in a workshop, or with technicians or in a printing works. His work can be entirely executed by a third person .. and he must show approval by signing the print.'

A good print like any other work must make you forget the process which created it. Printmaking is a way of forming an intimate relationship with a creative process, revisiting, editing, reworking; allowing successive states until a final work is achieved. A print is not created in the same way as a painting because of the intervention of a process and machinery in between the direct contact of the artist and paper and a printmaker is an artist who makes his work with a disciplined process involved at every level. For many printmakers this involvement with a process (which can take years of apprenticeship, hard work and labour to learn) is essential in the production of work. A printmaker has been defined as an artist with the comprehension and techniques of a printer.

Ref 3 Jules Heller *Printmaking Today* Holt, Rinehart & Winston, New York 1972

'the artist who does not print his own lithographs from the stone does not begin to know lithography....In the very act of printing it is possible, and many times desirable, to alter, change, improve, or strengthen the initial visual statement. Only when an artist has explored the printing process on his own can he completely understand printmaking.' (Ref 3)

All the processes - relief, intaglio, lithography and screenprinting - have a history that dates back hundreds of years; what makes them relevant to us today is the way in which contemporary artists creatively use and manipulate them for their own individual expression. That is not to say, however, that every artist needs to master difficult techniques before s/he can use them for expression. An artist with little experience in printmaking can employ the skills of others in the production of prints and at the heart of the creative work is often the interaction of the artist and master printer. Much fascinating debate has gone on recently about the issue of collaboration and the changing role of the craftsman/master printer (not to mention that of the renowned and inventive publisher). Pat Gilmour, whose most recent book on Ken Tyler discusses in detail the role of the master printer, states in an article for the *Print Collector's Newsletter* that

Ref 4 *Print Collector's Newsletter* Vol XVI, No 5, Nov-Dec 1985

'Despite this interdependence (artist and printer) and the fact that without such a partnership some of the most successful prints in the world would never have come into being, history has a way of recording, and therefore remembering, only the name of the artist....' (Ref 4)

The importance of the open workshop and studio to printmaking cannot either be ignored or underestimated. However, there is no one way laid down for an artist/ printmaker to work. Artists are free to choose whichever way they wish to work and it is with the artist that the process begins.

Defining a reproduction is a contentious issue. It is necessary that reproductions are acknowledged but it is also necessary to distinguish them beyond question from original prints. What is a reproduction?

Ref 5 Carl Zigrosser *The Book of Fine Prints* rev. ed. New York, Crown 1956

'An original etching is one which the artist has conceived and executed himself. A reproductive etching is one which the etcher has copied from another artist's design or painting.' (Ref 5)

A reproduction is an attempt to copy an existing image, often in another medium '
'A 'Faux Graphique' is an image made by hand in the style of the artist, with or without the artist's consent, but not in the artist's own hand.' (Ref 6)

Ref 6 Kip Gresham Letter to Silvie Turner

Ref 7 Kip Gresham Letter to Silvie Turner

'A forgery is a deliberate attempt to pass off either an unauthorised impression from an original matrix or reproduction or faux graphique as an authorised original.' (Ref 7)

Chapter 1 **MAKING PRINTS**

Making prints is the subject of this chapter. It aims to look at the professional practice of printmaking in open access workshops throughout Britain and Northern Ireland. This chapter also includes a national and international directory of open access printmaking workshops and for artists without their own equipment it represents a useful guide to professional studios where a wide number of options for work exist.

All over England and Wales in the past ten years there has been a quiet expansion, a steady growth in the establishment of print workshops with an emphasis that is often regionally based attracting local connections, servicing and promoting professional printmaking in many different ways. In Scotland there has been a printmaking explosion! The Scottish workshops that receive revenue funding from the Scottish Arts Council are the envy of many of their British counterparts who do not. But whatever the circumstances, the community of an active workshop is engaging, productive and attractive, whether it is organised and run by one person or by a group of artists. The output is identifiably British in character, ranging from prints made by the age-old practices, still self-sufficient and strong, to more experimental work with newly-developed techniques.

ORIGINS OF PRINT WORKSHOPS IN BRITAIN

To begin to understand the origins of the contemporary print workshops it is useful to look back at part of the history of printmaking.

The printing processes developed as methods of circulating information and remained so for hundreds of years. In the early nineteenth century, when it was discovered that these craft-orientated processes could imitate the effects of painting so well and large numbers of copies could be made so easily, a whole new business developed. The utilisation of these printing techniques popularised the pictorial tastes of a new and affluent middle-class society in Britain. Business for print publishers boomed and craftsmen became extremely skilled in producing etchings, aquatints, mezzotints by hand reproducing aspects of artists' drawings and paintings. Hundreds of print workshops were established, especially in London, training people in the skills of platemaking and printing, although few of the workshops concentrated solely on prints for the fine art trade.

Interestingly enough, the firm of Dixon & Ross was one of the very few businesses which described itself as 'Fine Art Printers'. Set up in 1833, this firm of copper and steel plate printers established itself with a reputation for first-class workmanship. In 1903, under the name of Thomas Ross & Son, it was located in Camden Town in London where it remained for over sixty years, printing and reprinting from the

plates of copies of paintings which it had collected during its formative years. Even the studio workshop remained true to its original design and layout, little changing in the processes and procedures of printing. A move to Putney, in 1966, changed the location but not the work and this firm continues the old traditional methods of training printers and the printing of intaglio plates of copies of the old masters to this day.

As all the printing techniques began to be more widely used in areas connected with book illustration and journalism, as in most areas of commerce, new developments were to curtail hand-operated work. It was the introduction of photography, leading to the development of photogravure and photolithography at the beginning of this century, followed by the invention and use of fast-running machines, that eventually made the labours of the autographic craftsman-printer redundant.

It is well-known that artists of the calibre of Dürer, Rembrandt and Goya had been fascinated by printmaking for its own sake and not for its imitative qualities. However, these were isolated examples. Strange as it may seem, artists in England only became interested in the qualities of the print when the rapid increase in technology began to close the hand-operated workshops. Unfortunately none of the original commercially- based workshops were converted to artists' use. There were some businesses, such as the Curwen Press, which invited artists to contribute to the design of books, in the making of illustrations as part of the studio's commercial work. Europe was very different; for example in France there was a long tradition of workshops set up solely for the creation and editioning of artists' prints whereas in England no such studios existed. Instead, with only a few presses in art schools, artists turned to their own studios where, if inclination and cash allowed, presses were set up for personal use.

Shortly after the second world war, circumstances changed with the arrival on the print scene of Robert Erskine, who, in 1955, opened the St George Gallery which pioneered the exhibition and sale of modern artists' prints in this country. It was, however, left to a Swedish artist studying in London to initiate the establishment of the first artists' printmaking workshop. Birgit Skiöld opened the 'Printworkshop' in George Street in London in 1957 and one year later, moved to more permanent headquarters in the basement of Adrian Heath's house in Charlotte Street, WC2. Robert Erskine, writing about the workshop, described the atmosphere:

'.....Whereas a painter's studio requires only a space containing canvas, brushes and paint, in a printmaker's workshop are to be found far more complex paraphernalia, all expensive and elaborate, from the presses themselves to the dangerous acids. As a result there are few artists who can own their own equipment, so that printmaking has perforce become one of the more social arts, carried out in communal studios where a clean discipline must be observed and where the equipment is booked in advance.

Such is Birgit Skiöld's Printworkshop........There are two rooms; one, a bare area supplied only with benches....... where stones are drawn and plates engraved. Somewhat monkish, its character is contemplative and quiet. The other room is the press room wherein stand like refugees from the Industrial Revolution the symbols of printmaking, the presses themselves. There is a comfortable scent of printer's inks and occasionally the volcanic stink of acid in a tray.

It would be difficult for more than three people to work here at the same time, so that the use of the studio has to be apportioned out to the twenty-odd artists who work there. The clientèle comes from many countries, and of course London printmakers know of it. One would have thought, with the growth of interest in making prints that there would be many such studios dotted about the London scene, but in fact the 'Printworkshop' remains unique.' (Ref 1)

Ref 1 Robert Erskine 'Introduction' to Curwen Gallery print catalogue, 1968

Birgit Skiöld continued to run this workshop until her death in 1982.

It was also an Erskine connection that aided the establishment of the second print workshop in London barely a few months later. On a trip to Paris, Robert Erskine had arranged to meet Stanley Jones to discuss the idea of setting up a lithography studio under the auspices of the Curwen Press. Stanley Jones was at the time an apprentice at Atelier Patris in Paris, printing for many important artists and gaining

much experience in his own work. The first Curwen Studio was set up close to the Curwen Press but barely a year later moved to a more central position just off Tottenham Court Road in London.

Pioneered by Chris Prater of Kelpra Studio, screen printing offered artists qualities that the three other processes could not imitate. With his wife Rose Kelly, the Kelpra Studio (Kelly & Prater) began a tradition that was to inspire artists to the production of much outstanding work. Kelpra produced a series of twenty-four prints for the ICA in 1964 which was to arouse the enthusiasm of many other artists in Britain.

Editions Alecto, set up in 1962, (with Erskine as a director) was the first major print publisher to include a series of workshops where artists could work with ease, especially by 1964 when they moved to 27 Kelso Place which housed an impressive studio plus living quarters for visiting international artists. In every way this was an inspirational time in British art which was to have resounding effects in the printmaking field to this day.

Chronology of British Printworkshops up to 1980

1957	Printworkshop, London (Founder Birgit Skiöld)
1958	Curwen Studio, London (Stanley Jones)
	Kelpra Studio, London (Rose & Chris Prater)
1959	Taurus Press of Willow Dene (P. P. Piech)
1962	Editions Alecto, London (Joe Studholme, Laurie Hoffman)
1965	C. A. L. A. Cambridge (Carol Wheeldon)
1967	Sky Editions, London (Alan Cox)
	Edinburgh Print Workshop (Ken Duffy)
1968	Studio Prints, London (Dorothea Wight)
	Advanced Graphics, London (Chris Betambeau, Bob Saitch)
1969	I. M. Imprimit, London (Ian Mortimer)
1970	Paddington Litho and Etching Workshop, London (now Essendine)
1971	J. C. Editions, London (James Collyer, John Crossley)
	Mati Basis, London
1972	Coriander Studio, London (Kevin Harris) (now Cowper Studio)
	Lowick House Printmaking, Cumbria (John Sutcliffe)
	Penwith Print Workshop, Cornwall (Roy Walker)
	Glasgow Print Studio (John Mackechnie)
1974	Clarendon Graphics, London (Anthony Benjamin)
	Peacock Printmakers, Aberdeen (Arthur Watson)
	Ingham Press, Glos (R. Broadbent)
	Ceolfrith Print Workshop, Sunderland
1975	Aymestry Mill, Leominster (Ian Lawson)
	Manchester Print Workshop (Kip Gresham)
	South Hill Park Arts Centre, Bracknell, Berks
1976	Etching Studio 39 Mitchell Street, London (Jean Vandeau)
	Kirktower House, Montrose (Sheila McFarlane)
	Oxford Printmakers Co-op
	Bracken Press, Scarborough (Mike Atkin)
1977	Charlotte Press, Newcastle (now Northern Print)
	Printers Inc. (Flax/Downie/Pelavin/Schaverein)
	Printworkshop, Belfast (Jim Allen)
	Dundee Printmakers Workshop
	Bristol Print Workshop (Peter Reddick)
1978	Yorkshire Printmakers, Leeds (J. M. Anderson)
	Palm Tree Editions, London (Terry Wilson)
	The Print Centre, London (Hugh Stoneman)

	Gainsborough House, Sudbury
	Dunfermline Print Workshop (T. Keast)
	North Star Sudios, Brighton
	Pigeonsford Workshop. N. Wales (G. Jones)
	107 Workshop, Westbury (Jack Shireff)
	Clifton Editions (Marie Walker)
1979	Talfourd Press (Tom Phillips)
	Wilkey's Moor Printworkshop. Devon (Michael Honnor)
	Cardiff Printworkshop (AADW)

STAGES IN MAKING A PRINT

The basic stages in making a print which are common to all print media have been listed below to illustrate opportunities that exist . An artist using a print workshop may require to use one or all of these facilities.

1st stage	Concept and research, made either in or away from workshop.
2nd stage	Experimentation with media, proofing, colour proofing, variations until final proof (BAT) is made with the approval of the artist shown by his signature on the BAT. May take hours/weeks/occasionally months.
3rd stage	Production of the edition (or part of it)
4th stage	Finishing which includes drying, cleaning, trimming and signing.

PRINT WORKSHOP PRACTICES

Types of workshop

These are descriptions of the basic categories. Many workshops have devised systems to suit themselves which fall somewhere between these categories, e.g. 107 Workshop, Westbury.

Open workshops
This describes workshops run by a group of artists, e.g. as a co-operative, sharing overheads, equipment and costs. They operate on many levels - experimental, proofing, one-offs, platemaking, editioning; work can be produced by technicians or do-it-yourself. Artists with and without practical experience normally welcome, e.g. Oxford Printmakers Co-op.

Private specialist workshops
These are workshops that offer a special or particular expertise and are set up and run by individual artists who have developed particular skills often to satisfy their own work. Not an 'open' situation. Entry often by invitation, e.g. I. M. Imprimit.

Workshops run by master printers
The workshops which are run by highly-experienced printers offering collaborative skills at all stages of the processing. A venture in which the artist does not need to have practical printmaking skills although a knowledge of the basic process is always useful. Artists often work for an intense period up to the BAT stage and leave the studio to do the editioning alone, returning to sign the prints, e.g. Curwen Studio, London.

Editioning houses
This category describes workshops which only offer editioning facilities, where concept and proofing work is made away from the studio. In some cases the BAT is proofed at the studio with the artist. The edition is made without the artist being present. A studio which publishers often use for contract editioning (i.e. a commissioned edition which is then the property of the publisher), e.g. Studio Prints, London.

Publishers' workshops
Private workshops set up and funded by print publishers solely to print their own artists' work are not listed in this survey. e.g. Retigraphic Society, Kent; Petersburg Press, London and London Contemporary Art Ltd. (See Chapter 3, Print Publishers, p.77ff).

Costings and charges

These operate on many different levels and are individual to each studio. They include membership schemes, daily rates, annual rates, subscriptions, levies on materials, etc. It is assumed that each workshop offering chargeable facilities has been effectively set up with regard to safety and health; that it has been legally constituted; considers itself as a business and is aware of the relationship between all the parties involved in the production of work and maintains professional ethics and standards. Types of charges all bear a relationship to how much the finished print will eventually cost. The charges should always be set out on paper whatever scheme of costing is operated. The following list contains some of the criteria for a discussion on costs and charges :

1 The rate of proofing and the rate of editioning are charged separately at £- per hour/day/week.
2 It is normal for the studio to provide plates, screens, paper, inks, etc. and all other necessary materials which should be included in the price per hour/day.
3 The studio does not usually accept any responsibility for the artist's original material whilst it is at the studio.
4 Is the proofing work the property of studio or not?
5 After the BAT has been agreed by the artist (on the editioning paper), the edition is made and charged at £ - per hour/print/colour inclusive of necessary materials.
6 10% of the final edition number will be made for the artist's own personal use e.g. in an edition of 50, an extra five will be made for the artists and marked a/p.
7 Extra copies, e.g. a/p's, p/p's, insurance copies, hors commerce, etc. should be included in the final number printed. Discussion should take place before prin ting as to who will pay for these extras - artist, studio or publisher?
8 One copy is normally retained for the printer, marked p/p. Who meets this cost?.
9 VAT may be charged to the account if prints are not for export.

Estimates for printing costs are estimates and not firm quotations. All the points above should be thoroughly discussed. Required production time should be estimated and delivery dates agreed. These may vary depending on the nature of the printing. A studio's quotation can be valid for one/three months or longer but time must be stated. Before work begins, a client may be asked for a 1/3rd deposit to cover consumables and the balance may be required on delivery of work. Delivery notes are an important item, especially if the work is collected from the studio in separate consignments.

Services
The range of services offered by workshops listed in the Directory (p.21) is enormous, from the hire of machinery and consumables per day to a mobile printshop. The workshops have been individually set up to suit the requirements of the founders. In many, the services offered correspond to needs of their communities and in the most successful, activities have often diversified and expanded into related fields e.g. print publishing, organising exhibitions, scholarships, bursaries, etc.

Clients
The range of clients is wide and can include printmakers, artists from other disciplines (e.g. photographers, sculptors, painters), galleries, publishers, students, general public, etc.

FURTHER READING

Directories *A Catalogue of Fine Press Printers in the British Isles* Tom Colverson & Dennis Hall 1986, Inky Parrot Press, Design Dept, Oxford Polytechnic, Headington, Oxford OX3 OBP
Directory of Art Centres Arts Council of GB105 Piccadilly, London W1
The Printworld Directory Printworld Inc., Post Office Box 785, Bala Cynwyd, Pennsylvania 19004. USA. This is a major printmaking reference directory produced in the USA, expensive at around $95 .
Printing is Easy Community Printworkshops Directory 1970-86. Greenwich Mural Workshop, Mcbean Centre, Mcbean Street, London SE18 6LW
Small Press Group Year Catalogue Ed Baxter, SPG. 308c Camberwell New Road, London SE5 ORW
Running a Workshop - Basic Business for Craftspeople Crafts Council,12 Waterloo Place, London SW1

Workshops *American Lithographers 1900-1960 The Artists and their Printers* Clinton Adams University of New Mexico1983
Atelier 17 Elvehjen Art Centre, Wisconsin. Maddison1977
L'Atelier Lacourière-Frelaut ou 50 Ans de Gravure et d'Imprimerie en Taillle Douce B.Contensou Musée d'Art Moderne, Paris 1979
Artists at Curwen Pat Gilmour London, Tate Gallery 1977
Contemporary Lithography Workshops Around the World M. Knigin & M. Zimiles Van Nostrand Reinhold 1974
Gemini GEL Art & Collaboration Ruth Fine, Washington, Abbeville 1984
Kelpra Prints Pat Gilmour London, Tate Gallery 1980
Kelpra Prints Arts Council of GB 1970
Ken Tyler : Master Printer and the American Renaissance Pat Gilmour New York, Hudson Hills Press 1986

ESTABLISHING YOUR OWN PRINT WORKSHOP

Before any commitment is made to taking on a studio workshop, it is essential to assess your needs. It is important to identify what your aims are and write down the answers to questions like - Do you want to live in the space? What area do you need (in square feet)? Do you need daylight or artificial light? Is access easy? What right of access do you have? Have you any special requirements? And especially important, what can you afford?

Finding a building to work in

A workspace can be located in many ways - word of mouth; from advertisements in local papers or post office windows; small ad columns of *Artists Newsletter* or local papers; by contacting your local RAA's. Local councils may have lists of property for rent . Quite often the simplest method is to travel round your area spotting the properties you think suitable for your workshop and then trying to contact the owners.

Working from home
Technically anyone who operates a business from their home needs to have planning permission. To obtain this, contact the planning department of your local council and tell them what your plan is. To work from home without the council's permission is dangerous and illegal and if you attract the council's attention you will be ordered to stop operating. Special note to screenprinters and lithographers - screenwash and MEK have the same fire-hazard rating as petrol, making insurance difficult. Planning permission and fire advice is really vital.

Provided you are not causing a public nuisance - for instance by working late at night, making a lot of noise or fumes, causing traffic or parking problems, creating offensive/dangerous rubbish piles, etc., it is permissible to make prints at a *hobby level* whilst working at home (hobby level is difficult to put strict limits on but can loosely be defined as working and not intending to make a profit). If you operate without planning permission, ensure that you keep on good terms with your neighbours and generally avoid drawing attention to yourself.

Note that an owner/occupier with *a mortgage* is bound by the terms of a mortgage deed to use premises only as a residential dwelling. It is wise to write a letter to the

bank or building society indicating your plans. Also in terms of a *tenancy*, if the landlord discovers a breach of contract then he can require the tenant to cease working or terminate the contract. Note also that the same applies to *insurance* on premises often linked to a mortgage,or an individual policy. These often prohibit the use of the premises for anything other than residential use. They may cancel the policy in case of a non-disclosure.

Self-employed people working from home usually deduct a proportion of their household expenses appropriate to the artistic activity (see Chapter 4, p. 94ff).Take advice with regard to Capital Gains Tax liabilities.

Renting a workshop

If you decide to rent a space outside your home, there are two alternatives :

Group workshops

There are two types of group workshop. One type involves the workshop being *open to the public* either for part or all of the time. Rents can sometimes be lower in these types of workshop than the usual commercial rent. These workshops normally offer the opportunity for selling direct to the public. If public access is allowed it may restrict the amount of time available for working.

The other type of group workshop are developments which contain a number of units which are *not open to the public*. These are more popular as they combine advantages of a private workshop plus contact with people working in a similar process or area. Some group workshops offer central services such as secretarial help, bookkeeping and a selling/gallery space.

Individual workshops

As an individual workshop, you can opt to be either private and hence closed to public access, or open to the public. Before you decide it is important to assess your needs both now and in the future.

Consider the following questions : Where you would like to work? How far is it away from where you are living (hence travelling costs)? Is it accessible to others? Who are your neighbours above and below and what might prove objectionable to you and to them? How much can you afford? What does the rent include?(Rates? heating? light? cleaning?). What weight load will floor hold? How will you extract fumes? What are safety regulations? Can you get work in and out easily? Is water available? Is there already a telephone or a communal phone? What are the restrictions on the space - is it closed in evenings or at weekends? Is it secure?etc.

A check list of things to consider that will need immediate cash should include the *capital costs* of setting up a studio : Does the roof need mending or the windows? Will you need to install power points? What are the legal costs of a lease? What fire equipment is there and will there need to be fire doors installed? Is there water supply and waste disposal? Do not forget the *capital costs of machinery and equipment* you will need to start working. Do not forget that the landlord may also require you to purchase *fixtures and fittings* and that you will have *survey and legal fee*s. After all this are the*ongoing expenses* of keeping the workshop running e.g. rent, rates, water rates, insurance, heat, light, telephone, etc. and the *running expenses* needed to continue your work.

Leases

Will you sign a lease or licence? A lease gives security of tenure but many workshops are now offered by licence agreement. When an individual signs a lease or a licence with a landlord, that individual makes him/herself liable to pay the rent/occupation fee and carry out all the obligations under the lease/licence. Consider the length of a lease. For those first starting up it is worth considering a

short renewable lease. Make sure you have a written agreement about who is responsible for what. If you are sharing a workshop make an arrangement in writing (even if the co-lessees are your friends) with the others that is quite clear about what the arrangements are concerning ownership of and sales of equipment, use of joint facilities e.g. telephone, and payment of bills, etc. In a group situation the artists will need to discuss the legal identity of the group, rights and obligations between individuals and whether the lease should be signed by the group or an individual.

Legally an artist or a group of artists could form any of the following :

 sole trader

 a simple (unincorporated) association

 a partnership

 a co-operative

 a company limited by guarantee

 a trust

and any one of the last three can be a charity provided they have charitable aims. Whichever legal grouping is chosen, it is important is to set out rules to govern rights and obligations (e.g. rights of members, who will sign the cheques, etc.) and run the business as such. A formal constitution may be necessary.

Raising the money

It may be possible to obtain a studio conversion grant. Local patronage, a local RAA scheme, loan from a bank or an individual award /grant or support from one of the many schemes now offered for setting up small businesses may be avenues to explore. Discuss your plans with the landlord who may be prepared to offer a rent-free period in exchange for conversion, repair or improvement to properties. Try local firms for sponsorship-in-kind for materials. There is no way of paying for the running costs of a studio other than earning the money. Provided you are making money from selling work or offering courses, etc. your studio and running costs/ expenses are deductible from your income. Note that VAT affects all businesses to a greater or lesser degree (See Chapter 4, p. 94).

FURTHER READING *Artists Studio Handbook* Artic Producers PO Box 23, Sunderland SR1 IEJ
Artists Studio Management Handbook Richard Seddon London, Muller1983
Running A Workshop - Basic Business for Craftspeople Crafts Council. Available from Crafts Council12 Waterloo Place, London SW1 4AT

HELP AND ADVICE Talk to already existing workshops and studio groups; get help from solicitors, Companies House, Inland Revenue, Customs & Excise; from associations such as the Crafts Council or local RAA'S and specialist organisation such as :-

ACME 15 Robinson Road, London E2 9LX Tel. 01 981 6811 Helps individual artists to find housing with integral studio space and some industrial studio sites.Waiting lists.

SPACE 6&8 Rosebery Avenue, London EC1 Tel. 01 278 7795 Space provides studio workspace for artists in London and free information about setting up and running a studio. Subsidies mean that studios are at low cost. 1-2 year waiting list. ASG Ltd. is the parent company of which AIR and SPACE are subsidiaries.

Workshop & Studio Provision (Scotland) (WASPS) 26 King Street, Glasgow G1 5QP Tel. 041 552 0564 A major resource for artists looking for studios in Scotland, subsidised by the Scottish Arts Council.

Association of Artists & Designers In Wales (AADW) Gaskell Building, Collingdon Road, Cardiff. S.Wales Tel. 0222 487607 Advice on studios in Wales.

HEALTH AND SAFETY IN PRINTMAKING

There is often little provision for health and safety in a small workshop environment. When planning your workshop, looking after your own health and safety should be a major consideration. Many artists mistakenly think that implementation of health and safety regulations might restrict their creative expression or that

disease caused by working in various environments is part of the job.

If you touch or inhale the solvents, acids, inks, or other chemicals used in print-making, then sooner or later you may suffer from some kind of occupational disease. The effect might be mild, for example, a minor irritation due to a slight acid burn, or it might be serious, for example, pneumonia resulting from an overdose of fumes from nitric acid etching. Even more insidious than the immediate or acute reactions are the long-term or chronic diseases resulting from repeated exposure to small amounts of toxic materials. In many cases, it is difficult to say that any one substance is responsible in an occupational disease as a variety of materials are usually present.

Actual hazards of working with a particular material depend on several factors - the amount of material you are exposed to, the actual toxicity of the material, the length and frequency of exposure and your susceptibility. For instance, a technician working with screen inks and solvents every day is more likely to develop health problems than a student only working a few hours a week. The range of dangerous materials is broad. A label may warn you but what it does not say is what it will do to you and how long it will last/take. If you are poisoning yourself you may be aware of headaches, dizziness, nausea, vomiting, fatigue, blurred vision, irritability, coughing. If you ignore these first signs from your body, and let accumulation occur, even though it may take years to build up, the illness may be serious. Act when you have minor symptoms and register with your doctor.

According to the experts there are three main categories of high risk (susceptibility) and these are a major factor in determining illness: age, state of health and environment. This means children, pregnant women and old people are particularly at risk. Other high-risk groups include people with allergies, asthmatics, smokers, drinkers and people who have already had an illness in a particular organ, - especially heart, lungs and liver. If you go to see a doctor take along leaflets on the materials concerned and if you are working with lead, barium, toxic liquids or silica dust, have regular checkups.

How materials affect the body

There are three ways in which materials can enter and affect the body - through the mouth and digestive system, by skin contact and by inhalation.

1 Intake of poisons through the mouth is quite common because printmakers often eat and drink in their studios. It is very important to clean up thoroughly before you eat and not to eat where you work.

2 It is easy to see surface damage to the skin when it has been in contact with a dangerous substance but damage can also occur internally when the substance is absorbed through the skin. Some people have an immediate allergic reaction to a substance whereas in others it may take years for an allergy to develop. The secret is good health and to know and understand your own body.

3 Substances also enter the body by breathing in dust, vapour, mists or fumes. The effect of this can be a temporary headache or a more serious lung disease (especially with fumes of nitric acid). The size of the chemical particles which damage the body by inhalation are important. Fine particles are more toxic because they penetrate deeper. Repeated exposure to items such as chalk and talc (silica and asbestos) may cause silicosis, asbestosis or lung cancer. Larger particles get trapped in the mucous of the nose or in the upper breathing parts were you might naturally cough and spit out the offending particles. Vapours, such as solvent vapours, can be soluble in blood and travel to other organs. The organs most at risk are liver, kidneys and the central nervous system.

Working practice

Cleanliness and hygiene

Ref 1 *Health and Safety in the Arts And Crafts* by Tim Challis and Gary Roberts Artists Newsletter April 1984

This next section contains instructions for good working practice and is reproduced by kind permission from Tim Challis, Gary Roberts and *Artists Newsletter* (Ref 1).

Spills of hazardous materials should be wiped up immediately. The floor surface should be non-slip, at one level, and free of obstructions. Dirt should be wet-mopped, not brushed as this only stirs up the dust enabling it to resettle later.

Never eat, drink or smoke in the studio as this only increases the risk of accidental ingestion of hazardous materials. If working at home, avoid contaminating the living area and never use the kitchen as a studio. Only pour chemicals down the sink if absolutely necessary and then only slowly and diluted with lots of water.

Space

The studio must be large enough to avoid overcrowding, and planning of work areas, e.g. wet and dry, open-plan or small rooms with specific risks, etc, should be carefully considered in the initial planning of a workshop.

Temperature

The studio should be heated to a comfortable temperature as coldness increases the risk of accidents. Temperature and humidity levels should remain constant if at all possible to allow accurate registration of fine work.

Ventilation

Adequate ventilation should be the first means of controlling air contaminated with toxic substances. This can be achieved by diluting the contaminant to a level below that hazardous to health (general ventilation), or removing the contaminant at the point of generation (local ventilation). General ventilation is less efficient than local ventilation and may even prevent fine dust from settling, thus prolonging its presence in the breathing zone. An individual working with a particular substance, such as a solvent, may be at risk from a harmful level of exposure even though the general level in a room is safe. In such situations, local exhaust is obviously an advantage.

The following points should be noted when using a local ventilation system :
1 Enclose the source as effectively as possible.
2 Capture the contaminant with moving air of adequate velocity.
3 Keep contaminants out of the breathing zone by not working between the vapour source and the exhaust fan.
4 Ensure exhausted air is replaced by clean air, i.e. adequate general ventilation.
5 Discharge contaminated air in such a manner as to prevent it from re-entering the work place.

Electrical machinery and equipment

Machines should be stable and fixed so as not to vibrate or move during operation. A clear, unobstructed space must be provided around each machine. The Health and Safety Executive recommends a clearing on three sides of the machine of three feet beyond the maximum length of material being handled.

When not in use, machines should always be stopped, even if unattended for only a few minutes. Tools should be properly stored so as not to clutter the machine table. Worn tools should be replaced. Adequate protective clothing should be worn for all operations. Secure and efficient guards should be fitted to all machines.

Electrical safety

A main circuit breaker should be provided in any studio where electrical equipment is used. Emergency stop buttons should be strategically placed around the workshop area. Machines should also be fitted with an isolating switch. Safety cut-off devices should be fitted to machines that are left on overnight. Safety equipment and mechanisms should be appropriately coloured.

Electrical cable connected to the machine should be properly covered with trunking or conduit. Special flexible cable should be used where movement of machinery is involved. All cables should be kept away from naked flames, radiators, sharp edges and wet surroundings. Ensure plugs are fitted with the right fuse and that all connections at supply and equipment ends of cable are fast and safe. Regular maintenance of electrical machinery by qualified personnel is essential to any workshop.

Highly flammable liquids and sprays

There are three statutory classifications of flammability :

1 Highly flammable; liquids with a flashpoint of 32°C (90°F)or below.
2 Flammable; materials with a flashpoint above 32°C
3 Petroleum mixtures; those with a flashpoint of 23 °C (73°F)or below are by definition highly flammable.

A flashpoint is a method of rating the relative flammability of liquids. The lowest temperature at which a liquid gives off a flammable vapour/air mixture which can be ignited by sparks or static electricity is known as its flashpoint. If a substance is cooled below its flashpoint the danger of ignition is much reduced.

Only use highly flammable liquids at a temperature lower than the liquid's flashpoint. Consider the liquid's properties and conditions of usage when assessing whether or not a dangerous concentration is likely to occur. For instance, a vaporised liquid used as a spray may still be ignited at low temperature by an ignition source of sufficient energy.

Cleanliness is the most effective precaution against fire or explosion where highly flammable liquids are concerned. Places where highly flammable deposits accumulate should be thoroughly cleaned at least once a week. Use plastic, wood or phosphor-bronze scrapers, rather than metal, to remove nitro-cellulose residues. Spray booths can be cleaned more efficiently if preparatory coatings of sheet material or hardening liquid are applied to the booth surfaces before use and peeled off afterwards.

When spraying highly flammable materials, clean, dry filters should be used for each different material to eliminate the risk of spontaneous combustion of interacting residues.

Labelling

The Packaging and Labelling of Dangerous Substances Regulation 1984 lists over eight hundred dangerous chemicals, the manufacturers or suppliers of which are obliged to provide warning labels of specific dimensions and content as follows:

 Guidance concerning hazards
 Procedure for safe handling
 A pictorial symbol (black on orange)
 A key word indicting the hazard
 One or more risk phrases and precautions
 Name and address of supplier
 Name of chemical

Attention is also drawn to Section 6 of the Health & Safety at Work Etc. Act 1974 as amended by the Consumer Protection Act 1987. The implications of this are explained in a booklet *Articles and Substances at Work* obtainable from the Health & Safety Executive's library (Tel. 01 243 6384, 10am-3pm weekdays) quoting reference IND (G) 1(L) REV.

Major health hazards in the print processes

Listed below are a few of the more major hazards in each process. It is worth stating than human error is often responsible for a large number of accidents, for example - people smoking in studios, the usual non-adherence to safety regulattions,etc.

Traditional methods of relief printing are less hazardous than most processes. Lino etching with caustic soda can cause severe skin burns but most accidents are probably caused during the block-cutting stage when using sharp tools.

In intaglio, inhalation of rosin dust can cause lung difficulties and respirators should be used when laying aquatints, asphaltum is a skin irritant especially when hot and, like lamp black and carbon black, contains substances which may cause skin cancer. Most acids are corrosive, cause burns from splashes and are irritants. One of the greatest dangers is from the gas that is produced during nitric acid etching of copper and zinc. Mixing of some acids can cause toxic gases. Remember **always add the acid to the water**

In screenprinting the major health hazard is the large-scale use of solvents. These are used for mixing inks, thinners, cleaning liquids, lacquers, stencil adherers and blockouts. One of the greatest hazards is the evaporation that occurs when the prints are drying in the racks and the harmful vapours evaporate into the atmosphere. As fumes are heavy the drying rack should have its own low-lying exhaust ventilation. The other major hazard is in screen cleaning. Large-scale use of lacquers, cleaners or thinners is not recommended. High concentration of these solvents causes drowsiness and fatigue and many cause dermatitis.

Mixtures of talc, French chalk and rosin in lithography if inhaled can cause severe chronic lung problems. Many solvents used should be handled only if good ventilation is present; desensitising or gum etches contain gum arabic (probably safe) plus a variety of chemicals which can cause dermatitis.

FURTHER READING

Artists Beware Michael McCann Watson Guptill
Caution: A Guide to Safe Practice in Arts & Crafts T. Challis & G. Roberts Sunderland Poly. 1984
Dangerous Properties of Industrial Materials Irving Sax New York, Van Nostrand Reinhold,1975
Etching Leonard Edmonson New York,Van Nostrand Reinhold 1973
Health & Health &Safety in Printmaking Moses, Purdham, Bowhay, Hosein Occupation Hygeine Branch, Alberta Labour, Canada 1978
Health and Safety at Work Etc. Act 1974 HMSO
Safe Practice in the Arts & Crafts - A Studio Guide Gail Canningsby Barazoani College Art Association of America 1978
Safety First James Tye and Tim Challis London, J. M. Dent & Sons 1988
Tamarind Book of Lithography G. Antresian & C. Adams New York, Abrams 1971
Toxicology : The Basic Science of Poisons L. Casserat and J. Doull New York, Macmillan 1975

DIRECTORY OF BRITISH OPEN ACCESS PRINT WORKSHOPS

Since 1980 a proliferation of new workshops in Britain has occurred where artists can go and collaborate on many levels with other artists skilled in printmaking processes. Workshops that offer every conceivable opportunity from the technical expertise of an accomplished skill to being taught how to print, from hiring of the whole studio to travelling with a mobile print workshop.

At the other end of the workshop spectrum are the more established studios run by master printers, many of which have existed since the new wave of artists' workshops began in Britain. Studios such as Curwen Studio, Kelpra Studio, Advanced Graphics and I. M. Imprimit are run by significant craftspeople in their own right who have over the years developed and become well known for a particular expertise.

This survey looks only at the studios where original, fine art prints are the only output. The product is termed original because the artist conceived, created and for the most part produced the work and because it utilises the qualities of the process for itself and not as an imitative discipline. The type of work that is made in the workshops listed is that which continues the age-old craft traditions of lithography, intaglio, relief and screenprinting, perhaps with modern additions e.g. photo processes and computer/laser techniques; where the work is for the most part

hand printed and in which the artists have made the screen/block/plate themselves or with the help of technicians; where the edition is small (1-500) and is often self published.

The studios in this survey are limited to professional , open access printmaking workshops, i.e. those that an artist can approach to seek expertise in the field of printmaking. Other types of printmaking studios which exist in Britain such as private press workshops, community workshops, adult education workshops etc. which are not geared to use by professional artists have not been included (see Further reading).

ENGLAND

Appledore

Appledore Press
2 Meeting Street, Appledore, Nr. Bideford, Devon Tel. 02372 75933
Contact David Tomlin
Media Lithography

Bath

Bath Artist Printmakers
11a Broad Street, Bath Tel. Bath 446136
Membership secretary Elizabeth Irving,
Description Limited company, established 1984
Media Etching, screenprinting, relief printing, lithography, bookbinding
Services Artists' workshop. Annual membership fee. New members welcome. Frequent opportunities to exhibit at home and abroad

Birmingham

Birmingham Print Workshop
Unit P, 113 Glover Street, Digbeth, Birmingham B9 4EN Tel. 021 449 5895
Contact Peter Grego
Description Fine Art Print Workshop, established 1984
Media Relief, intaglio, lithography, screenprinting
Services Annual membership scheme, beginners' courses for individuals and schools

Braintree

Linda Richardson
Unit 16, Blake House Farm, Blake End, Rayne, Braintree, Essex Tel. 0376 551 360
Contact Linda Richardson, Philip Pickering.
Description Intaglio workshop, established 1988
Media Intaglio
Services Platemaking (including photographic), proofing, editioning, colour printing.

Brighton

North Star Studios
65 Ditchling Road, Brighton Tel. 0273 601041
Contact Nicholas Sinclair
Description Fine art printworkshop, open access, established 1978
Media Lithography, relief printing, etching, B&W photography
Services Self-financing workshop via membership subscription. Editioning services. Evening classes in etching and lithography. Lectures on aspects of printmaking. Workshops and summer schools.
Information Complete internal and external renovation of building in last five years. Installation of new screen bed, new etching press, printing-down frame and litho press. Custom-built darkroom. 30 members of studio

Bristol

Bristol Printmaking Workshop
MacArthur Building, Gas Ferry Road, Bristol BS1 Tel. 0272 49167
or c/o 18 Hartington Park, Bristol BS6 7ES Tel. 0272 49167
Contact Chairman Peter Reddick
Description Artist-run workshop, company limited by guarantee, established 1977
Media Intaglio, relief, letterpress, screenprinting, darkroom
Services Membership allows artists to use all facilties in workshop. No editioning facilities or classes

Clifton Editions and Clifton Press
10 Clifton Hill, Bristol BS8 1BN Tel. 0272 730653
Contact Marie Walker
Description Editioning workshop and artists'workshop, established 1978
Media Intaglio and stone litho
Services Editioning and use of workshop

Bridgewater

Moorland House Workshop
Burrowbridge,Nr Bridgewater, Somerset TA7 0RG Tel. 0823 69200
Contact Lucy (Anderson) Willis
Description Private workshop with limited access, established 1980
Media Etching, lithography, relief

Cambridge	**Chilford Hall Press**

Chilford Hall Press
Chilford Hall, Balsham Road, Linton, Cambridge Tel. 0223 893544
Contact Kip Gresham (owner)
Description Screen printing studio, established 1982
Media All forms of autographic and photomechanical screen printing
Services Proofing, editioning, publishing, co-publishing, exhibition origination, design.
Other Introducing a fully equipped lithography studio during 1989

Exeter
Intaglio Editions
The Studio, Banbury, West End Road, Bradninch, Exeter Tel. 0392 860189
Contact Amanda Ford , Dan Dickens
Description Partnership
Media Intaglio
Services Studio facilities and editioning. Teaching. Mobile children's workshop
Other Experts in editioning antique plates. Strong commitment to education

Hastings
Hastings Etching Workshop
74 West Hill Road, St Leonards on Sea, East Sussex TN38 ONE Tel. 0424 424235
Contact Martin Ware
Description Private studio, established 1988
Media Intaglio
Services Proofing, editioning. Classes. Courses

Helston
Balwest Studios
Lower Balwest Farm, Ashton, Helston, Cornwall TR13 9TD Tel. 0736 762491
Contact Simon Averill
Media Lithography

Huddersfield
Yorkshire Printmakers & Distributors Ltd
26-28 Westfield Lane, Emley Moor, Nr.Huddersfield HD8 9TA Tel. 0924 480514
Contact Mrs Armitage
Description Limited company
Medium Intaglio

Ivybridge
Wilkey's Moor Print Workshop
Ivybridge, Devon PL21 OJJ Tel. 0752 893686
Contact Michael Honnor
Description Private workshop, established 1979
Media Stone lithography, intaglio, block printing
Services Annual summer school

Knighton
Borderline Printmaking Cooperative
The Old Post Office, Knighton, Market Drayton, Shrops. TF9 4HL Tel. 063 081 225
Contact Phil Sayers
Description Artists' group; three layers of membership-working members, exhibiting members, class
members, established 1985
Media Etching, screenprinting, photography, monoprinting, collograph, relief printing, wood engraving
with introduction of lithography planned for 1989
Services Contact and support of other artists; printmaking facilities for its members and promotion of
their work; materials, papers and framing at cost; mobile print workshop within the community and
public or in-service courses at the studio
Other Some residencies and placements

Langton Green
First Edition Studios
Stable Cottage, Shirley Hall, Leggs Lane, Langton Green, Kent TN3 0RQ Tel. 0892 86 3752
Contact Robert Cornish
Description Company, established 1987
Media Etching, relief printing, bookbinding, letterpress
Services Proofing, printing, editioning. Bookbinding of artist's books

Leicester
Leicester Print Workshop
68 Knighton Lane, Aylestone, Leicester Tel. 0533 830587
Contact Workshop co-ordinator Sue Emsley
Description Company controlled by management committee, established 1985
Media Intaglio, relief, lithography (on small scale)
Services Membership scheme for artists and non-printmakers giving technical advice. Courses on
etching for both members and non-members. New scheme to sell and exhibit members' work

Leominster
Aymestry Mill Print Studio
The Mill, Aymestry, Nr. Leominster. Hereford Tel. 056 886 431
Contact Ian Lawson
Description Fine art print workshop, established 1974
Media Direct lithography
Services Limited edition printing, contract editioning. One week courses in lithography.
Other Accomodation available

Bluecoat Etching Workshop
Bluecoat Gallery, School Lane, Liverpool Ll 3BX Tel. 051 709 5689
Contact Chris Kennedy.
Description Part of Bluecoat Gallery, limited company, established 1968
Media Etching
Services Individual hire to artists. Platemaking and editioning. Evening classes for beginners.
Other The studio is open for group courses, i.e. colleges, community groups and tuition by local printmakers can be provided

Advanced Graphics
Faircharm C103, 8-12 Creekside, London SE8 3DY Tel. 01 691 1330
Contact Chris Betambeau, Robert Saich, David Wood
Description Fine art printing workshop
Media Screenprinting, relief and monoprinting
Services All forms of screenprinting (including large sizes) plus mixed media - woodcut, monotype and screenprinting
Other 6,000 sq.ft. print floor with natural light. Facilities for artists to experiment. Advanced Graphics also publishes prints

Andrew Nyderek
62a Southwark Bridge Road, London SE1 (No phone)
Contact Andrew Nyderek
Description Intaglio editioning studio, established 1985
Media All forms of intaglio
Services Proofing and editioning

Apollo Etching Studio
3 Charlton Kings Road , London NW5 Tel. 01 485 2204
Contact Jo Robinson and Linda Black
Description Etching studio/open artists workshop

Barrington Studio
110 Barrington Road, London N8 8QX Tel. 01 340 1762
Contact Pip Benveniste
Description Private, established 1982
Media Intaglio
Services Daily/weekly hire of studio (2 persons max.). Technical assistance/instruction
Other Accommodation by arrangement

The Block Printing Studio
Paragon Centre, Searles Road, London SE1 Tel. 01 840 6222
Contact David Laing
Description Fine art printworkshop partnership
Media Very well equipped, new studio for etching, plate and stone lithography, screenprinting plus one small relief press. Facilities for photo-stencils.
Services Primarily artists' studio with rates of hire. Also tuition. Proofing and editioning.
Other Brand new studio with 15,000 square feet of space. Very well equipped with emphasis on large size printing. Aim of this group is to open studio to all artists as a resource centre

Coriander Studio & Coriander (London) Ltd
Unit 4, 7-11 Business Centre, Minerva Road, Park Royal, London NW10 6HJ Tel. 01 965 8739
Contact Brad Fayne
Description Limited company, commercial fine art studio, established 1972
Media Screenprinting
Services All aspects of screenprinting including monoprints. Full photographic process backup.
Other The studio encourages artists to work on their own stencils and to proof in the workshop. Coriander also publishes prints

Cowper Studio
28 Cowper Street, London EC2A 4AP Tel. 01 624 9087
Contact Kevin Harris
Description Partnership, established 1973
Media Screenprint
Services All forms of screenprinting

Culford Press
151 Culford Road, De Beauvoir Town, London N1 4JD Tel. 01 241 2868
Contact Paul Coldwell
Description Small independent workshop, established 1986
Media All forms of intaglio
Services Proofing/editioning facilities. Private workshop; artists' involvement mainly by invitation only.
Other Publishes annually portfolio of fine art prints produced and published at Culford Press

Curwen Studio
Midford Place, 114 Tottenham Court Road, London W1P 9HL Tel. 01 387 2618
Contact Stanley Jones
Description Limited company, established 1958
Media Autographic litho on grained zinc, aluminium and stone, continuous tone litho
Services Proofing and editioning in limited runsof offset and direct lithography. Suppliers of grained zinc for litho work
Other The studio continues to promote limited edition litho originated by artists in both traditional and experimental processes. Advice is given to both professional printmakers and artists new to litho

Egerton-Williams Studio Ltd
28 Phipp Street, London EC2
Contact Edward Egerton-Williams (Chairman and Managing Director)
Description Limited company, private fine art studio, established 1980
Medium Intaglio
Services Proofing, editioning, hand colouring, restoration
Other Private studio undertaking commissioned work for publishers only. New premises 1989

Essendine Art Centre Printmaking Studio
Essendine School Annexe, Essendine Rd, off Shirland Rd, London W9 Tel. 01 286 4475
Contact Guillem Ramos-Poquí
Description Printmaking studios ILEA
Media Plate and stone lithography, etching up to imperial size
Services Access studios, day and evening work. Artists able to edition their work under supervision. Artist-in-residence programme, recent college graduates welcome; art gallery on ground floor. Canteen and crêche facilities availble
information Approx. 120 artists using studio of which ten each term are artists-in-residence

Holland Park Studio
50 Queensdale Road, London W11 4SA Tel. 01 602 1563
Contact St Claire Allen
Description Private studio offering access to professional printmakers and students requiring tuition, established 1981
Media Etching plus other intaglio techniques, relief printing, wood engraving
Services Contract editioning service for intaglio and relief (for artists and dealers.Illustrated talks and lectures. Demonstrations. Tuition - private plus small groups in intaglio, relief and watercolour.
Other Studio policy is to be able to offer an efficient and reasonably priced editioning service; to provide thorough tuition in a stimulating yet sympathetic atmosphere

Hope Sufferance Studios
Unit 3B, The Granary, Hope Sufference Wharf, St Mary's Church St,, London SE16 Tel. 01 237 4809
Contact Simon Marsh, Peter Koswicz
Media Intaglio
Services Proofing, platemaking, editioning

I. M. Iprimit
219a Victoria Park Road, London E9 7DH Tel. 01 986 4201
Contcact Ian Mortimer (Director, Master Printer)
Description Private, established 1969
Media Relief printing, woodcut, wood engraving, linocut, letterpress typesetting and proofing
Services Proofing, editioning all of relief printing. Design, typesetting, printing limited edition texts etc

Jane Anderson
62a Southwark Bridge Road, London SE1 OAS Tel. 01 928 8956
Contact Jane Anderson
Description Sole trader
Medium Stone lithography
Services Access for professional printmakers. Stone preparation, proofing and editioning. Tuition plus some classes
Other Professional experienced artist printmakers welcome. Publishing connected with studio

Kelpra Studio Ltd.
23-28 Penn Street, London N1 5DL Tel. 01 253 1365
Contact Chris Prater
Description Fine art printing studio, established 1958
Media Screenprinting and intaglio
Services Proofing and editioning

Kew Studio
St Luke's House, 270 Sandycomb Road, Kew Gardens, Richmond Tel. 01 940 2791
Contact Sally Hunkin
Description Co-operative open workshop, established 1980
Media Intaglio
Services Artists hire space to do their own work, automatically becoming members. Tuition available

Leopard Press
24a Church Lane, London N2 8DT Tel. 01 883 6140
Contact Celia Jones
Description Sole trader, established 1987
Media Intaglio and block printing
Services Facilities for platemaking, proofing and editioning
Other Workshop combines with small art shop from which art and etching materials are available.

Nautilus Press and Paper Mill
79 Southern Row, London W10 5AL Tel. 01 968 7312
Contact Jane Reese.
Description Co-op, open educational opportunities, private workshop. Book-art, paper mill, bindery, letterpress printing and printmaking studios, established 1985
Media: Hand papermaking, book arts, marbling, typesetting and letterpress printing, printmaking
Services Designer bookbinder and custom work for graphic design studios, custom-made handmade paper, book kits, classes: book art, hand papermaking, marbling
Other Studio has expanded from 1 room to 5 rooms; co-operative workshop for members; afternoon, evening and weekend classes for students and practising artists

New North Press
27-29 New North Road, London N1 6JB Tel. 01 251 2791
Contact Graham Bignell
Description Private press, established 1986
Media Relief printing - woodcut, wood engraving, lino, typography
Services Studio hire
Other This workshop is connected to three other separate studios - Hope Sufferance, Paupers Press and Lizzie Neville Bookbinding which combine trade under the name of Tricorne Publications aiming to promote and publish artists' books and portfolios of prints using facilities in each individual studio

North London Workshop
13 Cranbourne Road, London N10 2BT Tel. 01 444 7833
Contact: Mati Basis
Description Studio workshop, established 1971
Media Intaglio
Services Steel-facing copper plates

Paupers Press
27-29 New North Road, London N1 6JB Tel. 01 253 2726
Contact Michael Taylor
Description Private workshop, established 1986
Media Etching, lithography, relief printing
Services Refer also to New North Press, London and Tricorne Publications

The Print Centre Ltd.
63 Barnsbury Street, London N1 el. no. 01 836 1904
Contact Hugh Stoneman, Sarah Lee
Description Limited company, established 1979
Media Etching and intaglio, photogravure, lithography, letterpress. Specialists in hand colouring
Services Organisation of specialist or unusual projects

Printers Inc
27 Clerkenwell Close, London EC1 Tel. 01 251 1923
Contact Pat Schaverien, Cheryl Aaron, Judith Downie and Zena Flax.
Description Private studio, established 1977
Media Intaglio
Services Private studio available for rental by experienced printmakers who may wish to draw, proof, edition. No technical assistance or supervision available. Tuition by arrangement

The Printing Studio
Correspondance 20 Wickham Road, London SE4 INY Tel. 01 469 0619
Studio The Coach House, Adj.14 Wickham Road, London SE4 1PB
Contact Sylvia Finzi
Description Private studio, established 1983
Media Intaglio (mainly B&W)
Services Studio available for hire, tuition by arrangement, courses for beginners and children

Studio Prints
159 Queens Crescent, London NW5 Tel. 01 485 4527
Contact Dorothea Wight and Marc Balakjian
Description Editioning studio, established 1968
Media Intaglio
Services Editioning
Other Mezzotint specialists, multi-colour intaglio printing specialists. Plates prepared with hard and soft ground service. Celebrating twentieth anniversay 1988

Sky Editions
33 Charlotte Road, London EC2A 3PB Tel. 01 739 7207
Contact Alan Cox
Description Fine art printing studio, established 1967
Media Plate lithography, woodcut, lino, monoprinting
Services Proofing and editioning

Tetrad Press
Hega House Studio, Ullin Street, London E14 Tel. 01 515 7783
Contact Ian Tyson
Description Private workshop with limited access, established 1970
Media Letterpress, relief and intaglio (no platemaking facility)

Lowick **Lowick House Printworkshop**
Lowick, Nr Ulverston, Cumbria LAIZ 8DX Tel. 0229 85 698
Contact John and Margaret Sutcliffe
Description Open access, established 1973
Media Lithography, intaglio, relief and screenprinting. New litho techniques.
Services Litho editioning, open access to artists. Print publishing
Other Introduction of a new litho technique to assist artists' use of fine art lithograph

Lyndhurst **White Gum Press**
Fleetwater Farm, Newtown Minstead, Lyndhurst. Hants SO43 7GD Tel. 0703 812273
Contact Katie Clemson
Description Company, established 1987
Media Specialist relief workshop plus space for experimental monoprints and experimental paperwork
Services Custom printing. Tuition by appointment. Workshops. Residencies for Australian
printmakers. Work on display, viewing by appointment
Other WG Editions publishes portfolios of prints. Agent and promoter of various Australian artists

Mirfield **Kirklees Arts Space**
Easthorpe Gallery, Huddersfield Road, Mirfield WF14 8AT Tel. 0924 497646
Contact Daphne M. Alsop
Description Society, established 1984
Media Screenprinting, etching, textile, photography
Services Educational classes. Materials

Nettlecombe **Nettlecombe Studios**
Nettlecombe, Nr.Williton. Somerset Tel. 0984 40894
Contact Lizzie Cox
Media Lithography, relief printing, etching
Other Cottages to let accommodating 6 persons

Newcastle **Charlotte Press (formerley Northern Print)**
5 Charlotte Square, Newcastle upon Tyne NE1 4XF Tel. 091 232 7531
Contact Director Fran Bugg
Description Established 1976
Media Intaglio, screenprinting, relief printing, stone and plate lithography
Services Printmaking support on an open access basis. Marketing and promotion for artists using
workshop. Editioning regularily undertaken for artists and publishers. Courses in all media

Oxford **Oxford Printmakers Cooperative Ltd**
Christadelphian Hall, Tyndale Road, Oxford OX4 IJL Tel. 0865 726472
Contact Pete Dobson, Joanna Gorner
Description Co-operative workshop, established 1976
Media Intaglio, lithography, relief, screenprinting, typography, photo processes
Services Workshop for members of co-op. Contract editioning. Print marketing. Exhibition
organisation. Educational programme. Slide library

St Ives **Penwith Print Workshop**
Penwith Galleries, Back Road West, St Ives Cornwall Tel. 0763 795657
c/o Roy Walker, Warwick House, Sea View Terrace, St Ives Tel. 0736 79 5657
Media Etching, screenprinting, relief printing

Porthmeor Printmakers Workshop
Unit 4, Porthmeor Road, St. Ives, Cornwall TR26 1NP
Contact Peter Fox
Description Company
Media Intaglio techniques
Services Guided workshops for individuals and groups. Educational services

St. Mawes **Pomery's Print Workshop**
Pomery's Kings Road, St. Mawes. Cornwall Tel. 0326 270406
Contact Brenda D.Pye
Media Screenprinting, lithography, etching, darkroom

Scarborough	**Crescent Arts Workshop**
	The Art Gallery Basement, The Crescent, Scarborough, N.Yorks YO11 2PW Tel. 0723 351 1461
	Media Screenprinting and etching
Sudbury	**Gainsborough's House Print Workshop**
	Gainsborough's House, Sudbury, Suffolk COIO 6EU Tel. 0787 72958
	Contact Assistant curator
	Description Registered charity, established 1978
	Media Intaglio, lithography, screenprinting, relief printing, photography
	Services Adult education courses during scholastic term, 3&4 day summer courses
	Information Refurbishment of workshop during last three years to include heating, enlargement of working space, darkroom. Screenwash area proposed for 1989
Todmorden	**Red Water Arts**
	Back Rough Farm, Coal Clough Road, Todmorden, Lancs UL14 8NU Tel. 0706 815328
	Contact Mike Pensel
	Description Private studio, established 1985
	Media Relief printing, intaglio
	Services Hire of facilities, instruction, tuition, short courses
	Other Accomodation available
Totnes	**Ingham Press**
	Unit 13, Staverton Bridge Mill, Staverton, Totnes, Devon Tel. W/E 0803 865544
	Contact R. M. Broadbent
	Description Owner managed workshop, established 1979
	Media Lithography
	Services Complete facilities for direct transfer colour printing. Enquiries from experienced self-printers welcome
Westbury	**107 Workshop**
	Unit 1, Angel Mill, Edward Street, Westbury, Wilts BA13 3BG Tel. 0373 826728
	Contact Jack Shireff
	Description Fine art studio
	Media Everything from fabrication to hand painting, also including intaglio, lithography, relief and photo-techniques
	Services Wide range, specialist in plate making, proofing and contract printing. No educational courses or tuition. Work for international publishers and dealers
Weybridge	**Olive Tree Press**
	7 Ridgemount, Oatlands Drive, Weybridge.Surrey Tel. 0932 227134
	Contact Owner
	Description Print workshop, established 1981
	Media Intaglio
	Services Platemaking, editioning. Private tuition and classes in intaglio and drawing
	Other Permanent collection of prints by various artists on sale or loan
Wolverhampton	**Wolverhampton Art Space**
	Eagle Works, Alexandria Street, Wolverhampton, WV3 OTE Tel. 0902 25958
Upper Beeding	**Senefelder Press**
	New Brook Farm, Pound Lane, Upper Beeding, Steyning. West Sussex BN4 3WJ Tel. 0903 814331
	Contact Andrew Purches
	Description Sole owner
	Media Offset plate lithography. Hand-drawn work only
	Services Proofing and editioning. Chromolithography (direct plate, not continuous tone). Aims to provide a competitive proofing and editioning service and encourages hand drawn work directly onto plate
	Other Plate graining and stockist of some sundries and inks. Accommodation arranged in village

SCOTLAND

Aberdeen	**Peacock Printmakers**
	21 Castle Street, Aberdeen ABI IAJ Tel. 0224 639539
	Contact Arthur Watson
	Description Non-profitmaking company run by artists with a membership scheme, established 1974
	Media Intaglio, screenprinting, relief printing, lithography, process photography, typesetting
	Services Facilities for artists through open access workshop. Contract editioning, Instruction. Courses. Demonstrations. Exhibitions. Publishing
	Other In 1986 Peacock took over the running of Art Space Galleries which now houses two galleries showing a variety of contemporary exhibitions in all media
Dundee	**Dundee Printmakers Workshop**
	38-40 Seagate, Dundee DD1 2EJ Tel. 0382 26331
	Contact Bob McGilray
	Description Charitable company, limited by guarantee

Media Screenprinting, intaglio, relief, lithography and photography
Services Memberrship for working artists and amateurs. Classes and educational courses. Print hire schemes. Friends of the Workshop scheme
Other The workshop runs a large adjoining gallery which has a continuous programme of exhibitions

Dunfermline **Fife Print Workshop**
The Basement, Netherton Institute, Netherton Broad Street, Dunfermline. Fife
Contact Ian Lindsay
Description Educational charity, co-op established 1978
Media Intaglio, lithography, relief, screenprinting, photo processes
New developments Development of screenprinting and relief as well as intaglio viscosity printing.This workshop exists to service the needs of artists in Fife and provide print facilities and exhibition space

Edinburgh **The Printmakers Workshop**
23 Union Street, Edinburgh EH1 3LR Tel. 031 557 2479
Contact Director Robert Livingston
Description Non-distributing limited company with charitable status, subsidised by Scottish Arts Council, established 1967
Media Screenprinting, lithography, etching, relief printing plus photographic darkroom
Services Editioning and co-publication. Open access to facilities for members. Regular courses for adults and schools. Varied programme of activities e.g. Open Door Day (studios opened to public). Framing service available
Other Moved to large converted premises in 1984 which includes spacious gallery showing regular programme of exhibitions with printmaking links; workshop supported by active Friends' Group

Glasgow **Glasgow Print Studio**
22 King Street, Glasgow G1 1EJ Tel. 041 552 0704
Contact Director John Mackechnie
Description Subsided limited company, open access workshop by membership, esatblished 1972
Media Screenprinting, etching,lithography and relief printing plus dark room
Services Workshop is open to artist printmakers. Platemaking, proofing and editioning. Evening classes and W/E courses.
Other Original Print Shop Gallery located at 25 King Street run by Glasgow Print Studio, selling members work plus variety of national and international exhibitions. Active promotion of members work e.g. by exhibition programmes and visiting print fairs (such as Olympia and Los Angeles). Framing service. Paper sales

Inverness **Inverness Printworkshop**
20 Bank Street, Inverness Tel. Daytime 0463 234121 x 448
Contact Margaret Robertson or Gina Quant
Description Registered Charity and Company Limited by guarantee, established 1985
Media Screenprinting, intaglio, relief and lithography
Services Access to all workshop by membership. Gallery space. Shop. Evening and weekend classes. Framing service planned

Kirkton of Craig **Kirk Tower House Print Studio**
Kirkton of Craig, Montrose DD10 9TB Tel. 0674 72306
Contact Sheila Macfarlane
This studio established 1976 is at present up for sale but the printmaker, Sheila Macfarlane, is still available for consultation, commissions, exhibitions, lectures, etc. and is willing to travel. She can be contacted at the above address or through Peacock Printmakers, 21 Castle Street, Aberdeen

Kirkwall **Solisquoy Printmakers Workshop**
16 Hatston, Kirkwall, Orkney Tel. 0856 3065
Contact Secretary Sheila Cameron
Description Co-operative, (open to key holding subscribers), established 1983
Media Intaglio, screenprinting, relief printing
Services Membership facilities. Courses. Artist-in-residence scheme. Educational instruction to senior school pupils

WALES
Cardiff **Association of Artists & Designers in Wales:Cardiff Printworkshop**
Gaskell Buildings, Collingdon Road, Cardiff CF1 5E Tel. 0222 487607
Contact Vanessa Webb (AADW national administrator)
Description Functions as a co-operative and exists as a group within AADW, established 1979
Media Stone and plate intaglio, lithography, screenprinting
Services Use of facilities (free to PW members, discount to AADW members). Tuition. Exhibitions

Porthcawl **Taurus Press of WIllow Dene**
11 Limetree way, Porthcawl, Mid Glamorgan CF36 5AV Tel. 0656 771356
Contact Paul Peter Piech
Description Private 'garage' workshop, established 1959
Media Relief printing and letter press
Services Editioning and proofing. Poster work & book work (poetry, political and social)

Swansea **Atelier Sixteen**
The Barn, Rhoose, Nr Barry. S, Glamorgan, CF6 9QE Tel.0446 710293/711608
Contact Ruth Nicholas, Director
Description Partnership, established 1988
Media Lithography *Services* Proofing. Editioning

NORTHERN IRELAND
Belfast **Belfast Print Workshop**
181A Stranmills Road, Belfast BT9 5DU Tel. 0232 381591
Contact Jim Allen.
Description Open workshop for artists financed by Arts Council of N.Ireland, established 1977
Media Intaglio, stone lithography, screenprinting, small process darkroom
Services Facilities available to printmakers and artists. Printmaker-in-residence fellowship

Bangor **Seacourt Print Workshop**
120 Princetown Road, Bangor Tel. 0247 271235
Contact Margaret Arthur
Description Self supporting independent workshop, established 1981
Media Lithography, relief, intaglio
Services Editioning relief prints and etchings. In-service courses for teachers. Tuition in relief/ etching
Other Negotiating for new premises to expand

Newcastle **Carnacaville Litho Prints**
1 Church Hill Road, Newcastle. Co Down BT 33 OJU Tel. 03967 22356
Contact John Breakey
Description Privately owned workshop, established 1985
Media Lithography (mostly stone)
Services Work with artist up to BAT. Editioning

DIRECTORY OF INTERNATIONAL PRINT WORKSHOPS

This compilation of international print workshops is not comprehensive and may not be as complete as I would wish, but aims simply to be a starting point for visitors to each country. This list is organised alphabetically by country, alphabetically by town and alphabetically by name of workshop in the same town or city.

AUSTRALIA
Adamstown **Newcastle Printmakers Workshop** 27 Popran Road, Adamstown 2289. NSW
Fitzroy **Port Jackson Press** 236 Brunswick Street, Fitzroy 3056. Victoria
Victorian Print Workshop 188 Gertrude Street, Fitzroy 3065. Victoria
Hobart **Chameleon Print Workshop** 46 Campbell Street, Hobart 7001. Tasmania
Kingston **Studio One** 71 Leichardt Street, Kingston. ACT 2604

BELGIUM
Kasterlee **Rijkscentrum Frans Masereel** Zaardendijk 20, 2460 Kasterlee
Tournai **Jean Marie Mol** 8 Ave des Etats Unis, 7500 Tournai

BRAZIL
Sao Paulo **Taller Anna Luizi Bellucci** Rua Cardoso de Almeida, Sao Paulo 2060 01251
Taller Evandro Carlos Jardim Av Joao Dias 95, Sao Paulo 04723
Taller Sergio Fingermann Travessa Ponder 72, Sao Paulo CEP 1400

CANADA
Banff **The Banff Centre School of Fine Art** PO Box 1020, Banff. Alberta TOL OCO
London **Editions Canada Inc** 13 & 30 Prospect Ave, London. Ontario N6B 3A4
Lone Butte **Cariboo Stone Press** RRI Lone Butte. British Columbia VOK 10
Montreal **Graff** 963 Est Rachel, Montreal. Quebec H2J 2JH
Southern Shore **St Michaels Printshop** St Michaels,Southern Shore. Newfoundland AOA 4AO
Scarbrough **The Greenwich Workshop Ltd** 1620 Midland Avenue, Scarbrough ON M1P 3C2
Toronto **Di Bello Editions** 363 Queen Street West, Toronto ON M5V 2A4
Open Studio 520 King Street West, Toronto M5V 1L7
Presswork Editions 98 Richmond St. East, Suite 420, Toronto Ontario M5C1P1
Sword Street Press Ltd 10 Sword Street, Toronto Ontario M5A 3N2
Val -David **Atelier de l'Ille** 1289 rue Dufresne c.p. 343, Val -David Q.C. JOT 2NO P. Quebec
Vancouver **Crown Printers** 2221 Ontario Street, Vancouver British Columbia V5T 2X3
Malaspina Printmakers Workshop 1555 Duranleau Street, Granville Island, Vancouver V6H 3F3
Winnipeg **Moosehead Press** 503-99 King Street, Winnipeg Manitoba R3B IH7

CHILE
Santiago **Taller Artes Visuales Ltd** Galleria Bellavista 61,Bellavista 0866 Santiago
Eduardo Vilches Yrarrazaval 5052,Santiago

DENMARK

Aarhus **I. Chr. Sørensen, Verksted for Grafisk Kunst** Grønnegade 93, DK 8000 Aarhus C
Copenhagen **Edeling Graphic (Galeri & Edition)** Gammel Mont 39, DK-2400 Copenhagen NV
Hostrup-Pedersen & Johansen Aps Valhøjvej 14, Baghus, DK-2500 Copenhagen. Valby
Niels Borch Jensen Prags Boulevard 49E, DK 2300 Copenhagen S
Permild & Rosengreen Værkstedvej 20, DK-2500 Copenhagen Valby
Bjorn Rosengreen Sortedam, Dossering 95A, 2100 Copenhagen Ø
UM Grafik (Stentryck) Nøppebrogade 20, DK 2200 Copenhagen N
Karise **Mogens Sandberg** Barupvej 38, DK-4653 Karise
Lyngby **Eli Ponsaing** Caroline Amalievej 16, DK-2800 Lyngby
Værlose **Grafodan Grafik** Lejrvej 1, Kirke Værløse, DK 3500 Værlose

EIRE

Dublin **Black Church Print Studio** Ardee House, Ardee Street, Dublin 8
Graphics Studio 18 Upper Mount Street, Dublin

FINLAND

Helsinki **Grafiris** Tehtaankatu (Fabriksgatan) 29a (4), SF-00100 Helsinki 10
Konstgrafikernas verkstad Ritobergsvegen 18, SF-00330 Helsinki 33
Taidegrafikot, Grafiska Sällskap Pohj. Rautatiekatu 11a5, SF-00100 Helsinki 10

FRANCE

Luc en Diois **Atelier Claude Pigot** 26310 Jansac, par Luc en Diois
Lucq de Bearn **Atelier de Lucq** 64360 Monein, Lucq de Bearn
Paris **Arte** 13 rue Daguerre, 75014 Paris
Atelier Bellini 83 rue de Fauborg Saint Dennis, 75010 Paris
Atelier Clot-Bramson et Georges 19 rue Vieille du Temple, 74004 Paris
Atelier Crommellynck 172 rue de Grenella, 75007 Paris
Atelier Daragnes 14 avenue Junot, 75018 Paris
Atelier Degyrse 22 rue de la Folie Mericourt, 75011 Paris
Atelier Desjobert 10 Villa Couer de Vey, 75014 Paris
Atelier Digard 6 Rue Pavée, 75004 Paris
Atelier Fequet et Baudier 9 rue Flaguière, 75015 Paris
Atelier Jaques David 43 square Montsouris, 75014 Paris
Atelier Lacouriere-Frelaut 11 rue Foyatier, 75018 Paris
Atelier Luc Moreau 4 rue de Dahomey, 75011 Paris
Atelier Mario Boni 18, Rue des Suisses, 75014 Paris
Atelier Maurice Felt 20 rue Saint-Sauveur, 75002 Paris
Atelier Michel Casse 10 rue Mahler, 75004 Paris
Atelier Mourlot 49 rue de Montparnasse, 75006 Paris
Atelier 17 10 rue Didot, 75014 Paris
Atelier 63 63 rue Daguerre, 75014 Paris
Chalcographie du Louvre 10 rue de l'Abbaye, 75006 Paris
Jacques David 43 Sq. Montsouris, 75014 Paris
Mario Boni 18 rue des Suisses, 75014 Paris

WEST GERMANY

Berlin **Michael Schlemme** D-1 Berlin 37, Onkel Tom Str. 37
Wilhelm Schneider & Co Kupferdrukerei und Kunstverlag, D-1 Berlin 37, Feurig Str. 54
Grasleben **Atelier 35** D 3332 Grasleben, Magdeburger Str.
Hamburg **Hartmut Freilinghaus** Hamburg. Falkenreid 42
Jens Cords Hamburg. Hamburg- Rahlstedt, Feltheim Str. 29
Peter Loeding and Peter Fetthauer Hamburg 60. Willi Str. 8
Workshop Hamburg 2HH 60. Schinkel Str. 5
Mohnesse-Wamel **Druckgrafik H.Kätelhön** D 477 Mohnesse-Wamel. Herman Kätelhön Str. 8
Wuppertal **Werksatdt Konigshohe** D-56 Wuppertal 1. Auf der Konigshöhe

GREECE

Athens **Kentpo Xapaktikh Aohna, Pandolfini-Siaterli**, K.Partheni 4, 11524 Athens

GREENLAND

Godthåb **Grafisk Værksted** Box 286, 3900 Godthåb

ISRAEL

Haifa **The Etching Studio** 18a Ruth Street, Haifa
Jerusalem **Jerusalem Print Workshop** 38 Shivtei Yisrael, Jerusalem
Kfar Gannot **Har-el Printers and Publishers** Kfar Gannot 107, Israel 50293

ITALY

Florence **San Reparata Graphic Art Centre** Via Santa Reparata 41, 50129 Florence
Il Bisonte Via San Niccolo 24r, 50125 Florence
Lucca **Studio Camnitzer-Porter** Melchiade 1, Valdottavo, Lucca
Communicazione Visuale Arti Incisorie Via Albani 4, Milano
Milano **Grafico Uno** Via G.Fara 9, Milano

Pietra Santa
Roma

Grattica d'Arte Luciano Cerrone 1, Piazza Castella no.3, Cassano d'Adela, Milano
Stampaeria d'Arte "Il Malbacco" Vicolo Lavatoi, 55045 Pietra Santa
2RC Studio Via Guido Baccelli 64, Roma
Il Ponte Editrice d'Arte Via S. Ignazio 6, Roma 00186
Stabilimento Cromo Lithografica Via del Vantaggio 2, Roma

JAPAN
Kamura-city
Kanagawa
Kyoto

Tokyo

Kihachi Kimura Print Workshop 1350 Yamazaki, Kamura-city
Okabe Printworkshop 158 Shibusawa, Hatano-city, Kanagawa 259-13
Hoshida Printworkshop Takoyakushi-agaru, Kuromon-dori, Nakagyo-ku, Kyoto 604
Shiundo Printworkshop 11 Takanawacho, Shichiku, Kitaku, Kyoto 1982
Adachi Print Institute 3- 13-17 Shimoochiai,, Shinjuku-ku, Tokyo
Green Graphics 9-5-4 Nishi Azabu, Minato-Ku, Tokyo
Guild Print Workshop A-4,270 Fukushima-cho, Akishima-shi 196, Tokyo
The Japanese Society Lithographic Workshop 667 2-chome, Ochiai, Shinjuku-ku, Tokyo
Kitazono Printing Studio Oiso T40 Nishi Koiso, Oiso-Cho, Naka-gun, Kanagawa-ken, Tokyo
Mori Workshop 6-34-3-102 Honcho, Shibuya-ku, Tokyo
Print Studio Kafu 43-3 Inadiara 5-Chome,, Musashi-Murayama-shi, Tokyo
Toshi Yoshida 2-chome, Wakabayashi, Setagaya-ku, Tokyo

MEXICO
Coyorcan
Zona Rosa
Mexico City

Andrew Vlady Cruz Verde 8, Barrio del Nino Jesus, Coyorcan, Mexico D.F.
Mixografia Gal.del Cirulo Hamburgo, Entre Amberes X Genova, Zona Rosa, Mexico
Taller Erehmberg (c/o G. Macotela) El Casillero Galeria, Frontera Y Tabasco,Col. Roma, Mexico

NETHERLANDS
Amsterdam

Amsterdam Graphic Atelier 155a Anjelierstratt, Amsterdam
Printshop Prinsengracht 845, Amsterdam

NEW ZEALAND
Auckland
Christchurch
Hamilton

Snake Studios 3 Darby Street,2nd Floor, Auckland
Ginko Print Workshop Arts Centre,Christchurch
Claudia Workshop 9 Claudia Street, Hamilton

NORWAY
Bergen

Masi
Oslo

Ski
Stavanger
Stavern
Svolvær
Trondheim
Vågsbygd

Grafikkhuset Odd Melseth, N-5000 Bergen
Gruppe Vest Lars Hilles gate 16, N-5000 Bergen
Lungruppen Finnegården, Bryggen, N-5000 Bergen
Embla-Gruppen Tartargt 1, N-5035 Bergen-Sandviken
Samisk Kunstnergruppe Kunstnerverkstedene Masi, 9525 Masi
Atelier Nord Borggt Sb, 0650 Oslo 6
Frysja Grafikkverksted Fryusja Senter, Kjelsåsveien 141, 0491 Oslo 4
Nora-Gras Grafikkverksted Maridalsveien 3, 0178 Oslo 1
Statens håndverk-og kunstindustriskole Ullevålsveien 5, 0165 Oslo 1
Gunnar Sæthren Sæthrevegen 15, 1400 Ski
Rogaland Kunstnersentrum Grafisk versted, Nedre Dalgate 4-6, 4000 Stavanger
Litoverkstedet Iselin Bast, Fuglevik Gård, N-3290 Stavern
Nordisk Kunstnersentrum Kunstnerhuset N-8300 Svolvær
Kunstnerverkstedene Bakke Gård Innherredsveien 3, N-7000 Trondheim
Myren Grafikk Muren Gård, N-4620 Vågsbygd (KristiansandS)

PORTUGAL
Lisbon

Sociedade Co-operativa de Gravadores Portugueses-Gravura Gallery Gravura, Travessa do Sequeirio 4, Lisbon 2

SPAIN
Barcelona

Madrid
Formentera

Federacio Sindical d'artistes de catalunya Mitjana de Sant Pere 62, Barcelona 3
Litographias Artisticas Gallo 47, Esplugas de Llobregata, Barcelona
Taller Galleria Fort (ADOGI) Apartado de Correos 9319, Barcelona 08080
Joan Torrens Calle Belen 20, Barcelona 12
G. Quince Fortuny 7, Madrid 4
Taller Formentera Casa Isabel el Pilar, Formentera, Ibizia. Balearic Is.

SWEDEN
Göteborg

Helsingborg
Malmö

Mariefred
Mölndal

Lito-Grafik Gösta Andersson Kronhusbodarna, S-411 13 Göteborg
Hägersten **Ingvar Landberg** Husabyvägen 5, S-126 50 Hägersten
Mikawl Wahrby Fastingsgatan 97, S-126 58 Hägersten
Atelie Larsen OD Krooksgatan 37 (Box 7044), S-250 07 Helsingborg
Karsten Lundberg Jakob Nielsgatan 24, S-211 21 Malmö
Lindströms Original Lito AB Gårdsvägen 2, S-171 52 Solna
& also at Långgaten 3, S-150 30 Mariefred
Bolaget Vardagsbilder Forsåkersgatan 29, S-431 33 Mölndal

Nacka	**Grafiktryckarna** Gösta Fredriksson, Turbinvägen 10b, S-131 38 Nacka
Stockholm	**Grafiska Sällskapet** Rödbodtorget 2, 111 52 Stockholm
	Grafikverkstaden Brauners Koppartryckeri Luthens gränd 2, S-116 69 Stockholm
	Koppargrafikverkstaden Fiskargatan 1, S-116 45 Stockholm
	Litoverkstaden Arbetargatan 33a (4), S-112 45 Stockholm
	Ove Löf F. Husmoderbostaden, Skeppsholmen, S-111 49 Stockholm
	Siv Johansson Kocksgatan 38, S-116 29 Stockholm
	The Workshop Renstiernasgata 30, 11631 Stockholm
Tomelilla	**CBS-Grafik** Gamla Bryggeriet, Storgatan 23, Smedstorp, S-273 02 Tomelilla
Vikmanshyttan	**Rolf Jansson Eftf AB** Tallgata n 5 (Box 214) S-776 02 Vikmanshyttan

SWITZERLAND

Dieseldorf	**Mattieu AG** Schulstrasse 6, CH 8157 Dieseldorf
Geneva	**Centre Genevois de Gravure Contemporain** Bureau et Ateliers, 17 Route Malagnou, 1208 Geneva
Pully-Lausanne	**Atelier Raymond -Meyer** 9-10 Avenue des Deax Ponts, CH-1009 Pully-Lausanne
Valle Maggia	**Editions La Franca** 6675 La Collinasca , Valle Maggia
Seprais	**Litho Atelier** CH-2857 Seprais
Zurich	**Wolfensburger AG** Bederstrasse 109, 8059 Zurich

USA

Alameda	**Robert H. Arber & Son** PO Box 10121, Alameda NM 87184
Albuquerque	**Tamarind Institute** 108 Cornell Avenue, SE Albuquerque NM 87106
	Naravisa Press 128 Naravisa Road, NW Albuquerque NM 87107
Anchorage	**Solstice Press** PO Box 10-1272 Anchorage AK 99511
Berkeley	**Kala Institute** 1060 Heinz Street, Berkeley CA 94710
Boulder	**Shark's Lithography Ltd** 2020 B 10th St, Boulder CO 80302
Camden	**Pearl Street Printmakers** 13 Pearl Street, Camden ME 04843
Chicago	**Landfall Press Inc** 5863 North Kenmore, Chicago IL 60660
Cincinatti	**Prasada Press, Inc** 4303 Hamilton Ave, Cincinatti OH 45223
Lakeside	**Lakeside Studio** 15263 Lakeshore Road, Lakeside M149116
Los Angeles	**Angeles Press** 800 Traction Ave, Los Angeles CA 90013
	Cirrus Editions Ltd 542 South Alameda Street, Los Angeles CA 90013
	Gemini G.E.L. 8365 Melrose Ave, Los Angeles CA 90069
New York	**Atelier Ettinger** 155 Avenue of the Americas, New York NY 10013
	Exeter Press 168 Mercer Street, New York NY 10012
	Handworks/Maurel Editions 236 W, 27th Street, New York NY 1001
	Irwin Hollander C/o 2830 Ocean Parkway Apt 10J Brooklyn NY 11235
	Petersburg Press 17 east 74th Street, New York NY 10021
	The Printmaking Workshop 114 West 17th St. New York NY 10011
	Solo Press Inc 578 Broadway, 6th Floor, New York NY 10012
	Tyler Graphics Ltd 250 Kisco Avenue, Mount Kisco NY10549
	Water Street Press Ltd 223 Water St, 1&2 floors, Brooklyn, New York NY 11202
	Universal Limited Art Editions 5 Skidmore Place, West Islip, Long Island NY11795
Oakland	**Archer Press** 6139 Wood Drive, Oakland CA 94611
	Crown Point Press 1555 San Pablo, Oakland CA 94612
	Teaberry Press "Landfall West" 291 Fourth St. Oakland CA 94607
	Western Wedge 5400 Trask St., Oakland CA 94601
Philadelphia	**Limited Editions Workshop Inc** 610-12N. Amercan St. Philadelphia PA 19123 *Rochester*
Rochester	**Visual Studies Workshop** 1 Price St. Rochester NY 14607
Rockford	**Fishy Whale Press** 411 Lincoln Ave. Rockford IL 61102
Sag Harbour	**Hampton Editions Ltd.** PO Box 520, Sag Harbour NY 11963
San Francisco	**Institute of Experimental Printmaking** PO Box 77504, Pier 46B, San Francisco CA 94107
	Trillium Graphics 181 S. Park, San Francisco CA 94107
Santa Monica	**The Litho Shop Inc** 2058 Boradway, Santa Monica CA 90404
Tempe	**Print Research Facility,** School of Art, Arizona State University, Tempe AZ 85287
Torrence	**The Quiet Sun Press** 2351 Sonoma, Torrence CA 90501
Van Nuys	**Efram Wolff Studio** 14535 Arminta St. E Van Nuys CA 91402
Washington	**David Adamson Editions** 406 7th Street NW, Washington DC 20024

DIRECTORY OF PRINTMAKING COURSES IN BRITISH ART SCHOOLS, POLYTECHNICS AND UNIVERSITIES

I have included a section on print workshops in art schools in this chapter because for many of the artist printmakers in Britain today, the beginning of their printmaking experience is on an art college course. Experience not only of the processes (often as a basic training course early in the Fine Art programme) but also of workshop and machinery operation as part of the curriculum. This is an important and much underrated aspect. In the true tradition of printmaking, the training of apprentices no longer happens in the existing master printer's workshops in Britain today. Training does occur, however, in the Fine Art Departments of British art schools where almost all undergraduates receive a primary grounding in printmaking techniques coupled with a creative education, which many then pursue to a high level of technical competence and image making at degree level. Post-graduate students develop these skills even further and master complicated technical procedures concurrently with their personal development as artists. Without this support and training of the craft of printmaking in art schools, the traditional and creative practices of printmaking in Britain would have a narrow future.

Undergraduate level printmaking courses leading to approved degrees

Course information
A student may choose to base their major study on the traditional activities of painting, sculpture or printmaking or be encouraged to use other media or combinations of media such as performance, video or computer studies. In either case, a course in this area is likely to be relatively open-ended, taking its direction from the creative development of the individual student. All courses contain elements of critical and theoretical studies, including the history of art and design. The majority of the printmaking areas/courses exist within the Faculty oF Fine Art in each college listed and in many cases the facilities and workshops are extensive and run by well respected teachers who are printmakers in their own right. The majority of courses are CNAA approved.
Extra curricula activities in each college vary greatly; some outward looking colleges have taken the iniative and organised large print competitions such as Open To Print (Sunderland Polytechnic) and National Print Biannual (Humberside College of Further Education).

*'The teaching of printmaking within Fine Art courses now has the opportunity and responsibility to develop new initiatives and attitudes towards the traditional model of the artist/crafts person virtually always seen in a supporting role to the previous hierarchical position of painters and sculptors. The development of photographic practice and processes through issue-based art and concern for the power of the mass media have opened up more avenues for discourse and possibilities of media use in xerography, computer aided imagery, word processing, etc. The 'new technologies' give even more substance to the notion of and need for transferable skills available for Fine Art graduates and at the same time breathe new life into the traditional autographic skills of lithography, etching, screenprinting and bock printing, but most significantly provide students with a wider pool of media with which to place a greater emphasis on theory, concepts and imagination, and an understanding of the responsibilities towards a wider public, and social engagement.
All this is taking place however against a background of reduced resource and provision, where, in fact, an input of financial and moral support to these courses would inevitably give credibility, new hope and wider recognition of the role and fundamental necessity of Fine Art courses within the fabric of Art Education and society in general..* (Ref 1)

Ref 1 Comment on printmaking courses within the Fine Art area by Mike Peel who runs the printmaking at the Central.St Martin's School of Art in London

The colleges are listed alphabetically by country and alphabetically by town, in sections of colleges, polytechnics and universities.

Undergraduate printmaking courses in Colleges of Art, Technology and Higher Education

ENGLAND

Bath

Bath College of Higher Education
Newton Park, Newton St Loe, Bath BA2 9BN Tel. 0225 873701
Area of study Fine Art. Full time 3 years. *Degree awarded* BA (Hons) Fine Art, CNAA aporoved.
Not possible to obtain a degree with printmaking as a major study area although print facilities do exist within the college.

Canterbury

Kent Institute of Art and Design
(incorporating Canterbury and Maidstone Colleges of Art)
Oakwood Park, Oakwood Road, Maidstone. Kent ME16 8AG Tel. 0622 52786/9 (Maidstone) or 0227 69371 (Canterbury))
Area of study Fine Art. Full time 3 years. *Degree awarded* BA (Hons), CNAA approved.

Cheltenham

Gloucestershire College of Arts and Technology
Pittville Campus, Albert Road, Cheltenham. Glos GL5 3JG Tel. 0452 426700
Area of study Fine Art with printmaking as a major study area. Full time 3 years. *Degree awarded* BA (Hons) Fine Art (Printmaking), CNAA approved.
Name of person in charge of print James Beale
Short description of course Printmaking is a specialisation within Fine Art and all the general precepts of artistic practice are equally applicable. Whilst emphasis is placed on traditional methods of image-production, experimentation and renewal are central to teaching and learning. All students from Painting and Sculpture areas study printmaking as a subsidiary subject in their first year.
Facilities Workshops/press rooms, drawing/design studio, darkroom, aquatint room, offices/seminar rooms, etching presses, litho presses plate and stone, screen tables, relief presses.

Exeter

Exeter College of Art and Design
Earl Richard Road North, Exeter EX2 6A Tel. 0392 273519
Area of study Fine Art. Full time 3 years. *Degree awarded* BA (Hons), CNAA approved.

Falmouth

Falmouth School of Art and Design
Woodlane, Falmouth. Cornwall TR11 4RA Tel. 0326 211077
Area of study Fine Art. Full time 3 years with printmaking as a major study option. *Degree awarded* BA (Hons) Fine Art, CNAA approved.
Name of person in charge of print John Utting
Short description of course Printmaking is one of four study areas alongside Painting, Sculpture and Photography/Film. Specialist and non-specialist students are catered for. Total commitment to continued development of printmaking as a major component of the FA course.
Facilities Purpose built workshops in lithography, intaglio, relief, screenprinting
Other Annual summer school in printmaking (running for eleven years). Adult education classes. Plans for development of a part-time BA Fine Art course.

Farnham

West Surrey College of Art and Design
The Hart, Falkner Road, Farnham. Surrey GU9 7DS Tel. 0252 722441
Area of study Fine Art with printmaking as a major study option. Full time 3 years or 5 years part-time.
Degree awarded BA (Hons) Fine Art, CNAA approved.
Name of person in charge of print James Tierney
Short description of course The course recruits 12 specialist printmakers per year. The first year is project orientated and comprises common course components plus specialist components with a specific emphasis on print. All students share a visiting lecture programme.
Facilities Workshops in lithography, etching, relief printing and screenprinting plus full photographic darkroom facilities.
Other School of printmaking holds regular exhibitions of students' work outside the college. This is seen as part of the gallery and project management course option.

Hull

Humberside College of Higher Education
Queens Gardens, Hull HU1 3DH Tel. 0482 224121
Area of study Fine Art with printmaking as a major study option. Full time 3 years. *Degree awarded* BA (Hons) Fine Art, CNAA approved. (Also Certificate, Dip HE, BA, BA Hons in Visual Studies (with printmaking option) part-time 2-5 years).
Name of person in charge of print Eleanor Gates
Short description of course Printmaking is introduced to all students in first year by a series of workshop projects to establish basic skills. The basic aim of the area is the acquisition of traditional printmaking skills linked to an understanding of the printed mark and imagery. Development from these first courses is encouraged in following years. The course teaching team has the conviction that printmaking is not necessarily about any single area of study in isolation but should be founded on an attitude where individual creativity can be expressed in an open manner and across a number of areas.
Facilities Well equipped workshops in etching, relief, lithography (plate & stone), screenprinting and photo repro darkrooms.
Other CNAA MA degree in Art & Design with Printmaking option. Humberside National Print

Competition (a biannual event) is centred in and organised by the print area with the Exhibition Programme. Summer schools and professional use of workshops not available at present but considered for immediate future.

Byam Shaw School of Art
2 Elthorne Road,London N19 4 AG Tel. 01 281 4111
Area of study Fine Art. Full time 3 years. *Degree awarded* Byam Shaw Diploma in Fine Art
Name of person in charge of print Chris Crabtree
Short description of course Printmaking is taught as a complimentary medium to painting and sculpture.Technique and methods are subordinate to discussion and development of student's individual ideas and demands that ideals place upon general pictorial approach.
Facilities Etching, direct lithography, screenprinting and photo-screenprinting, relief.
Other Short-term studies (personal courses) and 1 year post-graduate are available.

The London Institute Secretariat
2nd Floor, 388 396 Oxford Street, London W1 Tel. 01 491 8533
Rector John McKenzie
The London Institute is a collegiate institution and each constituent college retains its name and identity as a community of staff and students. From 1 April 1989, the Institute becomes a corporate institution with much of its work funded directly by the PCFC.

Camberwell School of Art and Crafts (The London Institute)
Peckham Road, London SE5 8UF Tel.01 703 0987
Area of study Fine Art/ Graphic Design (Illustration). Full time 3 years. *Degree awarded* BA (Hons), CNAA approved
Name of person in charge of print Tony Wilson
Short description of course The Fine Art course accepts a small number of students who wish to specialise in printmaking.Printmaking options also exist in Graphic Design (Illustration).
Facilities Full range of printing studios including screenprinting, intaglio, relief and lithography plus associated darkrooms

Central St. Martin's (The London Institute)
Southampton Row, London WC1B 4AP Tel. 01 405 1825
Area of study Fine Art plus printmaking as a major study option. Full time 3 years (in association with St Martin's School of Art). *Degree awarded* BA (Hons) Fine Art, CNAA aproved.
Name of person in charge of print Mike Peel
Short description of course A broadly based course with an emphasis on Fine Art concepts and exploration structured initially through introductions to traditional print media, photography and electronic/computer media. Students are encouraged to develop individual programmes,working alongside painting, film and sculpture students. Formal timetabled links operate through other fine art options as well as photography (B&W and colour), computer image making, book binding (in conjunction with LCP).
Facilities Well equipped workshops in intaglio, relief/block printing, lithography, screenprinting; photomechanical darkroom. Good access to other school facilities including computer. Individual studio places for development of work.
Other Part-time etching classes. Summer courses in etching. Post-graduate advanced level printmaking 1year full-time, 2 year part-time, awarding the Central School's own diploma.

Chelsea School of Art (The London Institute)
Manresa Road, London SW3 6LS Tel. 01 376 4661
Area of study Fine Art with printmaking as a major study option. Full time 3 years. *Degree awarded* BA (Hons) Fine Art , CNAA approved.
Name of person in charge of print Tim Mara Principal Lecturer, Jeff Edwards Course Leader
Short description of course BA (Hons) Fne Art at Chelsea is a specialist course. Students may apply for printmaking as a specialist area within the Fine Art course. BA printmaking is taught alongside MA printmaking and benefits greatly from the relationship. All the regular staff are practising artists. In addition several invited artists make visits each year. All other BA Fine Art students are encouraged to make use of printmaking in their work, with introductory courses in the first year and it is possible to opt for specialisation from their second year onwards. BA specialist printmakers may enrol on other college introductory courses within Fine Art e.g. photography, video, coputers, etc.
Facilities Housed on the whole of second floor, workshops include screenprinting, intaglio, relief printing and lithography plus comprehensive reprographic studios. Access to other school facilities.
Other Master degree course in printmaking; evening courses in screenprinting, lithography and etching.

Wimbledon School of Art
Merton Hall Road, London SW19 3QA Tel. 01 540 0231
Area of study Fine Art. Full time 3 years. *Degree awarded* BA (Hons) Fine Art, CNAA approved.
Name of person in charge of print Brian Perrin
Short description of course Students on the BA course, though tutorially based in Painting and Sculpture, can develop their studies in printmaking to a point where it plays a major role in their degree. Printmaking shares the same teaching philosophy within the Fine Art department as Painting and Sculpture. The areas are further integrated by shared staffing.

Facilities Workshops situated on ground floor of main building house lithography, etching, screenprinting and relief printing areas. Also reprographic facilities to back up the photographic element.
Other Post-graduate and MA in Printmaking courses .

Loughborough

Loughborough College of Art and Design
Radmoor, Loughborough, Leicestershire LE11 3BT Tel. 0509 261515
Area of study Fine Art. Full time 3 years. *Degree awarded* BA(Hons) Fine Art, CNAA approved.
Name of person in charge of print John Hawley
Short description of course Comprehensive introduction to main techniques and processes leading towards the production of fine prints to highest possible artistic and technical standards. Good workshop practice and print handling are emphasised. In general both traditional skills and experimental attitudes towards image- and object-making involving print and paper are encouraged. A papermaking and pulp working facility is now established and a typographic unit has recently been introduced for work on artists' book production.
Facilities Well equipped studios provide full range of photo-mechanical processes - screenprinting, etching, lithography, relief including collotype plus paper and handset type workshops.
Other Regular programme of studio visitors and whenever possible artists of repute are invited to produce work in the studio. Visits to specialist workshops are arranged and encouraged. Exchange opportunities are available within UK, France and USA and an annual foreign study visit is arranged in FA course.

Norwich

Norfolk Institute of Art & Design (formerly Norwich School of Art)
St George's Street, Norwich. Norfolk NR3 1BB Tel. 0603 610561/5
Area of study Fine Art. Full time 3 years. *Degree awarded* BA (Hons), CNAA approved.
Name of person in charge of print Derrick Greaves
Short description of course The fine art areas of study have three options - Painting, Printmaking, Sculpture - and there is complete parity between the options. The attitude in printmaking is image-based (rather than craft-based).
Facilities Workshops in all media including intaglio, screenprinting, lithography, and relief printing.
Other Printmaking has an open department where students can make prints. Evening class in etching.

St Albans

Hertfordshire College of Art and Design
7 Hatfield Road, St Albans. Hertfordshire AL1 3RS Tel. 0727 64414
Area of study Fine Art. Part-time 4 years (BA), 5 years (Hons).*Degree awarded* BA plus BA (Hons), CNAA approved.
Name of person in charge of print Bob Baggaley
Short description of course The printmaking element is intended to increase the students' range of image-making skills and to broaden their experience of creative work through use of print media. Printmaking is an integral part of the course and is studied initially on a block basis.
Facilities Facilities for etching, lithography, sreenprinting, relief printing plus darkroom.

Winchester

Winchester School of Art
Park Avenue, Winchester. Hants SO23 8DL Tel. 0962 61891
Area of study Fine Art. Full time 3 years. *Degree awarded* BA (Hons) Fine Art (Printmaking), CNAA approved.
Name of person in charge of print James Heward, Principal Lecturer in Printmaking
Short description of course The aims of the course are to develop the creative and artistic potential of the individual student within the specialisation fo printmaking. To foster professional and technical skills, and the intellectual ability to meet the high standard needed for postgraduate studies, exhibiting, editioning, professional practice, etc.
Facilities Workshops and studios house practices of screenprinting, etching, lithography and relief printing plus darkroom facilities.
Other The department has a substantial student exchange programme with the University of Barcelona, The National College of Art & Design, Dublin and Universities in the USA. Printmaking students are selected to be part-time resident fellow at a local sixth form college.

SCOTLAND

Aberdeen

Grays School of Art, Robert Gordon's Institute of Technology
Garthdee Road, Aberdeen AB9 1FR Tel.0224 313247
Area of study Fine Art with printmaking as a major study option. Full time 4 years. *Degree awarded* BA (Hons) Fine Art, CNAA approved.
Name of person in charge of print Lennox Dunbar
Short description of course Experience of printmaking (plus all other disciplines) in first year, with opportunity to specialise in printmaking for remaining three years; alternatively it can be used as a supportive study for another discipline. Applicants can also gain direct entry to second year (details from Head of School).
Facilities Well equipped workshops for screenprinting, etching, lithography and relief printing plus studio space for each student.
Other Summer placement for students in one of open access workshops throughout Scotland. At present also a one year post-graduate printmaking diploma course available to students.

Dundee

Duncan of Jordanstone College of Art
Perth Road, Dundee DD1 4HT Tel. 0382 23261
Area of study Fine Art with printmaking as a major study option. Full time, one general year plus three year specialist study. *Degree awarded* BA (Hons) Fine Art, CNAA approved.
Name of person in charge of print Elaine Shemilt
Short description of course First two terms of second year deal with structured project work. More specialisation occurs in third term and onwards with personal research and motivation becoming increasingly significant.
Facilities Well equipped etching, screenprinting, lithography plus photo processes.
Other Closely linked with Scottish printmakers workshops, especially with Dundee Printmakers Workshop.

Edinburgh

Edinburgh College of Art
Lauriston Place, Edinburgh EH3 9DF Tel. 031 2299311

Glasgow

Glasgow School of Art
167 Renfrew Street, Glasgow G3 6RQ Tel. 041 332 9797
Area of study. Fine Art. Full time 3 years. *Degree awarded* BA (Hons) Fine Art, CNAA approved.
Name of person in charge of print Philip Reeves
Short description of course Students entering the course learn the basic techniques of printmaking so that they can subsequently express their ideas in the medium most appropriate. All students spend at least one day per week investigating through drawing and mixed media.
Facilities Three main areas comprise of lithography, etching and screenprinting plus one flatbed press for lino and wood and photographic facilities for three major areas.
Other Throughout the course papermaking workshops are held in the Gallowgate Studios (15 East Campbell Street, Glasgow) under the direction of Jacki Parry. The course also has strong links with Glasgow Print Studio (22 King Street, Glasgow). A two-year MA course also exists within this area.

WALES
Cardiff

South Glamorgan Institute of Higher Education, Faculty of Art & Design
Howard Gardens, Cardiff CF2 1SP Tel. 0222 551111
Area of study Fine Art. Full time 3 years. *Degree awarded* BA (Hons) Fine Art, CNAA approved.
Senior Lecturer in Charge of Print Tom Piper
Short description of course Fully integrated course with printmaking as a specialist area and service area to general Fine Art.
Facilities Workshop facilities include lithography, etching, relief and screen printing plus darkroom facilities and computer access.
Other New building planned for 1991 with much expanded community input and large increase in space. Faculty also runs MA Fine Art and accepts printmaking specialists onto this course. Evening classes.

Newport

Gwent College of Higher Education Faculty of Art and Design,
 Clarence Place, Newport. Gwent NPT OUW Tel. 0633 59984
Area of study Fine Art. Full time 3 years. *Degree awarded* BA (Hons) Fine Art, CNAA approved.

Polytechnics

ENGLAND
Birmingham

City of Birmingham Polytechnic, Institute of Art & Design
School of Fine Art, Margaret Street, Birmingham 3 3BX Tel. 021 331 5972
Area of study Fine Art. Full time 3 years. *Degree awarded* BA (Hons) Fine Art, CNAA approved.
Name of person in charge of print Jean Vandeau
Short description of course All students are given an introductory course. Printmaking is available to Fine Art students throughout three years. It forms a major role as a support discipline and can be taken as a major study area.
Facilities Fully equipped etching, litho, screenprinting and relief printing areas.

Brighton

Brighton Polytechnic, Faculty of Fine Art
Grand Parade , Brighton BN2 2JY Tel. 0273 604141
Area of study Fine Art. with printmaking as a major study option. Full time 3 years. *Degree awarded* BA (Hons) Fine Art, CNAA approved.
Name of person in charge of print Harvey Daniels
Short description of course The aim of the programme is to help develop the student's concerns within the context of Fine Art and to ensure that those concerns mature fully against a background of both conceptual and practical involvement. In the final exhibition they will be seen not as printmakers but as artists who choose to use printmaking for the realisation of their ideas.
Facilities Four main printmaking areas well equipped and staffed with full-time technicians.
Other Adult education classes. Planning summer courses.

Bristol

Bristol Polytechnic, Faculty of Fine Art
Clanage Road, Bower Ashton, Bristol Tel. 0272 660222
Area of study Fine Art. Full time 3 years. *Degree awarded* BA (Hons) Fine Art, CNAA approved.

Name of person in charge of print Frank Fennel

Short description of course Printmaking is well established as an integral part of a broad-based Fine art course. It exists as a specialisation for some students and as a media extension to a 'two-dimensional study' option for students concerned with 'indirect' means of image making.

Facilities Lithography, etching, screenprinting, relief, photo-mechanical processes, computer-aided image-making. 'Painterly print' processes.

Other Links with Nettlecombe Court Print Studios. Part-time adult education courses.

Coventry **Coventry Polytechnic, Faculty of Art & Design**
Gosforth Street, Coventry CV1 5R2 Tel. 0203 631313
Area of study Fine Art. Full time 3 years. *Degree awarded* BA (Hons) Fine Art, CNAA approved
Person in charge of print Arthur Hilyer

Short description of course Printmaking is one of the four main areas of the BA(Hons) Fine Art course - Painting, Sculpture, Media studies and Printmaking. All students must successfully complete two main area short courses during Year 1; in the second half of the year students begin to concentrate on any one subject discipline or work in a multi- or inter-disciplinary way. In printmaking, self-reliance is stressed, innovation encouraged and a healthy relationship between art and craft promoted by the staff.

Facilities All main processes housed in two large purpose-built workshops. Series of visiting lecturers.

Other A small number of Associate Studentships available for practising artists each year.

Kingston upon Thames **Kingston Polytechnic**
Kingston Hill, Kingston upon Thames KT2 7LB Tel. 01 549 1366
Area of study Fine Art. Full time 3 years. *Degree awarded* BA (Hons) Fine Art, CNAA approved.

Leeds **Leeds Polytechnic, School of Creative Arts & Design**
Calverley Street, Leeds LS1 3HE Tel. 0532 462501
Area of study Graphic Design and Visual Studies Full time 3 years. *Degree awarded* BA(Hons) Fine Art, CNAA approved.

Name of person in charge of print Phillip Redford (Graphic Design), Brian Mcallion (Co-ordinator for Fine Art)

Short description of course Printmaking has two special courses at Leeds, one in the Graphic Design area, the other in Fine Art, as well as servicing other sections in the school such as illustration, graphics, painting and sculpture.

Graphic Design Students are required to designate their major study when interviewed for the course. One day a week of major study when they join the course and then join major study area at the start of second year. Practical experience of all print media including photography is built into the course. The nature of the work may reflect a wide range of possibilities from graphic/illustration-related work through to editions of prints and limited edition books.

Fine Art Students entering the course select one of the three options half-way during the first term - painting, printmaking or sculpture. If students decide to remain in printmaking after that, they are introduced to all the facilities in printmaking over the next two terms. Course is staff-lead, leading to students' self-innovation.

Facilities Four workshops - lithography, relief, etching, screenprinting plus darkrooms.

Other Henry Moore Printmaking Fellowship operates with a grant from Henry Moore Foundation. First fellow was Elaine Kowalsky (1987), second was John Hyatt (1988). Department also runs a part-time MA in printmaking/illustration. Short-term residencies in printmaking are usually awarded to local artists. Graphic printmaking course operates in close liason with the separate Fine Art Printmaking course, staff and students use the same workshop and facilities.

Leicester **Leicester Polytechnic, Faculty of Art & Design**
PO Box 143, Leicester LE1 9BH Tel. 0533 551551
Area of study Fine Art with printmaking as a major study option. Full time 3 years. *Degree awarded* BA (Hons) Fine Art, CNAA approved.
Senior Lecturer in Charge of Print Roy Bizley

Short description of course Printmaking is one of the four main study areas of the course (+Painting,Sculpture & Media Handling). All students are introduced to these by means of short courses in first term of year 1, after which they may choose to specialise. Attitude - to use printmaking in as many ways as possible, both traditional and experimental.

Facilities Well equipped studios include screen printing, lithography, etching, relief plus associated darkoom plus monotype, collograph and cliché verre areas.

Other The strongest current link inside the polytechnic is with Graphics, whose illustration students make use of Fine Art facilities. No summer schools or post-graduate studies at present.

Liverpool **Liverpool Polytechnic, School of Art & Design**
Rodney House, 70 Mount Pleasant, Liverpool L3 5UX Tel. 051 207 3581
Area of study Creative Printmaking. Full time 3 years. *Degree awarded* BA (Hons) Fine Art, CNAA approved.
Name of person in charge of print P. Derbyshire

Short description of course The creative printmaking unit within the school provides a service to all areas of study. Students do specialise in printmaking but are awarded a degree in Fine Art/Graphic Design

Facilities Well equipped studios in etching, litho, screenprinting with good technical backup.
Other Unit runs courses for students and has a long tradition of Sir John Moores scholarship winners who use the scholarship within print facilities. Intention of the unit to run summer courses in future.

London **Middlesex Polytechnic, Faculty of Art & Design**
Quicksilver Place, Western Road, London N22 6XH Tel. 01 886 2022
Area of study Fine Art. Full time 3 years. *Degree awarded* BA (Hons) Fine Art, CNAA approved.
Senior Lecturer in Charge of Print Carol Watts
Short description of course Printmaking is an integral area of study within a flexible Fine Art course. Students choose own pathway and encouraged to use 2D, 3D, 4D facilities.
Facilities Workshops include intaglio,screenprinting, lithography, blockprinting plus darkroom facilities for photo-images.
Other Printmaking facilities shared with students on Modular Degree Scheme (Fine Art). Few places are awarded annually for associate studentship. Planned summer courses 1989.

Manchester **Manchester Polytechnic, Faculty of Fine Art**
Medlock Fine Art Centre, Chester Street, Manchester M15 6DB Tel. 061 228 6171
Area of study Fine Art. Full time 3 years. *Degree awarded* BA (Hons) Fine Art, CNAA approved.
Person In Charge of Print William Orobiej (Acting Head)
Short description of course Students are able to take printmaking as a major full-time study within the Fine Art area. Work is concentrated on the development of the individual, with students selecting their own genre to work in.
Facilities Generous and ample working space with process housed in one large open-plan workshop including screenprinting, lithography, intaglio and relief plus photo facilties. Acces to computer facilities.
Other Extra-mural workshops given in schools and Whitworth Art Gallery. Large gallery space within polytechnic for exhibitions of work.

Newcastle **Newcastle upon Tyne Polytechnic, Dept. of Visual & Performing Arts**
Squires Building, Sandyford Road, Newcastle upon Tyne NE1 8ST Tel. 091 232 600
Area of study Fine Art with Printmaking as a major study option. Full time 3 years. *Degree awarded* BA (Hons) Fine Art, CNAA approved.
Name of person in charge of print Steve Burdett
Short description of course Printmaking is one of the three principal areas alongside painting and sculpture within the BA (Hons) Fine Art course. Students may combine printmaking with either of the two disciplines or specialise in print as a principal study. Studio spaces are allocated in printmaking block adjacent to the print workshops.
Facilities Full range of newly equipped and extensive studios. Full facilities for screenprinting, etching, lithography, relief printing and photographic facility.
Other Printmaking also forms part of the BA (Hons) degree in Graphic Design and Creative and Performing Arts at undergraduate level and is offered as an area of specialisation in the MA part-time Fine Art Course at the Polytechnic. Links exist with print workshops and outside bodies.

Nottingham **Trent Polytechnic, Visual Arts Department**
Bonnington Building, Dryden Street, Nottingham NG1 4BU Tel. 0602 418248
Area of study Fine Art with printmaking as a major study option. Full time 3 years. *Degree awarded* BA (Hons) Fine Art, CNAA approved
Name of person in charge of print Chris Sayers, Senior Lecturer (Printmaking)
Short description of course Workshops conducted in all areas of printmaking in first year. Students do not necessarily specialise but use printmaking when relevant to area of enquiry described by them.
Facilities Workshop for etching,lithography (direct & offset), relief and screenprinting plus process darkroom.
Other MA course, students, although required to have their own studios, may use facilities. Printmaking studios part of a large polytechnic with print areas available by arrangement in textiles, graphics and print resources.

Oxford **Oxford Polytechnic, Dept. of Fine Art**
Headington, Oxford OX3 OBP Tel. 0865 819460
Area of Study Visual Studies. Full time 3 years. *Degree awarded* BA (Hons)
Name of person in charge of print Colin Catron
Short description of course As a multi-disciplinary course, Visual Studies must be combined with an academic subject. Students select specific modules (normally one term in length). Students choosing printmaking study two advanced modules and can specialise under the Independent Study programmes or as a major project involving other art and design work.
Facilities Etching, lithography, screenprinting, letterpress and darkrooms.
Other Printmaking is one of the five major areas of work. Visual Studies also offers a one year post-graduate diploma

Preston **Lancashire Polytechnic, Faculty of Arts**
Victoria Building, St Peter's Square, Preston. Lancs Tel. 0772 22141
Area of study Fine Art. Full time 3 years. *Degree awarded* BA (Hons) Fine Art, CNAA approved.
Name of person in charge of print Harry Ball
Short description of course In the first year, emphasis is on acquisition of printmaking skills and drawing. Second-year projects are given with focus on news media, other mass media and the

conventions of traditional art practice. Students are encouraged to explore new experimental methods. Third-year students will have established a scheme of work to explore in depth to a high standard.
Facilities Intaglio, lithography, screenprinting, relief printing plus associated photomechanical equipment.
Other Printmaking is part of School of Art shortly to be merged with School of Fashion. Printing department services Graphics and 3D Design. Summer schools also include beginners and advanced workshops. Inset courses for teachers are organised by the department.

Sheffield **Sheffield City Polytechnic, Dept. of Fine Art**
Faculty of Cultural Studies, Psalter Lane, Brincliffe, Sheffield S11 8UZ Tel. 0742 720911
Area of study Fine Art with printmaking as a major study option. Full time 3 years. *Degree awarded* BA (Hons) Fine Art, CNAA approved.
Name of person in charge of print Stanley Jones, Subject Leader
Short description of course First-year students from all subject areas have a workshop programme in first two terms and printmaking students in third term are involved in self-initiated projects and receive instruction in photomechanical processes, etc.Second year students are expected actively to pursue drawing studies towards prints and engage in exhibiting work intra- and extra- murally. A broad catholic base is adopted accepting illustration, painterly concepts et al within this section.
Facilities Fully equipped workshops for etching, block, lithography (plate and stone plus regraining), and screenprinting. Fully equipped darkroom processes.
Other Part-time MA (Fine Art); Professional centre where ex-graduates use printmaking facilities by arrangement on hourly or termly basis; associate studentship open to ex-graduates of SCP printmaking to use facilities by arrangement; all above arrangements to be reviewed following corporate status in 1989.

Stoke-on-Trent **Staffordshire Polytechnic, Dept. of Fine Art**
College Road, Stoke-on-Trent ST4 2DE Tel. 0782 744531
Area of study Fine Art. Full time 3 years. *Degree awarded* BA (Hons) Fine Art
Name of person in charge of print Jennifer Sherrell, Senior Lecturer in Printmaking
Short description of course The school of printmaking is fully integrated within the Fine Art department and consistent with this a broad approach to printmaking is encouraged with a continuous exploration of image-making in other media. Drawing is considered to be of primary importance with opportunities for field study and life drawing.
Facilities Comprehensively equipped workshops for all autographic and photographic print media including relief, lithography, intaglio, computer-generated imagery plus separate areas for acid etching, screenwashing and photo processing.
Other Links with Borderline Printmakers Workshop provides opportunities for students to participate in demonstrations, workshops, and placements in schools. Joint seminars and exhibitions have been arranged with Manchester Polytechnic, Loughborough College of Art and Liverpool Polytechnic.

Sunderland **Sunderland Polytechnic, School of Art & Design**
Backhouse Park, Ryhope Road, Sunderland SR2 7EE Tel. 091 567 6191
Area of study Fine Art. Full time 3 years, part-time 5 years. *Degree awarded* BA (Hons) Fine Art, CNAA approved.
Senior Lecturer in Charge of Print Stephen McNulty
Short description of course Printmaking is a specialist area and students can obtain a degree with printmaking as a major study option.
Facilities Workshops for screenprinting, lithography, etching, relief plus related darkroom facilities.
Other As part of refurbishment of the gallery, it is planned to house a contemporary print collection. Organising college for 'Open To Print', the first national student printmaking competition.

Wolverhampton **Wolverhampton Polytechnic, School of Art & Design**
Molineux Street, Wolverhampton WV1 1SB Tel. 0902 313004
Area of study Fine Art with printmaking as a major study area. Full time 3 years. *Degree awarded* BA (Hons) Fine Art , CNAA approved
Name of person in charge of print Jim Chappin, Senior Tutor
Short description of course Printmaking studies operate three four-weekly modules in first year. Students specialise in second and third years.
Facilities Workshops available in all areas of study
Other Associate studentship and summer school. Possible future PG.

Universities

Leeds **University of Leeds, Dept. of Fine Art**
Leeds LS2 9JT Tel. 0532 335260
Area of study Fine Art with printmaking as a major study area. Full time 4 years
Degree awarded BA (Hons) Fine Art
Name of person in charge of print Barry Herbert
Short description of course With individual tuition being the norm, students at Leeds University themselves define the direction of their studies and practice. One, some or all of the printmaking areas may be chosen as a speciality or they may be used to support more mainstream activities.

Facilities Small-scale but fully-equipped studios and darkrooms for relief, etching, screenprinting, photography and computer graphics (Macintosh II, SE and Pluses as well as Fairlight Computer Video Instrument)

London
University of London, Goldsmith's College, School of Art & Design
New Cross, London SE14 6NW Tel. 01 692 7171
Area of study Fine Art. Full time 3 years. *Degree awarded* BA (Hons) Fine Art,CNAA approved.

Newcastle
University of Newcastle on Tyne, Dept. of Fine Art
Newcastle on Tyne NE1 7RU Tel. 091 2328511
Area of study Fine Art with printmaking as a major option. Full time 4 years.
Degree awarded BA (Hons) Fine Art
Name of person in charge of print Gavin Robson (Lecturer in Painting)
Short description of course: Printmaking is offered as part of Fine Art course to second, third and final years. They are encouraged to develop their own image-making through a variety of printmaking processes and to specialise where appropriate. Students may study printmaking exclusively or together with Painting and Sculpture.
Facilities Fully established areas of screenprinting, relief, etching and lithography plus full photographic facilities and Macintosh computers and paintbox programmes.
Other Evening classes and weekend courses in printmaking in association with Dept. of Continuing Education. Plans to extend department's MFA to include a specialist second-year option in printmaking. The department is linked to Hatton Gallery which houses a collection of old master and modern prints.

Oxford
University of Oxford, Ruskin School of Art
74 High Street, Oxford OX1 4BG Tel. 0865 276940
Area of study Fine Art. Full time 3 years. *Degree awarded* BA Fine Art
Name of person in charge of print Jean Lodge
Short description of course All first years do some printing and are examined in it. For the finals, candidates can major in printmaking or they can present it with half painting or half sculpture. These combinations often produce rich media exhibitions.
Facilities Etching, lithography, relief, screenprinting.
Other The Ruskin is a small art school with only about 60 undergraduates. Printmaking occupies large premises and offers servicing for areas and courses.

Reading
University of Reading, Dept. of Fine Art
London Road, Reading RG1 5AQ Tel. 0734 875234
Area of study Fine Art. Full time 4 years.*Degrees awarded* BA in Fine Art, BA in Art and History of Art, BA in Art & Pyschology.
Name of person in charge of print A. Hardie
Short description of course Printmaking is regarded as one of the many media available to the artist.
Facilities Printmaking areas includes facilities for screenprinting, etching, relief printing, lithography. Darkrooms provide comprehensive back up and ciba colour printing facilities.
Other Post graduate and MA Fine Art courses available. Move to new site on main campus1989.

WALES
Aberyswyth
University College of Wales, Visual Arts Dept.
Llanbadarn Road, Aberyswyth, Dyfed SY23 IHB Tel. 0970 623339
Area of Study Visual Arts *Degrees awarded* BA (Hons) Visual Art, BA Joint (Hons) Visual Art
Person in charge of print Alistair Crawford
Short description of course Printmaking, book illustration, photography are options within studio studies. Degree courses are 50% studio, 50% art history. Printmaking can be taken as a major option throughout the course or alongside other options including painting.
Facilities Workshops for relief, screenprinting, offset lithography, intaglio, photography, reprographics.
Other This department also runs the Catherine Lewis Gallery and Print Room which has a collection of 8000 prints adjacent to National Library of Wales extensive collection of prints, drawings and photos.

NORTHERN IRELAND
Belfast
University of Ulster, Faculty of Art & Design
York street, Belfast BT15 1ED Tel. 0232 328515
Area of study Fine Art or Graphic Design. Full time 3 years or 4 years with placement. *Degrees awarded* BA (Hons) University of Ulster
Person in charge of print David Barker
Short description of course Printmaking is followed either as a specialist study or as independent study units. Fine Art students are obliged to follow one unit (five weeks) of printmaking in year 1 and then by arrangement in years 2 and 3. Graphic design students follow at least one unit in year 2.
Facilities Excellent facilities in spacious, purpose-converted workshop offering intaglio, lithography, screenprinting and relief printing supported by its own large darkrooms.
Other Established links with Xian and Shanyang (PR China) Academies of Fine Art including exchange exhibitions and studentships. Post-graduate diploma in Art & Design (Printmaking) up to 1988. New post-graduate course in Fine and Applied Arts from 1989 onwards. Evening classes, summer schools. Staff contribute to French summer school in Martel each year.

FURTHER READING

The Art,Craft and Design Courses Directory 1987/88 Dept CD2 Blenheim Publications, I Quebec Ave, Westerham, Kent.
Degree Courses Guide 1986/87 : Art & Design Trevor Denning CRAC Cambridge, Hobsons Ltd
Directory of First Degree & Diploma in Higher Education Courses CNAA 344-354 Gray's Inn Road, London WC1X 8BP.
Directory of Grant Making Trusts Charities Aid Foundation.
Education Yearbook 1988 London, Longman Community Educational Guides
The Grants Register London, Macmillan Press Ltd.
Grants to students + Addresses of Local Education Authorities Produced and available from Dept of Education & Science, Information Division, Elizabeth House,York Road, London SE1 7PH
A Guide to the Major Grant Making Trusts Editor Luke Fitzherbert London, Directory of Social Change
Handbook for Art & Design Students Robin Jesson London, Longman Art & Design Series.

Post-graduate printmaking courses

Approved post-graduate study leading to an MA in Printmaking in Britain can only be undertaken full-time in a relatively small number of colleges. Full-time post-graduate studies, for example as practised at the Royal College, the Slade School and Chelsea, present a very special and important opportunity for students wishing to take up the profession of printmaking. A taught Master's Degree will entail a minimum period of 48 weeks full-time study offering opportunities to explore a first degree subject in greater depth; to apply and develop knowledge and skillsgained in a previous degree to a specialised area. It is where teaching methods of enquiry, research and critical analysis are at their best and most pertinent and planned on an individual basis to encourage initiative and self motivation. Together with professional and business studies, an MA course forms an important experience for a would-be professional artist printmaker.

Part-time printmaking courses, for example as practised at Wimbledon, present a different aspect of professional study which is less intensive and more suitable for some students. More recently developed courses offering a a full-time or part-time Masters Degree in Fine Art, for example as practised at Glasgow and South Glamorgan, give opportunities to specialise in printmaking but artists are often required to find their own studio spaces..

A post-graduate diploma will entail a minimum of twenty five weeks study. For unapproved advanced courses, such as the one-year full-time/ two-year part-time specialist course at Central.St Martins, refer to undergraduate level college information. The courses are listed alphabetically by country and by town.

Full-time approved courses

ENGLAND
Birmingham

City of Birmingham Polytechnic, School of Fine Art
Margaret Street, Birmingham B3 3BX Tel. 021 356 9193
Degree awarded MA Fine Art. 1 year full time
Area Co-ordinator Printmaking Jean Vadeau
Course information Spacious studios in Victorian purpose-built art school includes fully-equipped workshops in etching, lithography, screenprinting and relief printing.

London

Chelsea School of Art (The London Institute)
Manresa Road, London SW3 6LS Tel. 01 376 4661
Degree awarded MA Fine Art (Printmaking), 1 calendar year full-time study (48 weeks).
Principal Lecturer in Printmaking School Tim Mara
Course information Normally twelve places are offered on this full-time specialist course which gives students opportunity to continue their exploration of printmaking as a serious specialist means of expression. Printmaking studios are located on the entire second floor and the facilities are exceptional. All tutors are professional artists. The course itself is concerned with both the artistic and professional life of a printmaker and ensures that the students develop their full potential via a good tutorial system, many distinguished visitors and a unique course in professional practice incorporating visits and links with the profession.

Royal College of Art
Kensington Gore, London SW7 2EU Tel. 01 584 5020
Degree awarded MA Printmaking. Full time 2 years

Head of printmaking Professor Alistair Grant

Course information An annual intake of twelve students. Course aims to develop students to MA level in all aspects of printmaking techniques.

Facilities Include block printing, stone and offset lithography, etching, screenprinting and all associated processes. Photography and computer courses, painting and sculpture are available to students throughout the 2 years.

Slade School of Fine Art
University College, Gower Street, London WC1 Tel. 01 387 7050

Degree awarded Higher Diploma in Fine Art of the University of London, Post-graduate Printmaking. Full time 2 years. Also one year non-diploma in printmaking for foreign students.

Convenor in Printmaking Bartolomeu dos Santos

Course information The course has no set programme, students being encouraged to pursue their own research in an atmosphere and working situation of a Print Workshop. Staff work alongside students in their own projects. One or twice a term there are individual tutorials and a number of artists are invited each year to show their work and talk to the students. Students have opportunity to use other areas of the Slade as well as other departments of University College.

Facilities Well-equipped intaglio, lithography, screenprinting and relief printing facilities

Manchester
Manchester Polytechnic
Medlock Fine Arts Centre, Chester Street, Manchester M15 6BH Tel. 061 228 6171

Degree awarded MA Fine Art. Full-time 1 year, part-time 2 years. Printmaking option.

Acting Head of Printmaking William Orobiej

Course information This is a critically evaluated specialist printmaking course with an emphasis on experiment in all print disciplines. Intake of 3-4 students for full-time work and 2 for part-time (2 days per week). The printmaking has a well-equipped and large studio workshop which house all processes. The course includes notable visiting lecturers/artists and has links with London Studios.

Oxford
Oxford Polytechnic, Department of Fine Art
Headington, Oxford COX3 OBP Tel. 0865 819460

Degree awarded Post-graduate diploma, modular studies. 1 year full-time, CNAA approved.

Name of person in charge of print Colin Catron

Course information Visual Studies areas offers a one year post-graduate diploma with printmaking as one of five major areas of work.

SCOTLAND
Aberdeen
Grays School of Art, Robert Gordon's Institute of Technology
Garthdee Road, Aberdeen AB9 1FR Tel. 0224 313247

Diploma awarded One year post-graduate diploma in Printmaking

Part-time post-graduate level approved courses
ENGLAND

Brighton
Brighton Polytechnic, Dept. of Art
Grand Parade, Brighton BN2 2JY Tel. 0273 604141

Degree awarded Post-graduate Diploma and MA Printmaking, CNAA approved. Part-time 2 -3 years.

Principal Lecturer in Charge of Printmaking Harvey Daniels, *Course Leader* Lawrence Preece.

Course information Both courses are designed for artists who wish to develop their work through printmaking. Particular emphasis is placed on the development of the student's understanding of personal objectives coupled with acquisition of sound criticism, intellectual and perceptual skills. The acquisition of craft and professional skill is essential to the student's proper development. Printmaking is located in three workshops that include the four main processes, each staffed by a full-time technician.

Hull
Humberside College of Higher Education
Queens Gardens, Hull HU1 3DH Tel. 0482 224121

Degree awarded CNAA MA Degree in Art & Design. 2 years part-time. Option in printmaking.

Head of Printmaking Eleanor Gates

Course information Students are expected to have a suitable home or workshop based facility where their practical project work is normally carried out. Course participation is by part-time evening attendance, by home based tutorials and by part-time symposia and a summer school. Excellent facilities are available in college for executing fine print editions at modest cost.

Leeds
Leeds Polytechnic, Faculty of Design
Calverley Street, Leeds LS1 3HE Tel. 0532 462903/4

Degree awarded MA

Person to contact Philip Redford

Course information A part-time MA course exists within the department of Graphic Design to study illustration/printmaking.

Leeds Polytechnic, Dept. of Visual Studies, Faculty of Design and the Environment
Calverley Street, Leeds LS1 3HE Tel. 0532 462903/4

Degree awarded MA in Art & Design. Part-time. New course that starts January 1989

Contact G.Teasdale Regional course co-ordinator

Four institutions in the Yorkshire/Humberside regions combine to run this joint course : Huddersfield Polytechnic (textile design), Humberside College of Higher Education (painting and sculpture), Leeds Polytechnic (Painting, Illustration/printmaking, 3D design) and Sheffield Polytechnic (painting, printmaking, sculpture, visual communications, 3D design)

London

Camberwell School of Art & Crafts (The London Institute)
Peckham Road, London SE5 8UF Tel.01 703 3098
Diploma awarded CNAA Post Graduate Diploma in Printmaking. 2 years part-time.
Head of Printmaking and Course Leader Tony Wilson
Course information The overall aim of the course is to give students the experience of studying printmaking at a recognised advanced level while encouraging self determination and an awareness of their prospective roles as practioners in both commercial and cultural domains. By the end of the course students are expected to be equipped both technically and intellectually to continue to develop their work, set up workshops and operate in a professional manner. The course provides opportunities for students with a wide range of backgrounds including mature students.

University of London,Goldsmith's College,School of Art & Design
New Cross, London SE14 6NW Tel. 01 692 7171
Degree awarded MA Fine Art. Part-time 2 years

Wimbledon School of Art
Merton Hall Road, London SW19 3 QA Tel. 01 540 0231
Degree awarded MA Printmaking and CNAA Post Graduate Diploma. 2 years part-time.
Principal Lecturer in Printmaking Brian Perrin
Course information The post-graduate diploma course in designed to create, in a well equipped and staffed workshop, the kind of conditions in which the study of printmaking can be pursued at an advanced level. The course seeks to extend an area of study which is not adequately covered at the undergraduate level, to develop studies in areas related to the student's first degree and to update the knowledge of those who have studied printmaking at a previous stage.
The Masters courses provides highly gifted students who already possess substantial experience in printmaking, opportunities not possible or appropriate at undergraduate level. It enables student's to extend their abilities and ideas and pursue their studies to a recognised higher level and will encourage them to seek their work in context, to establish a theoretical base and to adopt an informed, deliberate and articulate stance, providing a bridge from the more general student activities to the life of a professional, practising artist. Students who have successfully completed the diploma course can be considered for entry to the MA with exemption from the first year of that course.

Newcastle on Tyne

Newcastle on Tyne Polytechnic
Ellison Building, Ellison Place, Newcastle on Tyne NE1 8ST Tel. 091 2326002
Degree awarded MA Fine Art. 2 years part-time. Printmaking option.
Course Leader Lloyd Gibson
Course information All artists who undertake the course are self-supporting and working in independent studios.The Fine Art course provides a forum for collaboration between artists living in the North East, staff of the polytechnic, visiting artists, specialists, theoreticians and administrators. It aims to encourage advanced levels of practice and understanding, and to extend and develop debate surrounding artists' activities. Annual intake normally 12 artists per year. Artists are expected to be self sufficient in studio accomodation but individual arrangements are made for facilities within polytechnic.

Nottingham

Trent Polytechnic,Visual Arts Department
Bonington Building, Dryden Street, Nottingham Tel. 0602 418248
Degree awarded MA Fine Art. 2 years part-time. Printmaking option.
Senior Lecturer in Printmaking Chris Sayers.
Course information MA students although required to have their own studios may use printmaking facilities in polytechnic print resource. Each student is expected to have a workspace/studio within reasonable travelling distance and to spend approx. 14 hours weekly in studio practice. Intake of 15 students at two year intervals (1988 - 10 painters, 2 printmakers, 2 sculptors).

Reading

University of Reading, Department of Fine Art
London Road, Reading RG1 5AQ Tel. 0734 875234
Degree awarded Post-graduate Diploma in Fine Art, I year full-time. MA Fine Art, 2 years full-time
Lecturer in Charge of Printmaking Mr A. Hardie
Course information Printmaking is regarded as one of the many media available to the artist and degrees may be obtained with printmaking as a major study area. Fully equipped studios house facilities for screenprinting, lithography, etching, relief and reprographics. Printmaking will move with the rest of the Department to the main campus in Summer of 1989.

SCOTLAND
Glasgow

Glasgow School of Art
167 Renfrew Street, Glasgow G3 6RQ Tel. 041 332 9797
Degree awarded MA Fine Art. 2 years part-time. Printmaking option.
Head of Printmaking Philip Reeves
Course information Two year course of study in which printmaking can be taken as a major study.

WALES
Aberyswyth **University College of Wales, Visual Arts Department**
Llanbadarn Road, Aberyswyth, Dyfed SY23 IHB Tel. 0970 623339
Degrees awarded MA and Post Graduate Diploma and M Phil (Art History) full or part-time, 1 or 2 years
Person in charge of print Alistair Crawford
Course information Post-graduate courses is studio and/or art history research into the Graphic Arts. Workshops exist for relief, screenprinting, offset lithography, intaglio, photography, reprographics.

Cardiff **South Glamorgan Institute of Higher Education**
Howard Gardens, Cardiff CF2 1SP Tel. 0222 551111
Degree awarded MA Fine Art. 2 years part-time. Printmaking option.
Senior Lecturer in printmaking Tom Piper
Course information MA Fine Art course accepts printmaking specialists. Well equipped studios include lithography, relief , screenprinting and etching plus darkroom and computer access. New building planned for 1991 with increased space and many new programmes.

NORTHERN IRELAND
Belfast **University of Ulster, Faculty of Art & Design**
York street, Belfast BT15 1ED Tel. 0232 328515
Degree awarded Post-graduate course in Fine & Applied Arts
Person in charge of print David Barker

FURTHER READING
A Directory of Jobs and Careers Abroad David Leppard
CNAA Directory of Post Graduatee & Post Experience Courses
Emplois d'Été en France F. Armen
Graduate Studies : The Guide to Post Graduate Study in UK Editor Jenny Knight
MFA Programs in the Visual Arts : A Directory College Arts Association, New York 1980-
Professional and Business Awareness in Art & Design Degree Courses CNAA 1986
Scholarships Abroad Britsh Council. Published annually in September
Scholarships Guide for Commonwealth Post-graduate Students 1989-91 Association of Commonwealth Universities, London 1988
Study Abroad HMSO PO Box 569 London SE1 9HN
Study Abroad UNESCO
Summer Jobs in Britain Editor Susan Griffith
Summer Employment Directory of USA Pat Bensterien

Chapter 2 **PROFESSIONAL PRINTMAKING PRACTICE**

This chapter details a range of professional printmaking terms and practices. Some of the information in this section may not be relevant to a printmaker working at home or in a private studio where a more formal routine is not necessary.

CARE OF PRINTS

Paper

Although the role of paper is often simply to act as a medium to support and hold together the printed image, it is far more than that. The substance and nature of the fibres used in papermaking are directly related to the durability, permanence, strength, stiffness and formability of a sheet of paper. Choosing a printmaking paper is difficult and a time-consuming task. Exhausting searches have often been made to find exactly what is required and often it is the aesthetic qualities, the look or feel of a sheet of paper that motivates its purchase. Three main types of paper are available for purchase in today's markets :

Machine produced paper
Two thousand sheets of this paper can be produced in the time it takes to make one sheet of handmade paper. Papers produced on the massive Fourdrinier machines are made specifically for the printing trade to accommodate the needs of a fast-running printing machine and for the immediate, short-lived and throw-away dissemination of printed matter.

Handmade paper
This is probably the purest and often strongest of the qualities of paper made today because of the care taken in the making, although the manufacture can vary. It can be reasonably argued that the production of handmade paper is geared and suited to work that is produced in small quantities by hand.

Mouldmade paper
The third category of papers is mouldmade. This paper is produced in the same way as handmade paper up to the forming process when a cylinder machine takes over the work of the vatman, coucher and drier.

Handling

Apart from selecting paper quality whose long life span can be anticipated, proper care of the finished work will benefit the artist and collector alike. Paper can be bruised, dented, creased, wrinkled or dirtied almost too easily. It should always be handled gently, using the thumb and forefinger of each hand grasping parallel short edges or opposite corners. It should be cradled when lifted so that it flows in an unbroken wave and from a curator's point of view should always be handled with clean hands, or with paper fingers, to protect the edges from grease and dirt.

Storage

Machine made papers are packed in large quantities in flimsy wrappers because they are manufactured for the printing trade to be moved straight to the printing works, loaded and unloaded mechanically on palettes. In the context of a studio where they are lifted by hand, damage is almost inevitable. Handmade papers are packed in much smaller quantities (quires and reams). This allows easier handling and storage especially as the outside wrapper is often waterproofed. Single sheets and small numbers bought from local shops suffer the most damage caused usually by inefficient wrapping.

All paper is affected by heat, light and moisture. When stored it should be wrapped in strong brown paper and kept off the ground in a dry, normal atmosphere. As long as the moisture content of a sheet of paper remains unchanged, it will not change size. If paper is kept unwrapped and simply stacked in piles, the edges of the paper, if exposed to damp conditions, will become wavy, whereas in a dry atmosphere the edges will become tight and the centres, if not allowed to share the same atmosphere, will buckle.

Paper tends to expand in winter and contract in summer. If it is dried quickly it will shrink more than if it is dried slowly. Many factors effect paper whilst it is awaiting use and anyone familiar with close registration will know to print on days with similar climatic conditions if at all possible and expose sheets to natural or studio air for several hours at least before beginning printing operations.

When estimating the number of sheets required for a completed edition, especially if the paper is extraordinarily long or large, or if there is a large number of colours in the printing, add at least 10 % to the number of overs on top of the spoils, simply because handling the sheets from rack to bed will cause unforeseen damage to the paper.

Registration and trimming

If the printing paper has natural deckles, it is often worth trying to retain them as they are an indication of the quality of the paper used. They are proof that the paper is either handmade (4 deckles) or mouldmade (2 natural deckles, 2 torn edges) if no watermark is visible. Preference for printing on or over the watermark is personal. However, paper inevitably needs to be trimmed to suit a particular purpose or process. At best, sheets are cut individually with a metal straight edge or ruler, or with a reliable guillotine.

All prints need some form of registration device whether it is for paper, plate or image. Many different methods are in use and for handmade paper with deckles three small cut edges into the deckle can be made, or small sharp-edged pieces of paper can be taped to the printing paper itself, to fit into the lays.

Finishing practices

When the printing of an edition is completed, it is normal practice to assemble all copies of the work together and review them. Defective, creased, badly printed or misregistered sheets can be torn up and discarded or piled for use as proofing paper in later editioning.

Cleaning

Dirty and small ink marks can be dealt with. Finger marks should be rubbed away lightly with caution. Pencil erasers which are quite safe to use on quality papers include Mars pencil eraser by Staedtler, Pink Pearl by Eberhard Faber (natural rubbers) or Mars Plastic Eraser by Staedtler (vinyl). Small ink spots lying on the surface of the paper can be lifted with the blade of a thin knife, such as a scalpel, working with the blade parallel to the paper surface. Care should be exercised as the fibres of the paper are easily damaged and large holes can be made. Ink below the surface of the paper can be removed occasionally by cutting a small cross in the paper opening up the corners and removing the ink then closing the paper cuts

again. Dirty marks on the bevelled edge of a printed etching plate can be removed with a glass brush, but the print may require redamping as the glass brush polishes the paper leaving a visible shiny area.

Final trimming

When trimming a sheet to its finished size on handmade or mouldmade papers, a sharp cut edge to the print is not always desired and a softer edge can be obtained by tearing. A common practice is to centre the printing on a larger sheet leaving a good margin for handling and finally to tear down the print to required size when printing has been completed.

Most papers can be easily torn down by using a straight edge or metal ruler. A special register board is a good idea if the whole edition is to be torn. The final print size guide lines are marked out in pins or small nails as a guide for the straight edge or ruler. The print is placed onto a marked position on the board *face down* under the metal straight edge, and the strips carefully torn off, pulling slowly in an upward, inward direction. If the paper is torn face upwards the mark of the ruler or straight edge is visible, as is a small part of the inside of the paper sheet. Various methods exist on this principle, one such used by Studio Prints in London who cut a mount out of card representing the size of the required print and use a pin mark in each corner of the mount to denote the tearing lines.

Japanese papers often require more care because the fibres used are much longer in length than the normal cotton linters used in many European papers. They tear badly and unevenly and to trim with any attempt at following a required line, the paper must first be folded and burnished. The fold is then opened and scored with the blunt side of a knife, folded again and the fold dampened with a sponge (best variety is elephant's ear sponge). Finally the sheet is opened and the paper gently separated along this line. This technique creates a very natural-looking edge in which the fibre lengths vary.

If an edition has been printed on cut stock of the required size, various ways exist to simulate a soft edge to the paper, the most common being to clamp the whole stack of paper to a firm flat surface overlapping an edge by approximately an inch; by drawing a wood rasp down the whole stack, a consistent rough edge is created. Single sheets requiring soft edges can be feathered by the use of a sharp razor blade, drawing the blade at a slight angle along the cut edge, working out towards the edge.

Glueing

It is well known that curators generally abhor additions to prints. Not only do they create problems of storage but also often stain or contaminate the rest of the print. Simple adhesives that will not stain or acidify the paper and will generally allow easy removal and revitalising are necessary if any collage is to be carried out. At all costs, sellotape, masking tape or double-sided tape, brown paper tapes or glassine photographic tapes should be avoided as they will all discolour or acidify the paper they are in contact with in a short space of time. Water-based adhesives are by far the best. Wheat starch paste is smooth, strong and white and will hold its tack even when diluted. It takes a little time to prepare: 100 grams of wheat (or arrowroot or rice) starch: 800 ml water; the two ingredients must be soaked together before cooking in double boiler for 30 minutes. Store in a stoppered jar in a cool dark place.

Signing

Having made sure that each print is identical and perfect, an HB pencil is used to sign the edition. Signing and numbering procedures are covered in detail further on in this chapter. Sequential numbering (numbering in the printing sequence) is not always essential as lithographs and screenprints are often exactly the same quality from beginning to end of the edition. It may be found that drypoints, etchings

and aquatints may slightly deteriorate if the plates are not steel faced and in such cases sequential numbering is usual.

Publisher's (and occasionally printer's) imprints are often stamped onto the print as an embossed mark after editioning, and sometimes the work is rubber-stamped on the back of the print with a stock book or other reference number (although it is wise to consider the quality of the stamp pad ink).

SIGNING PRINTS

Signatures

Note 1 I say this because a) artists can make original prints and not sign them and b) there have been cases of fraudulent practice.

Today an original print can usually (Note 1) be recognised by the artist's personal signature and associated numbering on each print made. It is only in the last hundred years that it has become customary practice for an artist to pencil his signature on a print. Before the invention of fast-running machines that could reproduce art work photographically, it was not normal practice to sign hand-printed impressions.

Artist's signatures first began to appear on prints around the mid fifteenth century. Initials or a monogram were cut into blocks and plates often as a mirror image in a personally chosen place in the plate. One of the best-known monograms is that of Albrecht Dürer who incorporated 'AD' into his plates and blocks.

Imitative engravings from the paintings and drawing of others usually carried the names of both artist and engraver along the bottom margin often but not always at the left-hand side. These became very popular in the mid eighteenth century; the artist's name being followed by a Latin term - *pinxit, delineavit, invenit* or *composuit.* The name of the engraver is often characterised by *sculpsit* or *incisit* which means 'has engraved' or *fecit* which means 'has made'. All of theses terms appear printed the right way round which indicates that they had been engraved in reverse on the plate. Other Latin terms used up to the late nineteenth century include *excudit* (has published it) and *formis* (in the stock of the publisher).

With the introduction of lithography, it became the practice for an artist to sign the plate actually in his own hand. First printed impressions where the signature appeared in reverse indicated the virtual impossibility of signing in reverse. A personal signature on a plate is a good indication that the plate was made by the artist (a signature the correct way round usually indicates transfer as opposed to direct lithography).

James McNeil Whistler was the first artist to sign his own original prints (as opposed to signing the plate) and in the late 1880s he issued a lithograph which was signed in pencil under the image with added wide margins which he promptly proceeded to sell for exactly twice the price of an identical image unsigned and on smaller paper. Thus the ritual of signing and the debate about values began.

An original signature on a print is the authentication by the artist that this is his work as he required it to be (see also Chapter 3, Copyright, p84ff)

Terms and marks used on original prints

With the recognition that artists have certain rights to their work, it has become normal practice to put identifying marks on original prints to help preserve those rights. The actual number of marks are many and varied and the following is an attempt to list them and their uses. The purpose of signing and numbering is to identify the print, the artist, the date, number in the edition, the printer or publisher,etc. Most of the marks are made in pencil except for chop marks which are often embossed with a steel die.

If, in the artist's opinion, the marks detract from the work or if the print bleeds to the edge of the paper, the artist can make the recognised marks on the back of the

print or on an accompanying title page, but it is more usual for them to appear on the front directly underneath the printed image. It is normal for the edition number to be on the left-hand side, title in the middle and the artist's name and date on the right-hand side.

Many of these terms listed below assume that a printer is involved. For printmakers working at home or in their own workshops, it is likely that only working proofs, finished proofs and the edition (including artist's proofs) would be used.

Guide proof
During the course of working with a printer, an impression of the plate is pulled many times before the artist is satisfied with the work. Each of these prints is termed a guide proof and marked with the artist's notes or corrections that must be made to the work for progression.

Trial proof
When an artist is working on a plate,screen or stone, s/he pulls an impression at a particular stage to see how the work is progressing.These prints can be marked trial proofs because they present the unfinished state of the print and are not considered part of the edition. These prints are often worth large sums of money if they find their way to the market place as they give an insight into the artist's working methods.

State proof (Épreuve d'artiste)
A series of proofs are often taken after each of the steps in the completion of a print.

The confusion that arises between state and trial proofs is not easy to understand or explain.Trial Proofs are prints pulled before the printing of an edition and therefore a subordinate part of the general term state proof which includes all prints which show any change in the plate by deliberate intent, by accident or by deterioration.

Remarque proof
Occasionally an artist may make a small sketch on the edge of a lithograph or copper plate to try out the drawing fluid or a certain tool. Prints taken with these tests showing are called remarque proofs. The small sketch is ground off normally when the edition is printed.

Spoils
Most discarded proofs and the spoilt prints from editioning are either torn up or the backs used for proofing another edition.

Bon à tirer (BAT)
When the artist is satisfied with the print from the finished plate, s/he works with the printer to make one perfect print. This is then marked BAT (French:good to pull). The printer then prints the edition matching it exactly to the BAT. There is only one BAT print and customarily it is the property of the workshop itself. This is open to negotiation.

Printer's proof (p/p)
Custom allows the printer to retain one or perhaps two (in the case of a large edition) prints for himself and the print is marked and signed by the artist p/p.

Artist's proof (a/p)
Originally and theoretically an artist's proof was one outside the quota of the edition but printed at the same time as the edition. In recent years this has changed somewhat and the practice is sometimes abused. By custom, the artist is allowed to keep a number of prints from the finished edition for his own use or personal sale, and if these come onto the market they acquire the added value of personal association with the artist. Usually an additional 10% of an edition total (or in the

case of a smaller edition, five prints) are printed specifically for use as artist's proofs. However, an artist may print extra a/p's and in some instances this has exceeded the total edition number in which case the a/p's are editioned themselves and marked with Roman numerals, e.g. a/p V/XX.

Hors commerce (h/c)
From the French (not for sale), these are prints pulled with the edition but marked by the artist for business use only and used for display, advertising, travelling with, etc; they often get torn, creased, damaged and dirty.

The edition
This is the total number of prints decided by the artist that s/he requires to make from the plate, stone or screen, matched to the BAT.

Special edition
This can have several meanings. It is often the case that the artist will mark his proofs as a special edition. These are numbered in Roman numerals to differentiate them from the edition itself, e.g. IV/X. They are identical to the printed edition of prints but are for the artist's own personal use. Sometimes a special edition is made to commemorate a festival, a person, etc. The rules that govern marks on prints remain the same for this special edition. In some cases an artist will rework a cancelled plate to produce a similar but different print and publish it again with the same titling as the original edition but with the Roman number II after it. These special editions are often numbered in Roman numerals also.

Number of prints made for the edition
In order to achieve an edition of 100 prints, numbers are calculated, for example, to include :- 10 a/p's + 1 p/p + 5 h/c's + 100 edition = 116 perfect prints. To achieve 116 perfect prints, it is likely in a four colour printing, for example, that 10% be added for wastage on each colour (i.e. allowance for bad printing, damage to paper in handling, etc.) Therefore the total number of sheets required for an edition of 100 may be over 164. The best and most thrifty printers can get away with less.

A multiple
This is a print which has no edition. In other words, there is no limit to the number of prints made. However they are often made to a limited number, but not numbered as such. It may be either the artist or the publisher that makes the decision not to set a finite limit on the works printed.

Numbering
Numbering prints has become an established practice and sets limits to the edition. The prints are signed in pencil with two numbers, e.g.12/75, on the left-hand side of the print underneath the image. This indicates that the edition maximum is 75 and this was one of those prints, number 12. There is often some misunderstanding of the significance of the left-hand or first number. It is sometimes assumed that the lower the number the better the print. Although this may be true of dry points in which the burr on the line wears down thus changing the character of the line, it is not true of all prints and definitely not of the majority of editions.

Although the right-hand (second) number may indicate the total number of prints that can be made, it is sometimes the case that an artist will only print a certain portion of this total number for various reasons and then complete the final number at a later date.

Title
It is customary to write the title of the print in the centre of the bottom margin under the image again in pencil and in the artist's own hand.

Signature
The signature of the artist on the print (in pencil) has come to stand for amongst other things a guarantee of good workmanship and an authentication of the print. It

would therefore be improper for an artist to sign an inferior print that did not meet the high standards of the rest of the edition, or a reproduction. Some artists still sign their print in the plate so that the signature is printed at the same time as the plate, but this was an historically common practice and is not used much today.

Imp.
From the Latin *impressit* meaning 'has printed'. In modern prints, this is usually written after the artist's signature and denotes that the artist himself has printed the work. In the case of a workshop producing the prints this term cannot be used except if the printer also signs the work underneath the signature of the artist and writes imp. after his signature. In the majority of cases, a chop mark carrying the logo of the studio is used instead.

Dates
The artist may put the date (generally the year only) after his signature or title on the print in pencil. This represents the date the print was signed, not the date the plate or the edition was made.

Dedication
The artist sometimes signs and dedicates a copy of the print to someone such as a friend or publisher. This can be an artist's proof or part of the edition.

Portfolios of prints
It is usual for the portfolio to have a title page which shows the name of the collection of prints and the publisher and either overleaf or on a separate sheet, the colophon information: - the name of the artist, the workshop, the type of paper, names of the printers, the binder and anyone else involved plus the size of the edition and the particular copy number. Added onto this page can be a dedication or quotation that inspired the making of the portfolio.

When a series of prints have been made which are presented in a portfolio, it is usual if the series has been made by the same artist, for the artist to pencil his initials in the bottom right-hand margin rather than fully sign each individual print, and for the main signing to take place on the colophon.

Leporello
This is a print that has been designed to be folded after printing with either one or several folds.

A suite
This represents a series of prints by the same artist, or by several artists, working on a theme and may be sold as a set (in a portfolio) or separately.

Edition de tête
This is another name for a 'deluxe' edition.

Chop mark
This is a small mark from an embossed seal or from a wooden or rubber stamp that is impressed onto the print by the publisher, workshop or printer. It is most generally situated in the bottom right-hand side margin of the work. It signifies that the print may have been commissioned by or simply printed at a particular workshop. Dealers and galleries also use chop marks, as do collectors.

Cancellation print
When the edition of prints has been completed, the plate, screen or block is defaced, changed or modified in some way so that it cannot be identically reprinted again. The safest method is to destroy a plate. Lithography stones are ground down; copperplate and woodcuts are rendered unfit for use by scoring two sets of parallel lines across the image or by drilling a hole in one corner. A print from a crossed plate is called a cancellation print and is evidence that the numbered impression can be trusted. Where prints have been particularly popular there may be a trade in 'crossed impressions'.

Restrike

A reprinting of a plate, usually neither signed nor numbered and in most cases reworked after the edition is completed.

Book-keeping identification marks

Occasionally, a well-organised studio will utilise a rubber stamp with a changeable number to stamp onto the back of the print which will allow the work to be readily identified and traced back to its place in the book-keeping system of a studio. Each edition made is allocated a number and all relevant details recorded (See also Chapter 2, Documentation and record-keeping, p.64).

STORAGE, FRAMING, CONSERVATION, RESTORATION

One of the most important aspects in the care of prints is simple common sense, especially if you keep in mind that every time a print is handled badly, it is damaged.

Storage

The planning of storage should accompany any print shop or studio design, and the space between each shelf of the system should be narrow to avoid stacking prints in huge piles.

All finished work should be interleaved with acid-free tissue, mulberry paper or Melinex. Interleaving prevents any offsetting and also friction between the top layer of ink or one print and the back of another.

Completed editions lying about in open air are prey to dust, dirt, smells, moisture, heat, etc. more obviously than if they were wrapped. It is advisable to sandwich and wrap each finished and interleaved edition between acid-free boards larger than the printing size in strong waterproofed paper, which will help to eliminate bent or creased edges when extracting single prints. Packets are easily labelled on top and side with print details and although this takes a little time and effort, in the long run it saves much trouble.

The best flat storage system should incorporates all the most salient points of plan chest storage design; it should be sturdy in construction, have ease of drawer running, easy locking systems, dust traps on drawers, hinged lids/fronts of drawers for easy removal of print; protective lip at the back of the drawer and a range of sizes for convenience. For the best storage conditions each print and the base of the drawer should be lined with Melinex.

Single prints for display purposes, copies for examination or for daily use (a/p's or h/c's) can be protected in any way considered necessary.

Mounting

Museums traditionally store all works on paper in window mounts made of special acid-free (neutral) boards for ease of viewing and handling, thus lessening the damage which may occur to a print. Ordinary card is made of two outside sheets of fairly good paper sandwiching an inferior (and dangerous) woodpulp filler. Eventually this poor quality card, if used in a mount, will infect the work and cause harm due to the acids migrating from one material to another. So if long term care is in your mind, it is wise to select cards and boards for mounting that are acid free (i.e. made from 100% pure materials) and often called 'conservation' board.

As well as the mount, all other papers close to the print must be of the same neutral quality for long term storage and preservation. The Museums Association has produced various leaflets on care and mounting and framing of works on paper and their advice should be acknowledged. Prints are normally attached to the window mount by long fibred Japanese paper hinges. The mount should then be hinged to a backing sheet or board of the same quality. Never use Sellotape,

masking tape, brown tape or any glue to do this as the effects caused by disintegration of these materials is detrimental and often irreversible to the print. Glues such as rice or wheat flour paste, or Cellofas B such as museums use, are best. Because of the hydroscopic quality of paper (it expands and contracts with prevailing atmosphere) it should never be held down on all sides in a mount as the strain caused may stretch and and even cause the original to tear.

Most museums use solander boxes of different sizes to store their collections on paper, each print being individually mounted in these dust free boxes.

Framing and damage to prints

Framing of prints is a well-worn, much-trodden subject. Almost every book on printmaking has a section on temporary and permanent framing which is probably very comprehensive. To avoid being repetitious I shall only deal here with the main causes of short and long term damage to prints on paper which are not generally known or taken into consideration.

Assuming that the print has been editioned with care (e.g. etchings have not been printed with too much pressure which will cause irreparable cockling), finished with proper care (e.g. completely dried flat and torn down when dry), and signed, the main causes of damage to paper are :
1 Careless handling and packing
2 Contact with excessive dampness or wetness which will give rise to weakening of adhesives, rotting of certain types of size in papers, blurring of inks, mildewing and growth of bacteria, etc.
3 Excessive heat or dryness which will give rise embrittlement or desiccation
4 Contaminated air. This is possibly the most common abuse. Soot and dust will cause friction between glass and print/paper surface (if in direct contact) in a frame causing discoloration and staining; sulphur dioxide in air causes bleaching of prints and makes paper more fragile; hydrogen sulphide causing blackening of lead-based pigments.

The elimination of all these aspects when choosing a frame requires a professional, knowledgeable framemaker. Do not assume because a framemaker is a good joiner that he knows how to mount and frame a print to preserve and not damage its life. Instead of simply slapping a print between a sheet of glass and hardboard and clipping together, it is worthwhile taking a little care in framing a work considering the time and effort spent making it. The main idea in the permanent framing of a print is to try and make a sealed unit within the frame preventing moisture, dust and dirt from entering it.

Simple do's and don't's include: Do mount print on acid free board, back and front; if the whole printed sheet is to be viewed, place a piece of a conservation board at the back; never let a print and the glass at front come in direct contact - a mount will provide a necessary gap, or if no mount is to be used, then insert 'spacers' at each corner of the frame to hold work away from glass. Perspex boxes form good dust-free framing but if an ordinary wooden moulding is used seal the back of the frame with brown tape, or if an aluminium section moulding is used it is possible to seal the mount and print into one unit before inserting into the frame.

Melinex (ICI), used in many museums, is inserted between mount and backing board to prevent any migration of acids and can be used as storage interleaving between individual mounted prints. Sheets of tissue impregnated with a fungicide such as Topane WS, simply brushed on and dried, can be placed in contact with the reverse side of some prints or drawing of great importance, and will help protect them from fungicidal attack or foxing.

It is sensible not to hang finished, framed work on a damp, outside house wall. At the very least prevent it from being in direct contact by placing corks between wall

and back of frame to allow air movement. Avoid hanging frames directly on the fire breast, over radiators or heaters. Even direct spotlighting can cause heating of a framed print and is not recommended for long term lighting.

Other factors detrimental to prints and paper

Light
Damage caused by the effects of light cannot be reversed at present. Faded colour and brittled materials cannot be restored to their original condition. Precautions should be taken to control the amount of light falling on valued paper works. It is generally supposed that, providing no direct sunlight falls on an object there will be no damage. This is actually an over simplification. Any light, whether strong or weak, may cause damage especially if a print is fragile or delicate. The effect of sunlight is mainly due to its strength rather than to any particular quality and as a general rule the bluer the light the greater the damage it will cause. The comparative reddish light of an ordinary incandescent light (infra red) produces, in general, less damage than daylight. Ultra violet light, the most dangerous of all, causes inferior papers to weaken, darken, some to yellow and others to be bleached. Since UV is invisible, many museums fit a filter to light sources in order to eliminate UV rays.

Acids
Acid conditions in paper destroy the cellulose molecules and generally cause embrittlement and degradation of paper. Sources of acids inherent in paper are found in sizes, alum, inks and dyes, bleaches and other processing and impure raw materials. Papers especially prone to acid attack are those manufactured in the early decades of this century when wood pulp had just been discovered and the use of rosin sizing (with alum as a precipitating agent) was widespread. Since that time much has been done especially recently to handmade and mouldmade paper manufacture to ensure that the papers are acid free, i.e. neutral, (ph7). Another major cause of acid attack is migration from one acidic material to a non-acidic material e.g. from poor quality cards, unstable plastics. Acid from the environment includes nitrogen oxide from car exhausts, heating fuels, salt air, etc. No particular control for acid paper has been found except to de-acidify them.

Pests
Most insects like dark, damp, quiet places where grease, carbohydrates and water are all available. Some insects actually feed on the cellulose in paper - silver fish, wood-worm, etc. One way of eliminating this type of attack is to use a paper with a built-in germicide. In Japan, kozo and gampi fibres used in papermaking naturally contain certain chemicals which are abhorrent to paper-eating insects. Mould spores are another form of pest attack. They are present every where and will grow in nearly every substance. They will not usually grow on paper that has a relative humidity below 70% but will flourish in conditions above that level. Mould grows more rapidly in warm damp air than in cool air and if encouraged will destroy the cellulose, size, increase acidity and cause deep discolouration. If a print does develop mould it is wise to keep it cool or even freeze it until fungicidal fumigation can be performed by an expert.

Man
Lack of commonsense is often responsible for the deterioration of valued works. Bad handling, bad mounting, bad framing account for the majority of malpractices.

Conservation and restoration

As Laura Drysdale points out (*Artists Newsletter* Nov.1987) conservation is essentially preservation rather than restoration. Restoration should only occur when factors harmful to paper works have been allowed to run their course and damage has resulted. It is advisable to submit all major treatments that involve the

direct manipulation of the paper or its support to a qualified restorer.

An ideal environment for a print is non urban and air conditioned. Paper survives best at a temperature of 60-65°F with a relative humidity above 3.5% but below 7% (relative humidity can be expressed as a percentage form as the amount of water vapour in the air).

Before attempting to remove old mounting materials, paper's reaction to water and other solvents must be ascertained. Disinfection by fumigation is a specialist job as is dry cleaning with an air jet gun to remove dust and dirt. Grease removal is not always as simple as it may appear. Rubbing with an eraser or soaking in acetone or methylated spirits may not be the best method to remove a greasy thumb print. Reasons for soaking paper in a bath of water are numerous (e.g. to remove discoloration, reduce acidity) but as many papers are weak when they are wetted much testing must take place before irreparable damage is done. The removal of creases by slight damping and stroking and mending of slight tears by patching with jap tissue, again may seem like an easy job and fairly straightforward, but unless the work is done by a professional, harm and more damage may be easily caused.

FURTHER READING

Conservation Source Book Crafts Advisory Committee 1979. Lists everything concerned with conservation. Possibly to be reprinted by Conservation Unit, Museums and Galleries Commission.
Handling and Packaging Works of Art Arts Council of GB 1978
How to Care for Works of Art on Paper Francis W.Dolloff and Roy I. Perkinson Boston, 1979
Restorer's Handbook of Drawings and Prints Robert Lepeltier New York, Van Nostrand Reinhold 1977
Artists Newsletter 'Posting Prints' Peter Ford June 1988
 'Conservation & The Practising Arts' Laura Drysdale November 1987
 'A Short Guide to the Conservation, Mounting and Framing of
 Works of Art on Paper' Jane McAusland August 1984
British Standard Recommendations for the Storage and Exhibition of Archival Documents (BS5454)
British Standard Repair and Allied Processes for the Conservation of Documents, Treatments of Sheets, Membranes and Seals (BS 4971) 1973
Museums Association (34, Bloomsbury Way, London WC1A 2SF Tel. 01 404 4767) produces many leaflets including *Mounting of Prints and Drawings*
 Conservation and Museum Lighting
 Simple Control and Measurement of

HELP AND ADVICE

Conservation Unit, Museums & Galleries Commission 7 St James Square, London SW1Y 4JU Tel. 01 839 9341. CU is a forum for information, advice, planning and support relating to conservation of the cultural heritage and includes a register of conservators and restorers available to private individuals.

United Kingdom Institute for Conservation (UKIC) 37 Upper Addison Gardens, London W14 8AJ Tel. 01 603 5643. Produces a conservation newsletter and has list of training institutions.

Institute for Paper Conservation Leigh Lodge, Leigh.Worcs WR6 5LB. Organisation devoted solely to conservation of paper and related materials. Objective is the advancement of the craft and science of paper conservation within the profession and in terms of public awareness. Membership open to all having an interest in paper.

Paper suppliers
Atlantis, R. K. Burt & Co. Ltd., Falkiner Fine Papers Ltd., Inveresk Paper Co., T. N. Lawrence & Sons, Ltd., John Purcell Paper, etc. (See Advertisers Section p.124ff)

PRICING PRINTS

Setting out a number of guidelines on pricing prints is complicated because what is relevant for one person in one situation is not for another. In this section I am offering guidelines directly to artists who make their own prints and who are probably not registered for VAT. I suggest that as there are many personal factors to take into account when calculating a price, each artist selects from the information exactly what is necessary or relevant to him/herself. It is important also to talk to other artists, to an accountant, to your RAA about ways of pricing. Before trying to price what you consider your work to be worth, look at the market you are aiming at.

Costing your work

Costing is the calculation of exactly what each print in the edition cost to make enabling the calculation of a selling price. It is simply a technical exercise. Knowing what it cost to make is essential in avoiding bankruptcy. This particular scheme calculates the *cost per hour* consequently allowing the cost of the print to be calculated. It is necessary to calculate your overheads, labour and materials in order to arrive at a *cost price*. Taking an average always presents a problem because there never is an average especially in the case of estimating materials for a print when sums could vary enormously. Each artist will have to solve this dilemma individually.

Overheads
Calculate the weekly (monthly or annual) cost of:-
1 Workshop expenses, rent, rates, light, heat, machinery repairs, etc.
2 Telephone, post, travel, photography, promotion, advertising, insurance, accountant, solicitor, etc.
3 Equipment necessary - these costs can be spread over a number of years if large sums are involved.
4 Stock. An average of 20% of average stock held could be added to overheads.
For example - (monthly £546, annually £6552) weekly costs = £126

Next the calculation of the number of hours spent making the edition or work which includes time spent travelling, writing letters, accounting - in fact anything connected with your work in hand.
For example -
You have calculated that 70% of your week is taken up in making the work. Base your calculation on a 40 hour week, 70% therefore = 28 hours.
If you based your costings on an 80 hour week (which some people obviously work) then you would have to work 52 hours to make the same amount of money. The hourly rate is then calculated by dividing your overheads by 28 hours
*Therefore £126 divided by 28 = **£4.50 per hour***

Labour
This is simply a calculation of what you would realistically like to earn in a year.
For example -
*If you would like to earn £9,600 and work a 48 week year, you would need to earn £200 per week divided by 28 hours working week = **£7.14 per hour***
If you would like to earn £16,000 per year in a 45 week year = £355.56 per week divided by 28 hour week = £12.70 per hour

Materials
Calculate exactly what the edition has cost you to make, taking into account that you have already estimated some stock in 'Overheads'. It is obvious that edition estimates will vary (often greatly) and it is wise to take the highest and the lowest estimates of materials to get an average.

For example -

paper	*£140*
inks	*£ 53*
plates	*£190*
extras	*£180*
Total	**£568 per edition**

Estimate the number of editions per year and therefore the materials' cost.
For example -
Number of editions p. a.=12, materials' cost totals12 x £568 = £6816 p. a.
Divided by a 48 week working year = £ 142 p.w .
Divided by a 28 hour working week = £ 5.07 p.h.

Calculation of Hourly Rate
The calculation of a realistic hourly rate for making a print is then calculated : -
Overheads £ 4.50 p.h.
Labour £ 7.14 p.h.
Materials £ 5.07 p.h.
Total = £16.71 p.h.

Cost price of your print
This hourly rate can then be used to calculate the cost price of any print you make.

For example -
An edition of 25 plus 5 a/p's which took two weeks to make = £16.71 x 28 (hours per week) x 2 (weeks) = £935.76
Divided by 30 prints = £ 31.19 per print

This is the cost price of the print. It represents an accurate method to price your work without guessing, and so enables the calculation of a break-even point. There are many variations on this method and every artist will develop his/her own practices.

Pricing structures

When you sell a print it is to one of four main categories : selling to the public (retail), selling to galleries (trade), selling it to agents (trade), selling it to publishers (trade). Pricing is dependent on many factors and the people who make the most money are those who by their judgment get the costs (expenses) and selling prices (income) just right for their market. This is not guess work but a combination of calculation, experience, gambling and knowledge. Although I am suggesting a series of guidelines below, it is obviously not advisable to follow them if your print ends up being priced at £250 when it will only sell at £50. So in all these calculations it is important to be able to adjust your calculated price according to the market, your own history of selling, etc.

Cost price
This is the price which the print cost to make. It is calculated by the artist.

Trade Price
This is the price that the work will sell at to the trade e.g. agents, dealers, galleries, etc. The trade price is calculated by either deducting a percentage commission (i.e.usually between 30-50%) from the retail price
For example -
If the print retail price is £65, the trade price might be £32.50 (50% commission)

or by adding the dealer's percentage to the trade price (60-100% mark up) to make up the retail price.
For example -
If trade price is £45, then the retail may be £80 (80% mark up)

For the artist to arrive at a trade price, it is necessary to add a percentage increase onto his/her own cost price so that a profit can be made.

For example -

If the print cost price is £31.19, a trade price might be £60 and a retail price £110.

For dealers wishing to buy in bulk, i.e. the whole edition, it is normal practice to reduce the trade price.

For example -

If the print cost price is £31.19 , a trade price might be £60 and a retail price £110, for dealers buying in bulk a trade price of £45 per print may be used.

Selling or retail price

The selling price (which is also called the retail price) is the price the print will sell at to the public and is based on knowledge of the cost price. The selling price is the price displayed to the public and can be calculated in a mark up of 1:3 from the cost price. The selling price should not vary from one dealer to another or from one part of the country to another although it may vary from one country to another. If you work out the selling or retail price professionally and accurately then the price of the work will bear a relationship to how you live.

For example -

If the retail price is £95, the gallery's commission 40% = £38, therefore the trade price (i.e. price paid to the artist) = £57. (The artist's cost price was £30.)

Many artists double their cost price to arrive at the retail or selling price although this is not necessarily a good idea because it doesn't give the artist any profit.

If an artist is selling individual prints in several galleries, it is very important to establish a retail price and to keep to it. Price tags which say 'price on application' or 'price negotiable' can indicate a variable selling price. Although the difference may appear subtle, a retail price that is fixed sets the worth of the work for the artist and therefore the buyer is not upset or confused by finding the same work for sale in different galleries at different prices.

Discounts

It is important for the artist to have calculated the *selling* or *retail price* of the print so that if necessary varying discounts can be given; e.g. a discount to an educational establishment (e.g. 10-20%) may not be as great as that to a dealer (40-50%) because there is probably no resale on the former.

Pricing an individual work

In the case of prints such as monoprints, photographs, speciall proofs, etc. the cost price can be accurately calculated by the above method. The retail price is decided by the artist when the profit requirement is assessed.

Pricing a print commission

This is basically a method of calculating how many hours the commission will take and costing it accordingly. When executing a print commission, calculations of the cost must include not only the overheads and materials necessary but also the labour costs in making the print. A commission is technically a contract for skill and labour and the commissioner purchases the time and expertise of the artist who produces the work. It is necessary that the artist and the commissioner come together at the very beginning of the commission to consider the necessary fees and terms for both the commission and its editioning. (Chapter 3, Contracts, p.82.)

VAT on print prices.

This is a complicated issue and advice should be sought from an accountant or solicitor. If an artist is registered for VAT then the price of every print must include 15% VAT.

For example - on a print that retails at £100, invoice value = £115 inc. of VAT

If the gallery selling your work is registered for VAT and you the artist are not and if the gallery does not own the work (i.e. S or R), the gallery should only add 15% VAT to the *commission charge to the artist..* No VAT is charged to the purchaser.
For example -

Print retail price	*£100*
Gallery commission (40%of £100)	*£ 40*
VAT on Commission (15% of £40)	*£ 6*
Gallery charges to artist	*£ 46*
Artist receives	**£ 54**

If the gallery is registered for VAT and you the artist are not and the gallery *buys the work outright* from you and resells it, the gallery then charges VAT on the *full retail price.*

If the gallery is registered for VAT and you the artist are also registered for VAT, and the gallery does not own the work, the artist (or the gallery acting on the artist's behalf) charges 15% VAT on the full retail price and the gallery also charges VAT on the commission it charges the artist for acting as agent .

If the gallery is registered for VAT and you the artist are registered for VAT and the gallery buys the work outright from the artist and resells it, the gallery charges 15% VAT on the price it pays to the artist but accounts to the Custom & Excise for the full VAT sum on the retail price.The artist accounts to the Custom & Excise 15% VAT on the price he has received from the gallery (i.e. retail price less 40% discount). (See also Chapter 4, VAT, p.100.)

Sale-or-return

Prints left *on consignment* with a gallery indicate that the artist is not selling outright to the gallery but merely leaving them in the gallery for sale. Technically speaking *sale-or-return* means something quite different to *on consignment*. S or R means that the artist is selling the prints to the gallery (for which s/he delivers an invoice and expects payment) and if the gallery has not sold them at the end of a specified period they return the work and the artist reimburses the gallery assuming that in the intervening period the gallery has paid the artist's invoice. In actuality, the latter probably never occurs but *consignment* and *sale-or-return* can be a confusing issue. A straightforward way to deal with prints left in a gallery is to leave them *on consignment* and exchange consignment notes. (See Chapter 3, Contracts for selling prints, p.81.)

Exactly which print in the edition is left with the gallery is up to the artist. It has been a practice in the past that artists leave an *hors commerce* and when the print is sold deliver an edition number to the gallery but if artist and gallery take care of the work there is no reason that an editioned number should not be left.

Note that when a gallery *buys* work from an artist for resale, this is different and the legal situation and implications are very different (i.e. revelation of identity of buyer) (See Chapter 3, Contracts for selling prints)

Factors affecting the price of prints

From discussions with many people on this issue, the reasons for high prices in original prints are very variable and include whether or not the print is numbered, what part of edition (e.g. a/p's and low numbers are regarded by some people as worth more), what the dedication (if any) says, the stature of the artist, the process employed (some consider that mezzotint, aquatint and drypoint should be higher priced than screenprints), whether it has been recorded either in a book or at auction, whether the artist is dead or alive, images that have become famous though reproduction or simply the (often transient) popularity of the artist.

Effect of signing and limitation on pricing

The idea of asking more money for a signed print as opposed to an unsigned work began with the reproductions controlled by the Printsellers' Association in the nineteenth century and was taken into the realm of the original print by Whistler, who charged twice as much for a signed lithograph as for an unsigned proof. It remains perfectly true today that a signed, limited edition of original prints will sell for more than a work which is unsigned or where there is no limit to the number produced although the returns may possibly be the same. Obviously the distributor must work harder to sell more to break even on large editions (e.g. into thousands) or on an unlimited run. However in the majority of galleries an edition size varies between 10 and 500 and the price between £45-£1,000. The decision for the size of the edition rests with many factors - a plate with a limited life, a commemorative or special edition, the stature of the artist, the decision of a publisher based on knowledge of the market, popularity of the artist, etc.

Technical factors that can affect the price of a print

1 Quality of the paper (i.e. handmade, mouldmade, special making, etc)
2 Handling and damage to work including dirty prints, tears, creases, etc.
3 If print was printed by a master printer and amount of collaboration time.
4 Size of the print
5 Method/number of colours
6 Number of prints available for sale/editioned or uneditioned/ etc.
7 Whether print was commissioned
8 VAT, whether charged or not, on whole or part of print price.
9 Framing costs
10 Subsidy/grants/awards/etc made to artist/studio for making work.
11 State of market ,e.g. market glut, lower prices, etc.

Note. The (mistaken) idea that painter's prints are superior to those made by artists who only make prints can affect the price in that the numbers of editions produced may be small lending a rarity value to the pricing.

Selling an edition

Although it takes Alan Cristea of Waddington Graphics in London as little as an international phone call to sell out an edition, it probably takes the average artist much longer. Even with the aid of a sympathetic dealer, unless (and even when) an artist is under exclusive contract to give all his/her production to a gallery, the process of placing and selling work is arduous and time-consuming. Selling prints is a long-term project and it may be years after the image was printed that the edition is sold out. It is always possible and quite often necessary to add on a percentage increase to prints left in an edition every few years to keep pace with inflation. Artists have many ideas for selling old work; a studio sale, an open day, a studio teaching week, a holiday course all may help to sell the final prints in an edition.

Income from an edition

Many people make the mistake of thinking in their calculations that the *retail price* represents the income they will make from the edition. Although selling patterns vary, an estimated total income from an edition may look like the example over the page.

In all probability these sales may cover the cost of making the edition and although bankruptcy or survival may not be an issue the prospect of continuing to produce prints might. Ideas to extend income in such cases include making larger editions, charging more, selling more, not giving any away, sending a/p's to competitions, giving proofs to family and friends, etc.

For example -
Edition 10 + 2 a/p's
Retail price £50 Trade price £25. Cost price £10. **Estimated income £500**

1/10	Sold to aunt	£35 (special price)
2/10	Sold to dealer	£25 (50% discount)
3/10	Sold in exhibition	£25 (50% discount)
4/10	Sold in exhibition	£25 (50% discount)
5/10	Sent to Bradford Biennale	
6/10	Sent to print competition (arrived back damaged)	
7/10	Damaged corner by dropping	
8/10	Unsold	
9/10	Unsold	
10/10	Gave to father	

Actual income £110

Documentation and record keeping

To keep tabs on your production and where your prints are, it is sensible to keep a print book for no one else's eyes other than your own. This information will not only provide technical information and edition data but also could provide historical insights in later years. The following guidelines can be changed for either personal or print studio use:

For example -

Name of artist	Jack Bell
Print Number	137
Title	The Night Before
Date Printed	Between May and July 1988
Date Published	September 1988
Name of studio	Printers Ltd, printed by Bill Basset
Method	Screenprint : 3 colours first stencil red, then blue, green
Paper	BFK Rives H.P. Royal, watermarked
Image size	50 x 58 cms
Print size	As above plus30 cms margin
Number printed	25 edition, 3 x a/p's, 1 x p/p, I x BAT,1 x archive
Studio costs to make	£552 Total
Total costs to make	£27 per print
Retail Price	£120
Notes	Signed on 28 August. Trial proofs to artist.

Sales

Date sold	Edition no.		
	1/25		
	2/25	private sale	£100
30.9.87	3/25	Sold to A. Drumm (dealer)	£ 80
	4/25	Sent to Cracow	
	5/25	Triennale Grenchen	
12.10.87	6/25	Sold to Wakefield Museum	£108 etc.

Although you will have an invoice or a bill of sale for each print you have sold, keeping a print book helps you see at a glance what has happened to your edition. It is also useful to add in which prints have been exhibited where, a useful reference when writing up a CV.

Chapter 3 **SELLING PRINTS**

Ref 1 *Marketing the Arts*
Keith Diggle, Centre for Arts and Related
Studies, City University, 1976

'The primary aim of marketing is to bring an appropriate number of people into an appropriate form of contact with the artist and in doing so to arrive at the best financial outcome that is compatible with the achievements of that aim.' (Ref 1)

Marketing is a series of separate activities that are linked and interdependent. Recent trends indicate that some artists want to be involved in the marketing of their own work. They therefore have to equip themselves by learning about activities such as advertising, sales assessments, distribution, financial planning, etc. This chapter is for those printmakers who are interested in aspects of self-promotion with a view to selling and exhibiting prints and presents some guidance and tips for that preparation.

MARKETING

General planning processes

Good print marketing is difficult for individual artists but not impossible. As with any plan for any objective, the first stage is to decide on your aims. Make a list in order of preference answering the question 'what do I want ?' Then ask yourself 'is it feasible?' Consider various plans and then choose what you consider the best one to be. Weigh up your financial resources and all the stages that will need cash input. When you have finally chosen the best plan, review and revise it, approve it and adjust it as you go along. Galleries do most of this when an artist holds an exhibition and many galleries have refined their marketing skills to a fine art !

The ability to plan is an important attribute in marketing and promotion. It will involve financial calculation of production costs, administration costs and marketing costs. If you are able to price your own prints (see Chapter 2, Pricing prints, p.59) then you are expert enough to plan and achieve your own promotion.

Promotion

Promotion is convincing people that they want your prints, marketing is ensuring that they get them. Although many artists are more than competent at creating and printing their own editions, they often find difficulty in extending information about what they do to others - a prime objective in a promotional plan. A lot of help and advice exists for those willing to take up the challenge of promotion but it takes time and effort. Many artists prefer to spend their time making prints and let others who are trained in promotion and marketing use their skills to sell work.

Self promotion

How to present yourself, your skills or your work to a particular market is essential knowledge to any aspiring professional printmaker. The first stage is to have ready accurate, up-to-date information about yourself and your work.

Curriculum Vitae

A CV is simply a personal statement about yourself presented in a standard, easily accessible form. It can be used for job applications, exhibition applications, catalogue reference, etc. It is a compilation of positive information which takes time to collate and will need updating periodically. Prepare a long CV, full of as much detail as possible for your own reference from which shortened, adapted versions (never more than two pages long) can be created whenever the need arises. With the increase in applications for employment, effort must be put into producing a clear, easily read document. A CV always needs to be accurately typed and neatly laid out and should contain the following information :

Name	*Full name or professional name*
Address	*Include post code*
Tel. no.	*If you have no tel. no., give a friend's.*
Date & place of birth	*Also possible to give age separately if relevant*
Nationality	
Education	*Colleges, universities, research, Show all results.*
Employment & dates	*Current employment and past employments.*
Exhibitions	*Selected, group, one person, biennales.*
Collections	*National, international and private.*
Awards	*Grants, scholarships, prizes even if minor.*
Dealer/agent/address	*If relevant*
Publications	*Any prints published other than by self.*
Bibliography	*a) Any books/articles you yourself have written*
	b) Articles about yourself in books, magazines.
	List chronologically plus name of reviewer
Committees	*List any group that you have been part of.*
Referees	*Ask referees first. Two names and addresses.*
Artist's statement	*Often impossible to do; decide what application is and write accordingly or ask someone else.*

Technical CV

For a printmaker who has special skills, it is worth acknowledging them in written form. This not only confirms your particular expertise but will give you extra confidence when you see it written out on paper. Consider writing a technical CV which details your craftsmanship and experience in areas that, for example, a specialist job may require. Add this as a separate page to your CV.

Main area of expertise	*E.g.Direct Lithography. List experience with plates, stones, drawing materials and processing plus B&W or colour work plus regraining, etc.*
Particular skills	*List expertise in specialist areas or techniques e.g. chromolithography, washes on plates, multi-colour work, large sized work, etc.*
Machinery expertise	*List names, types and sizes of litho presses you are skilled at using*
Other areas of expertise	*List other processes that you are competent or skilled in , e.g. screenprinting. List every technical process and technique that you are competent at*
Apprenticeships	*List studios or jobs or even help that you have given other printers /workshops in your field*
Technical courses	*List any technical courses you have been to or run yourself - even if you consider them unimportant.*

Portfolio of prints

First of all it is necessary to identify what your aim is for putting together a specific collection of works; not simply to show 'John Smith' but perhaps to illustrate versatility, variety, competence at a process, etc. The choice of works for inclusion depends entirely on the application. Some dealers specify what they want to look at e.g. recent work, landscape only, colourful work, small work, etc. It is worth considering carefully what *you* would like to include as well with your reasons. The prints must be professionally signed and clean.

Avoid if you can, carrying prints in a roll because they often will not lay flat to allow a gallery director easy viewing; work that is too large for carrying in a portfolio; work that is too heavy or awkward to carry easily; too many prints; work that is especially valuable or fragile; work that would damage easily while travelling or handling.

Include 10-20 prints or drawings in a specific viewing order (each covered with a plastic slipcase or tissued). It may be worth taking h/c's or a/p's instead of valuable editioned prints.

Slides and photographs

Taking a good selection of slides or photographs with the portfolio to an interview of any kind is a good idea. This can extend the range of work.

Professionally made slides (usually 35mm in triplicate or more) are necessary for many applications, e.g. to residencies, biennales, fellowships, etc. Always get photographs made before you need them - at least four weeks in advance. Use a professional photographer. Services of fine art specialist photographers cost a lot but are worth it. Scan *Artists Newsletter*, *Arts Review*, *Crafts* magazine, etc. for professional photographers' advertisements. Use 35mm for postal applications; for interviews; to add to your portfolio; to send to biennales; etc. This may mean having five copies of a print made. Larger colour transparencies or photographs are used for reproduction on posters, in magazines, etc.

Make sure each transparency has your name, an arrow showing which way up and a reference number on it all on the *viewing side* . It is important to have with you (or send) a typed list which gives details of the slides. This should contain the following information : slide no./ edition no./ name/ title/ medium/ date/ retail price/

B&W photographs are necessary for press releases, reproductions, etc. It is useful to have a selection of printed 6x8 in glossies for general use. On the back of B&W photographs print the same information - name, title, medium, etc. and an arrow showing upright viewing position. If the photograph is for reproduction, the photographer may need a credit. It may also be necessary to add permission for reproduction of the photograph (e.g. photograph courtesy of).

Other basic requirements

Another necessary item is a **Print Book** (See Chapter 2, Pricing prints, Documentation and record keeping, p.64) in which details of all prints made are kept so that you know at a glance what is available for sale, display, interview, exhibition.

Lastly, a **simple letter heading (and business card)** is essential from the minute you leave college. Cheap to print, it is useful for a variety of applications (See Chapter 4, Stationery, p.99) .All this advance preparation is to assist you when you take your product or service i.e. prints, workshops, lectures, to the person who wants to buy or use it.

FURTHER READING *The Artist's Survival Manual - A Complete Guide to Marketing your Work* J & T Klayman, New York, Scribner & Sons, 1984
Building Your Own Portfolio Publications Despatch Centre, Dept. of Education & Science, Honeypot Lane, Cannons Park, Stanmore Middsx HA7 1AZ

Making Ways : The Visual Artists Guide to Surviving and Thriving Editor David Butler, Sunderland, Artic Producers 1987

Marketing the Arts, An Introduction and Practical Guide Keith Diggle, Centre for Arts and Related Studies, City University 1976

Marketing the Visual Arts Prof. L.W.Rodger, Scottish Arts Council

Marketing Skills For Crafts People FEU Room 312, Dept of Education & Science, Elizabeth House, York Road, London SE1 7PH

Working in Art & Design Peter Green London, Batsford Academic & Educational Ltd 1983

Working in Fine Arts & Crafts Leaflets available from Manpower Services Commission Dept CW, ISCO 5, The Paddock, Frizinghall, Bradford BD9 4DH

Art Monthly 'Soul Trading' Henry Lydiate, May 1986

Artists Newsletter 'Getting Your Work Photographed' C. Le Poer Trench March 1986

Most colleges and polytechnics provide careers counselling for their own students and are often willing to see own past students. e.g. Brighton Polytechnic (Grand Parade, Brighton BN2 2JY Tel. 0273 604141 ext 211/272); they produce *'Artyfacts'* which anyone can subscribe to.

EXHIBITING PRINTS

In 'The Economic Situation of the Visual Artist" conducted by Calouste Gulbenkian Foundation published in 1985, it was conservatively estimated that at least £2.75 million was taken in sales of prints in 1979-80. Print galleries were found to have a multitude of different activities; some were publishers and/or were connected to a particular print workshop; occasionally a print gallery ran a workshop and commissioned artists to make prints; some bought editions; others took work on sale-or-return; in some print galleries framing accounted for 50% of the sales. One common factor in both high and low priced print galleries was that neither sold the majority of work to private individuals.The higher priced publishers' most important clients were businessmen who bought prints to decorate their offices. Another interesting fact to emerge was that the top price end of the print market consisted often of prints made by established artists who had been commisssioned by print publishers to make a print.

It is quite rare today to find many galleries that sell prints exclusively. The majority of galleries in Gt Britain exhibit various media - prints, drawings, paintings, sculpture, photographs, etc. Many include spaces in their programmes for print exhibitions. Of the galleries that are successful In maintaining a print specialisationsuch as CCA Galleries or Zella 9 in London or the galleries connected to major printworkshops in Scotland, each has a different emphasis and is very successful in its own area. (See also Press and Media, Publicity, p.89.)

Before approaching a gallery

However a gallery is the place where most prints are sold and if you are an artist looking for exhibition space, it is pointless to waste time heaving a portfolio of prints round to any gallery because the success rate will be so low as as to be demoralizing. It is an established fact that there are more artists looking for gallery space than there are opportunities available.

Be selective. Before making any contact with a gallery, decide what it is you want, short and long term. Articulate what your position is. Do you need a commission? Do you have editions you want to sell? Are you mainly interested in showing your work? Is selling less important? It is advisable to do some homework and legwork. Look at a range of galleries where you live and find out what they do. Visit only the ones that might suit you best. Look at their space and exhibiting programmes. A complete list of galleries/museums/exhibition spaces is given in books such as Arts Review Yearbook, Directory of Exhibition Spaces (see Further reading, p.72).

Most galleries prefer to be contacted prior to a request to look at a portfolio. Telephone and ask the gallery when they plan their shows, when submission is necessary, how to apply and what is required. Most galleries have established

systems for looking at new work (e.g. on last Friday of each month). This will give you an opportunity to make an appointment and time to consider your best approach.

Galleries and exhibitions

The range of opportunities in galleries is wide and if, after dicussions with a gallery, they refuse your particular application, ask them for a referral to a gallery they think is more suitable. If a gallery is interested in you, they may want to visit your workshop/studio before making a final decision on your application. Examples of applications can include leaving work in a plans chest, sale-or-return, wanting to join a group show, a mixed show, a one-person show or applying with an already packaged exhibition.

Types of exhibition spaces

Enterprising space Many printmakers who wish to do so can find a local venue to exhibit in, e.g., a workshop, an empty shop in the high street, upstairs in a pub, in a bank lobby or town hall entrance.

Workshop exhibition. Many of the more go ahead workshops have developed their own exhibiting space (often with an AC funding) with regular, planned print exhibitions. These play an important role in the venues for seeing British prints, e.g. Printmakers Workshop in Edinburgh hosts a number of exhibition activites including workshop open days where artists and printers can talk to the public. A group workshop may decide on an open week in which case all costs are shared and sales are not diminished by the deduction of large percentage commissions.

Artist run galleries Exhibition spaces run by artist printmakers like the Greenwich Printmakers Gallery and the Hardware Gallery in London, often provide a sympathetic venue for difficult or theme work that a mainstream gallery might not consider. The control and policies of the gallery are organised by artists.

Art fairs/festivals Artists can join together in purchasing space to display work at a trade fair, e.g. London ICAF

Independent galleries These are often run by independent trust or limited company and most have charitable status often relying on public funding from the Arts Council, Regional Arts Associations or other bodies such as local council. This means they do not have to rely on sales to survive and consequently are able to attract specialist audiences, e.g. Air Gallery, London.

Public Spaces Galleries funded by public money. Libraries come into this category usually offering small spaces (and possibly print loan schemes). Also schools, art centres, etc.

Public galleries These are exhibition spaces provided by a borough, district, county or town council. They often aim to have exhibitions with a local emphasis, support local artists and occasionally may accomodate or initiate large or international touring exhibitions. They also often house a museum collection, e.g. Bradford City Art Gallery which also runs the British International Print Biennale.

Private galleries This is possibly the largest category of exhibiting spaces that exists in Britain. These galleries have to make money (i.e. sell work) to survive. Many private galleries make their profits from some other activity that exists alongside the gallery space, e.g. framemaking services, artists materials, etc. They can elect to deal with a narrow range of work and may have exclusive contracts with artists (act as agents with sole right to deal in a particular artist's work) known collectively as a 'stable' of artists. Galleries in this category with print specialisation often have a permanent print display area and actively seek sale-or-return contracts, e.g. Flowers East and Thumb Gallery in London.

Exhibitions

Making estimates for exhibitions

Exhibitions are costly. Before finally agreeing to take part in an exhibition, make an estimate of how much it will cost . Estimates might take form of a) preliminary estimates and b) revised estimates. Remember that these items suggested for estimating costs are *after* you have paid for your own time and the making of the work.

Estimate of costs

Hire of gallery space
Painting & decoration
Framing and mounting of works
Transport (inc. insurance)
Insurance and public liability coverage
Hanging
Publicity- poster, cards, catalogues, adverts, labels, etc.
Preview _____

Estimate of income

Loans
Subsidies e.g. sponsorship, E.P.R., etc.
Gallery coverage _____

Estmate the net cost to you (the artist). _____

Funding

Your local RAA is possibly the best source of information, help and possible funding and many run seminars on aspects of business including planning exhibitions. Plan well ahead and give yourself time to apply for grants or find sponsorship,etc (See also Chaper 5, Sponsorship, p107). Recently the ACGB has taken the initiative to join a scheme which has an obligation to pay the artists for services they provide to the public; a number of galleries, museums and art centres now pay a fee to artists when work is exhibited.

Exhibition checklist

The following is a list of details you should have in your possession when agreeing to exhibit :

Title of exhibition	*Single person,mixed, group show.? Is the aim of show clear*
Dates of exhibition	*Is it a good time for you? Have you plenty of time to do everything necessary? What is best selling time ?*
Selection of work	*Who will select this, when and what criteria?*
Dates of preview	*Is this the best time for you? Your address lists, galleries,etc*
Dates press view	*Who contacts press,which and how? Adverts,etc.*
Gallery opening hours	*Are these listed on publicity?*
Admission charges	*Generally free. Consider implications of not being free*
Transport of work	*Who will organise and pay for this to and from gallery. Typed list of works that are coming to gallery*
Installation	*Who provides framing? Who frames it? Who will hang work? What system of hanging? When to and how to hang - evening, weekend? What lighting?*
Insurance	*Who is responsible for work in transit? Exactly what does gallery insurance cover? Does it cover prints in a plans chest that are damaged by handling as well as if print is stolen or drops off wall, etc.*
Prices	*What commission will gallery ake on retail price? Is gallery registered for VAT? Are prices displayed during*

	exhibition? How? Are prices framed or unframed? When does payment take place?
Finance	*Estimates for exhibition (see above). Fees (for selector plus author of catalogue).Application for exhibition subsidies,etc.*
Extras	*Do you want to do a workshop in conjunction with exhibition give a lecture or visit local community or schools, or show people around your studio? Discuss dismantling details. Collect from gallery addresses of buyers and sales of work.*

FURTHER READING *Artists Studio Handbook* Liz Lydiate, Artic Producers & Artlaw Services Ltd 1981
Directory of Arts Centres in England Scotland abd Wales ACGB & NAAC 1976
Directory of Exhibition Spaces Ed. N. Hanson & S. Jones Sunderland, Artic Producers 1989
Economic Situation of the Visual Artist Calouste Gulbenkian Foundation, London1985.
Exhibitions & Conferences Yearbook York Publishing Co.
Guide to Exhibited Artists: Printmakers Oxford, Clio Press 1986
Handling and Packing Works of Art F. Pugh London, Arts Council1978
Organising Exhibitions Francis Pugh London, Arts Council 1978
Organising Exhibitions Teresa Gleadowe London, Arts Council
Organise Your Own Exhibition-A Guide for Artists Debbie Duffin London, ACME 1987
Museums & Art Galleries in GB Museums Association 34 Bloomsbury Way London WC1A 2SF
Museums Yearbook Museums Association.
Museums & Art Galleries of London Malcolm Rogers London, Ernest Benn 1983
Some Notes for Young Artists on Galleries and Marketing Phillip Wright Scottish Arts Council.
Art Monthly 'Paper Promises' Henry Lydiate July/August 1986
Artists Newsletter 'Artist , Public & Art Gallery' July 1982
 'Exhibition Organising for artists and Artists Groups' Dec.1983
 'Organising Exhibitions for Non-Exhibition Organisers' Dec. 1983
 'Publicity' 1,2,3,4 April 1984 - August 1984

LONDON GALLERIES THAT SHOW PRINTS

This section includes a selection of London galleries that show prints as an important part of their exhibiting schedule. Their aims and objectives differ widely and should always be checked. Many also handle other media which is not discussed. I have not listed many large galleries that hold important exhibitions but do not have a print specialisation. I have also not collected print specialist galleries outside London but would welcome details for the next handbook. From the results of my questionnaires, the large majority of galleries indicated their willingness to see the work of new printmakers preferring to be contacted by a preliminary letter with slides before an appointment is made. Any exceptions are detailed. The galleries are listed alphabetically by name.

Anderson O'Day
225 Portobello Road, London W11 Tel. 01 221 7592
Trade enquiries 5 St Quintin Avenue, London W10 Tel. 01 969 8085
Contact Don Anderson
Deals in limited edition prints from St Quintin Avenue. Gallery has occasional print shows but always holds stocks of prints. Printmakers include Ackroyd, Allen, Arif, Bonnell, Brunsdon, Carlo, Cole, Eisemann, Neiland, Neville, Rowe, Wilkinson, etc.

Angela Flowers Gallery
11 Tottenham Mews, London W1P 9PJ Tel. 01 637 3089
Contact Jane Hindley
Publishers and dealers in prints of all media by gallery artists. Flowers East is their new gallery dealing specifically with Flowers Graphics.

Anima Gallery
132 Lots Road, London SW10 Tel. 01 352 7694
Comprehensive selection of contemporary prints by British, American, Japanese and European artists. Artists include Jameson, Chaplin, Hughes, Millington, Munns, etc.

Anna-Mei Chadwick
64 New Kings Road, London SW6 Tel. 01 736 1928
Stocks and sells small editions of prints. Prints on display in bins. Artists include Browne, Stokoe, Aggs, Faull, etc.

Anne Berthoud Gallery
First floor, 10 Clifford Street, London W1X 1RB Tel. 01 437 1645
One man shows by mainly British artists. Stocks prints by Auerbach, Bill, Caulfield, Dine, Hamilton, Jacklin, Phillips, etc.

Anthony Dawson Fine Art
41 Lillian Road, London SW13 9JF Tel. 01 748 1306
Contact Roger Kenney
Deals in all types of orginal prints by living artists. Work is taken on sale or return except in rare circumstances. Printmakers include Adair, Balakjian, Dos Santos, Fairclough, Freeth, Gracia, Jameson, Marchant, Morris, Newcombe, Stokoe, Thornton, Ware, Wight, Winkelman, etc.

Anthony Reynolds Gallery
37 Cowper Street, London EC2 Tel. 01 608 1516
Contemporary European and American artists including Arrowsmith, Breakwell, Head, Miller, Thompson, etc.

Art Lease/The Square Gallery
12 South Grove, London N6 6BJ Tel. 01 340 4983
Contact Harriet Green
Art lease is a business dealing exculsively in print rental schemes to businesses, linked to and operating from the Square Gallery. The gallery itself has changing exhibitions including work by contemporary printmakers. Artists include Plowman, Rothenstein, Neville, Laing, Dover, Rawlinson, Bull, etc.

Austin Desmond
15a Bloomsbury Square, London WC1 Tel. 01 242 4443
Contact David Archer
Contemporary prints by artists including Nicholson, Ravilious, Vaughan, Hayter, Hilton, etc.
Approximately 3 large print exhibitions each year.

Bankside Gallery
48 Hopton Street, Blackfriars, London SE1 9JH Tel. 01 928 7521
Headquarters of Royal Watercolour Society (founded 1804) and Royal Society of Painter-Etchers and Engravers (founded 1880). Educational charity which aims to promote understanding of printmaking and water colour painting. Exhibitions with varying themes. Art event days where artists demonstrate print techniques. Framing service.

Bernard Jacobson Gallery
2a Cork Street , London W1X 1PA Tel. 01 439 8355
Dealers in Abrahams, Auerbach, Denny, Freud, Heindorff, Mclean, Sandle, Smith, Tillyer, Tucker, etc.

Blackheath Gallery
34a Tranquil Lane, London SE3 Tel. 01 852 1802
A contemporary gallery showing oils, sculpture, watercolours and limited edition prints.

Blackman Harvey
36 Gt Queen Street, London WC2B 5AA Tel.01 831 0381
Contact Peter Leigh
Merged with Graffiti in 1984. Majority of business in limited edition prints including Bejamin, Devereux, Clarke, Dingle, Finmark, Marshall, Petersson, Pugh, Taylor, etc. Publishes prints under name of Clarendon Graphics.

Blond Fine Art
25 Commondale, London SW15 Tel. 01 788 0123
Contact J. S. Blond
Twentieth century British painting, drawings, sculpture and graphics. Artists include Bomberg, Gill, Gross, Meninsky, Nash, Williams, Willing, etc.

Boundary Gallery Ltd
98 Boundary Road, London NW8 ORH Tel. 01 624 1126
Modern British masters including Bomberg, Epstein, Kramer, Wolmark, etc. Master graphics by British, American and European artists.

Creaser Gallery
316 Portobello Road, London W10 5RU Tel. 01 900 4928
Contact Judith Groves
Holds in display print bin a regular stock of prints by contemporary printmakers with range of styles, subject matter and process. Holds approximately two print shows per year. Printmakers connected with gallery include Abrahams, Appleby, Jones, Soden, Sykes, Southall, etc.

CCA Galleries Ltd. (Christie's Contemporary Art)
8 Dover Street , London W1 Tel. 01 499 6701
23a Bruton Street,London W1X 7DA Tel. 01 493 7939 (Also in New York & Tokyo)
Founded 1972, CCA Galleries are Europe's leading distributors and publishers of lithographs, etchings, mezzotints and screenprints and feature the work of over 100 established and up-and-coming artists in on-going prints shows in their galleries. Artists include Attard, Bisson, Clarke, Davies, Hamilton Fraser, Jameson, King, Le Kniff, Miller, Penny, Richardson, Sanders, Topolski, Wilkinson and many more. CCA has branches in Oxford, Bath and Farnham.

Curwen Gallery
4 Windmill Street, off Charlotte Street, London W1P 1HF Tel. 01 636 1459
Contact Karol Pawsey
Founded in 1965. Holds a wide selection of graphics (40% of business) including their own lithographic publications in conjunction with Curwen Studio plus editions by other publishers. 2/3 print exhibitions per year. Printmakers include Cheese, Beattie, Boyd Harte, Gentleman, Scott, etc. Recent publications include lithographs by Green, Shiraish, Lim and Beattie.

Eileen Watson's Gallery
63 Sheen Road, Richmond Tel. 01 940 9629
A gallery selling limited edition prints, water colours, old engravings and antiquarian books.

Flowers East
199/205 Richmond Road, London E8 3NJ Tel. 01 985 3333
Contact Jane Hindley
Graphics gallery of Angela Flowers Gallery. Monthly exhibitions of prints. Also agents for gallery artists publishing prints in all media by gallery artists. Runs 'Print of the Month' club which has included Peter Howson's 'Saracen Heads', John Loker's 'Dangerous Games 1&2' and a set of new etchings by Patrick Hughes.

Francis Kyle Gallery
9 Maddox Street, London W1 Tel. 01 499 6870
British artists producing paintings, watercolours, drawings and limited edition prints.
Artists include Boyd Harte, Butler, George, Hogarth, Mynott, Webb, etc.

Hardware Gallery
277 Hornsey Road, London N7 6RZ tel.01 272 9651
Contact Deidre Kelly
Gallery holds a large number of prints on a consignment basis, both national and international work. Endeavours to show print in its own right i.e. not simply as an adjunct to painting and scuplture. Holds 4-8 print shows a year. Includes works by Sykes, Wyllie, Hendry, Wray, Mathelin, Goddard, La Nave, Miller, Lewandowski

London Contemporary Art
132 Lots Road London SW10 Tel. 01 352 7694
Contact A. Stancomb
Publishers and gallery for print exhibitions held every 2-3 months. Holds work of approximately 25 printmakers including Bisson, Jameson, Dodsworth, Woodard, Eastham, Byrne, etc.

Louise Hallett Gallery
27 Junction Mews, Sale Place, London W2 Tel. 01 724 9865
Monthly exhibitions of twentieth-century and contemporary art including prints by artists including Medley, Moore, Burns, Jones, Hockney, Hayman, McLean, etc.

Lumley Cazalet Ltd.
24 Davies Street, London W1 Tel. 01 491 4767
Specialises in orginal prints by twentieth-century masters including Braque, Chagall, Frink, Hockney, Klee, Matisse, Miro, Moore, Picasso. Also selection of prints by young artists of many nationalities.

Marlborough Graphics
39 Old Bond Street, London W1 Tel. 01 629 5161
Post 6 Albermarle Street London W1X 4BY
Contact Alexandra Wettstein
International gallery marketing prints by gallery artists. Continuous print exhibitions. Artists include Auerbach, Bayer, Chadwick, Davies, Freud, Hepworth, Jacklin, Jones, Kitaj, Kossoff, Moore, Motherwell, Nolan, Paolozzi, Pasmore, Piper, Rego, Tilson, Winner.

Medici Galleries
7 Grafton Street, Bond Street, London W1 Tel. 01 629 5675
Retail galleries for Medici Society Ltd. (Headquarters 34-42 Pentonville Road, N1 9HG Tel. 01 837 7099). Oils, watercolours, prints, limited edition graphics, postcards, greeting cards, etc. Kensington branch : 26 Thurloe Street, London SW7 Tel. 01 589 1363.

The New Academy Gallery & Business Art Galleries
34 Windmill Street, London W1P 1HH 01 323 4700
Contact Martha Alleguen
This gallery stocks and occasionally publishes good quality contemporary prints in any media plus monoprints. Holds print exhibitions twice annually but include prints in mixed media shows. They like to see new printmakers who are asked to send slides or leave portfolio before 11am and collect it after 3pm any weekday. Stock work by over 200 printmakers including Piper, Pasmore, Cox, Mynott, Trevelyan, Schnever, Plowman, Mclean, Irvin, Grant, Frink, Barker, etc.

Nigel Greewood Inc
4 New Burlington Street, London W1X IFE Tel. 01 434 3795
Stocks contemporary prints. Contemporary artists include Baxter, Beckley, Chia, Clemente, Chaimowicz, Donagh, Fisher, Le Brun, Immendorf, Setch, Walker, etc.

Petersburg Press
59a Portobello Road, London W11 3DB Tel. 01 229 0105
Works by Caulfield, Clemente, Hockney, Hodgkin, Johns, Jones, Kitaj, Roth, Stella, Tobey, etc.

Pomeroy Purdy Gallery
Jacob Street Studios, Mill Street London SE1 2BA Tel. 01 237 6062
Contact Richard Pomeroy and Jane Purdy
This gallery holds occasional individual print shows and includes prints in their mixed media shows. Hold work by young British artists including Thompson, Lowe, Di Stefano, Long, etc. Interested in monoprints.

Print Gallery
17 Newburgh Street, London WIV ILE Tel. 01 439 1530
Contact Terry Caddick
Prints on sale-or-return only. No exhibition facilities. Stocks work by Hartil, Caddick, Carlo, Thornton, Williams, Lewington, Veroni, Matchim, Wade, Bisson, etc.

Railings Gallery
5 New Cavendish Street, London W1M 7RP Tel. 01 935 1114
Limited edition original prints and paintings.

Redfern Gallery
20 Cork Street, London W1 Tel. 01 734 1732 /0578
Contact Raymond Lokker or Richard Gault
This gallery deals in late nineteenth- and twentieth century master prints but is also interested in contemporary prints which it actively deals in. Lower gallery houses an active print department. Twice yearly print exhibitions. Artists include Procktor, Irwin, Kowalsky, Rothenstein, Evans (deceased), Stevens (deceased).

Regatta
48 Hill Rise, Richmond, Surrey Tel. 01 940 9143
Contact Gina Holland
Gallery stocked with bought prints. Interested to see any professional printmaker. No exhibitions of work, simply continuous stock exhibited. Includes work by Fraser, Piper, Carlo, Ware, Evernden, Greenhalf, Millington, Wilkinson, Gorg, Beer, Ford, etc.

Saga Scandanavian Art Ltd.
3 Elystan Street , London SW3 Tel. 01 584 5684
Contact Anita Dalen or Elisabeth Hartmann-Kraft
This gallery deals in contemporary Scandinavian prints only. Twice yearly print exhibitions. Holds stocks of approx imately 60 Scandinavian artists.

Seen Galleries
8 Frederic Mews, London SW1 Tel. 01 245 6131/2
Contact Jeffrey Sion
This gallery has strong retail and corporate print sales, also publishers and distributors of limited edition prints.

Tessier Galleries
226 Blythe Road London W14 OHH 01 602 8522
Contact Guy Thompson
This gallery deals in original prints by around 25 exclusive gallery artists. They publish work and sell to other galleries, designers as well as the public. Monthly print exhibitions. Original prints including Bardone, Charoy, Laporte, Ting, Toffoli, Weistuck, Wray, etc.

Thumb Gallery
38 Lexington Street, London W1X IPA Tel. 01 439 7319
Contact Jill George

Specialises in paintings, drawings, watercolours and limited edition prints by contemporary British artists. Leave prints in print bin or exhibit in Gallery Two. Print show once a year but includes prints in mixed shows. Has a large stock of quality limited edition prints by British artists including Davies, Avialiotis, Barker, Cole, Hughes, Neiland, Orr, Pollock, Mara, Ota, Feldman, Cheese, Zanoni, etc.

Vortex Gallery
139-141 Stoke Newington Church street, London N16 Tel. 01 254 6516
Limited edition prints, jazz venue, secondhand books, artists' supplies, post cards, frames, etc.

Waddington Graphics
4 Cork Street, London W1X 1PA Tel. 01 439 1866
Contact Alan Cristea
Founded 1957. Dealers in modern and contemporary prints. Publishers of contemporary prints. Dealers in twentieth-century Livres Illustrés. Holds monthly print exhibitions. International artists include Baselitz, Bonnard, Buckley, Chagall, Clemente, Dibbets, Dine, Dunham, Francis, Giacometti, Heron, Hodgkin, Inshaw, Jones, Leger, Longo, Mansen, Matisse, Moon, Motherwell, Munch, Oldenburg, Penck, Picasso, Rauschenberg, Rothenberg, Schnabel, Tilson, Walker, Wesselman, etc.

William Weston Gallery Ltd
7 Royal Arcade, Albemarle Street, London W1 Tel. 01 439 0722
Specialist dealer in drawings, etchings and lithographs of nineteenth and early twentieth centuries. Catalogue available.

Woodlands Art Gallery
90 Mycenae Road London SE3 7SE Tel. 01 858 4631
Mixed exhibitions including original prints.

Zella 9
2 Park Walk Road, London SW10 Tel. 01 351 0588
Contact Mrs Mozella Gore
Founded 1971. Specialist in British limited edition prints. Holds continuous print exhibitions and likes artists to call in with their portfolios anytime Monday-Friday between 10-5pm. Holds stocks of 292 printmakers' work (!) including Browne, Brunsdon, Fairclough, Greenhalf,Grogor, Handsen, Jackson, King, Martin, Piper, Richecouer, St Clair Miller, Thornton, Whittle, etc.

Art to businesses

This is a growing field with an increase in galleries and dealers that direct their major marketing to specifically to businesses (i.e. corporate sales). Several have print loan schemes. A selection of these galleries who also handle prints includes :

Art for Offices and Contemporary Art Ltd
15 Dock Street, London E1 Tel. 01 481 1337
Comprehensive range of oil paintings, watercolours, sculpture, tapestry, photography and limited edition original prints, both abstract and figurative.

Art Lease/The Square Gallery
12 South Grove, London N6 6BJ Tel. 01 340 4983
Contact Harriet Green
Art lease is a business dealing exculsively in print rental to businesses, linked to and operating from the Square Gallery.

Business Art Galleries & New Academy Gallery
34 Windmill Street, London 1P 1HH Tel. 01 323 4700
Contact Martha Alleguen
Contemporary British painting, sculpture, original prints and textile works. Also offers a comprehensive art service to businesses including advice on purchase, special commissions and hiring schemes.

CCA Galleries Ltd
8 Dover Street, London W1X 3PJ Tel. 01 499 670
Print consultancy to business; clients include not only major multi-nationals but also small businesses and professional practices.

The Corporate Arts Ltd
23 Cavaye Place London SW10 Tel. 01 370 7427
Contact Sarah Hodson, Managing Director
Specialises in tailor-made art exhibitions in company offices.

Lynne Stern Associates
15 Albermarle Street, Picadilly, London W1X 3 HA Tel. 01 491 8905/6
Contact Rebecca Ruff
Specialise in assisting business and professional firms (and collectors) on all aspects of their acquisition, hire, commissioning and other links with contemporary fine art. They hold a wide range of prints in stock on a sale or return basis which vary in style and price. They hold mixed exhibitions of prints with other media,e.g. painting and sculpture. Prints held by gallery include Blackadder, Caulfield, Dunstan, Davie, Freeth, Frink, Frost, Gentleman, Grant, Hartill, Heron, Hoyland, Irvin, Jones, Loker, Mynott, Procktor, Rothenstein, Tillyer, Trevelyan, Wilkinson etc. plus many younger artists.

PRINT PUBLISHERS, DEALERS AND AGENTS

This section is a collection of fine art, original print dealers, publishers and agents. They exist with varying aims and productions. The first section is London based and is listed alphabetically. Dealers outside London are listed alphabetically by country and town .

ENGLAND
London

Advanced Graphics
Faircharm c103, 8-12 Creekside, London SE8 3DY Tel. 01 691 1330
Contact Chris Betambeau, Robert Saich or David Wood
Publications include 'The London Suite', plus work by Andrea Tana and future publications with Eduardo Paolozzi. Advanced Graphics is aslo a print studio and work for galleries includes prints by John Walker, Albert Irvin, Trevor Jones, John Kean, Katie Whitehead, etc.

Anderson O'Day
5 St Quintin Avenue, London W10 ENY Tel. 01 969 8085
Gallery address 255 Portobello Road, London W11
Contact Don Anderson
Publishers of and dealers in original, limited edition prints. Artists include Ackroyd, Allen, Bonnell, Carlo, Daveywinter, Deiderfield, Griffin, Matcham, Matthews, Neiland, Smallman, Wilkinson, etc.

Andrew Dickerson
129 Kennington Road, London SE11 6SF Tel. 01 587 1016
Publishers of work by Edwards, Miller, Millington. Dealers in original graphics by Hockney, Dine, Hamilton, Caulfield, Procktor, Abrahams, etc. Telephone before calling.

Angela Flowers
11 Tottenham Mews, London W1 Tel. 01 637 3089
Contact Angela Flowers, Matthew Flowers or Jane Hindley
Works in stock by Abrhams, Blake, Boshier, Breakwell, Burra, Clough, Farrell, Hepher, Hockney, Hunter, Irvin, Jacklin, Kanowit, Mara, Marchant, Mclean, Miller, Newsome, Phillips, Stevens, Thubron, Tillyer,etc. Runs 'Print of the Month' Club publishing prints by gallery artists. See also Flowers East.

Anthony Dawson
41 Lillian Road, London SW13 9JF Tel. 01 748 1306
Approximately 50% of business as dealer and publisher of fine art original prints.
Includes work by Adair, Balakjian, Barker, Dos Santos, Fairclough, Freeth, Gracia, Gross, Liao, Marshall, Munns, Stokoe, Taylor, Willson, Wyllie, etc.

Belgravia Contemporary Arts Ltd
8 Frederick Mews, off Kinnerton Street, London, SW1 Tel. 01 245 6131/2
Contact: Jeffrey Sion
Publishers and distributors of fine original limited edition prints

Bernard Jacobson Gallery
2a Cork Street, London W1 Tel. 01 439 8355
Publishers of work by Abrahams, Auerbach, Denny, Heindorf, Herman, Hodgkin, Kossoff, McLean, Paul, Smith, Ruscha, Tillyer, etc.

Campbell Fine Art
6 Nightingale Square, London SW1Z 8QN Tel. 01 673 1136
Contact Michael Campbell
Dealers in rare and original British and European prints, eighteenth to twentieth centuries. Artists include Austin, Cameron, Flint, Griggs, Knight, McBey, Sutherland, Webb, Whistler, etc. By appointment only.

CCA Galleries plc
8 Dover Street, London W1 Tel. 01 499 6701
CCA Galleries plc are Europe's leading publishers of lithographs, etchings, mezzotints and

screenprints featuring the work of over 100 established and up-and-coming artists. CCA commissions 200 new editions of original prints by up to 80 artists to form their annual collections.

Chelsea Prints
Chelsea School of Art, Manresa Road, London SW3 6LS Tel. 01 376 4661
Contact: Tim Mara, Silvie Turner
Commissions and publishes editions from contemporary international artists in association with their galleries and Chelsea School of Art. Artists include Paolozzi, Kiff, Faulkner, etc.

Circle Press
26 St. Luke's Mews, London W11 1DF Tel. 01 792 9298
Contact Ron King
Prints and publishes fine art books, limited edition prints, poetry and pamphlets by Ackroyd, Boyd, Christie, Furnival, Greaves, Hayter, Kent, Kidner, King, Legge, Maitin, Peel, Phillips, Reynolds, Skiold, Tillyer, Tyson. Workshop facilities for screenprinting, etching, lithography and letterpress for use by artists, poets and designers working on projects for Circle Press. Recent production includes 'The Left-Handed Punch' by Roy Fisher and Ron King.

Clarendon Graphics
36 Gt Queen Street, London WC2B 5AA Tel. 01 836 1904
Contact David Meldrum
Fine art original print publisher trading exclusively in prints. Publishes works by Benjamin, Bowyer, Dingle, Finmark, Hughes, Ingermalls, Marshall, Pettersson, Pugh, Taylor, etc.

Coriander Studio
Unit 4, 7-11 Business Centre, Minerva Road, London NW10 6HJ Tel. 01 965 8739
Contact Brad Fayne
Screenprinting studio which publishes artists' prints. Abrahams, Battye, Benjamin, Chopin, Fayne, Hughes, Johnson, Loker, Miller, McLean, Neilands, Richardson, Stevens, Thubron, Wilson, etc.

Culford Press
151 Culford Road, De Beauvoir Town, London N1 4JD Tel. 01 241 2868
Contact Paul Coldwell
Printworkshop that publishes annual portfolio of prints including work by Coldwell, Hodes, Stahl, Hatt.

Curwen Gallery
4 Windmill Street, off Charlotte Street, London W1P 1HF Tel. 01 636 1459
Contact Karol Pawsey, Gallery Manager
Gallery linked to Curwen Studio. Publishes and deals in contemporary artists prints including work by Beattie, Scott, Moore, Hepworth, Richards, etc. Recently published lithographs include works by Green, Shiraishi, Lim, Beattie, etc.

Desmond Page Ltd
28 Eldon Road, London W8 Tel. 01 937 0804
Private dealer who also trades in sculpture, paintings and drawings. Contact by appointment only. Artists include Auerbach, Buckley, Bomberg, Hamilton, Hodgkin, Hockney, Judd, Kossoff, Freud, Nicholson, Scully, Woodrow, Picasso, etc.

Editions Alecto Ltd
46 Kelso Place, London W8 5QG Tel. 01 937 6611
Directors J. G. Studholme, The Hon. Robert Erskine, L.E. Hoffman, Rachel Studholm,
Present publications include The Great Domesday Book, Banks' Florilegium, Birds of America, etc.

Flowers East
199 Richmond Road, London E8 3NJ Tel.01 985 3333
Contact Jane Hindley
Publisher and dealer in prints. Publishes gallery artists. Work in stock by Abrahams, Blake, Boshier, Breakwell, Burra, Clough, Farrell, Hockney, Hunter, Irvin, Jacklin, Kanowitz, Mara, Marchant, McLean, Phillips, Stevens, Thubron, Wererka, etc. Print of the month publishing scheme.

Garton & Cooke
1st Floor, 39-42 New Bond Street, London W1Y 9HB Tel. 01 493 2820
Contact Ursula Thompson
Nineteenth- and twentieth- century British and European original print dealers and book publishers. Published works by Holland, Drury,Tanner, Nash. Dealers in Nash, Ravilious, Whistler, Palmer, Meryon, Hermes, Gross, Lumsden, etc.

Julian Lax
Flat J, 37-39 Arkwright Road, London NW3 6BJ Tel. 01 794 9933
Print dealer in modern British (e.g. Nash, Nevinson), contemporary British (e.g. Hockney, Piper, Frink), and modern European (e.g. Picasso, Miro, Matisse). No gallery space. Only established artists.

London Contemporary Art Ltd
132 Lots Road, London SW10 ORJ Tel. 01 351 7696
Contact Tracey Kehoe
Original print publishers, corporate art consultancy, retail gallery and printing studios. 95% of business is in contemporary graphics and also sell originals on behalf of in-house artists. Artists connected with gallery include Andrews, Agbo, Baker, Bisson, Bolch, Bull, Bryne, Durant, Everbden, Hewitt, Hussey, Jameson, Livingstone, Mathews, McNulty, etc. Recent projects include a new corporate consultancy 'Art in Industry' project and recent opening of new gallery as part of Lots Road complex.

Marlborough Graphics
39 Old Bond Street, London W1 Tel. 01 629 5161
Dealers in and publishers of international graphics.

New Academy Gallery & Business Art Galleries
34 Windmill Street, London W1P 1HH Tel. 01 323 4700
Contact Martha Alleguen
Publishers of and dealers in contemporary graphics. Recently published works by Mynott, Green, Dunstan, Corselis, Taylor, Watson, etc.

Petersburg Press
59a Portobello Road, London W11 3DB Tel. 01 229 0105

Redfern Gallery
20 Cork Street, London W1 Tel. 01 734 1732/0578
Nineteenth and twentieth century master prints. Publish work by Andrews, Slight, Gill, Hockney, Jones, Moore, Nash, Power, Prockter, Stevens (deceased), Vaughan, Wadsworth (deceased).

Tetrad Press
Hega House Studio, Ullin Street, London E14 Tel. 01 515 7783
Contact Ian Tyson
Publish works by Tyson, Greaves, Breakwell, Farrer, Hugonin, Honegger, etc.

Thumb Gallery
38 Lexington Street, London WR 3HR Tel. 01 439 7319
Contact Jill George
Print publishing and dealing accounts for approximately 25% of business. Publishes and represents Aivaliotis, Barker, Cheese, Cole, Davies, Hughes, Mara, Neiland, Orr, Pollock, Zanoni, etc.

Tricorne Publications
27/29 New North Road, Hoxton, Hackney, London N1 6JB
Contact Michael Taylor or Graham Bignell
Tricorne Publications incorporates four separate studios - Hope Sufference Studios, Paupers Press, New North Press and Lizzie Neville Bookbinding. It aims to promote and publish artists' books and portfolios of prints. Artists include Marsh, Scott, Gray, O'Donahue, Hambling, Faulkner, Hughes, etc.

Waddington Graphics
4 (Also 11)Cork Street, London W1X 1PA Tel.01 439 1866
Contact Alan Cristea
Waddington galleries also deal in paintings, drawings, sculpture as well as prints. See galleries list for associated artists. Recent projects include prints by Roy Lichtenstein, Frank Stella, Jim Dine, Robert Motherwell and Howard Hodgkin.

Regional Print Publishers

Cambridge **Chilford Hall Press**
Chilford Hall, Balsham, Cambridge Tel. 0223 893544
Contact Kip Gresham
Active print workshop which aslo publishes and deals in contemporary original prints by Kindersley, Cardozo, Frost, Blumenfeld, Bulmer, Loizou, Steen, Sutton, Sorel, Potter, Gresham, Mi'Batma, Watson, Moore, etc. Recent projects include editions for Frink and monotypes for Elstein.

Ightham **Retigraphic/ Pratt Contemporary Art**
The Gallery, Ightham, Sevenoaks, Kent TN15 9HH Tel. 0732 882326
Publishers of limited edition screenprints and etchings. Artists include Bäckstrom, Beck & Jung, Bloomfield, Chaplin, Davies, Grater, Jaworska, Krokfors, Pacheco, Soderqvist, Warren, Wilde, etc.

Lowick **Lowick House Printworkshop**
Lowick, Nr Ulverston, Cumbria LAIZ 8DX Tel. 0229 85 698
Contact John and Margaret Sutcliffe
Printworkshop that also publishes prints exclusively, including works by Bryne, Stevens, Forster, Wilkinson, Jennings, Sutcliffe, Rugg, Norton, etc.

Lyndhurst	**White Gum Press**

Lyndhurst **White Gum Press**
Fleet Water Farm, Newtown Minstead, Lyndhurst, Hants SO43 7GB Tel. 0703 812273
Contact Katie Clemson
Original print publishers of relief prints through White Gum Press. UK agent for several West Australian artists. Published portfolio of 15 prints from West Australia titled 'Western Sight' including works by Haynes, Dudin, Snell, Lefroy, Davis, Hobbs, Oldham, Kisop, etc.

Newcastle **Charlotte Press (formerly Northern Print)**
5 Charlotte Square, Newcastle NE1 4XF Tel. 0632 327531
Printworkshop that publishes prints.

Richmond **Regatta**
48 Hill Rise, Richmond, Surrey 01 940 9143
Contact Nick Buchan or Gina Holland.
Printers and publishers of silkscreens. Young, recently established company, producing small editions by talented newcomers.

SCOTLAND
Aberdeen **Peacock Printmakers**
21 Castle Street, Aberdeen AB1 1AJ Tel. 0224 639539
Contact Arthur Watson
Active print workshop and gallery that publishes artist's prints

Edinburgh **The Printmakers Workshop**
23 Union Street, Edinburgh EH1 3LR 031 557 2479
Contact Robert Livingston or Susan Williams
Busy printworkshop which also runs in-house publishing. Sales of prints total 50% of income of studio (excluding grants). Also offers framing and mounting services. Co-published Festival Folios of prints with a wide range of Scottish artists and also collaborated with Angela Flowers Gallery in Peter Howson's 'Saracen Heads'. Published artists include Bellany, Howson, Rae, Ainsley, Currie, McIntyre, Gear, Woszniewki, Hardie, etc. Also holds print stocks of members' work on display including Bytautas, Crozier, Tyson, Donald, Polley, etc.

Glasgow **Glasgow Print Studio**
22 King Street, Glasgow G1 1EJ Tel. 041 552 0704
Contact John Mackechnie, Director
Another very active Scottish workshop and gallery that publishes prints including work by Blackadder, Campbell, Gonzalez, Hansen, Harley, Forbes, Houston, Howson, Low, McCulloch, McLean, Miller, Wilson, etc.

WALES
Cardiff **Seventhwave**
38 Penarth Road, Cardiff CF1 5DP
Contact Vicki Cornish
Vicki Cornish is an artist who has recently set herself up as a publisher to publish and market prints by herself and other artists.

CONTRACTS FOR SELLING PRINTS

What is a contract?

A contract is an agreement between two or more people that a "state of affairs" exists and that each person involved in the agreement has various obligations arising out of that agreement. In order for a contract to be legally enforceable, there must be an offer from one party (e.g. buyer Mr Smith) and an acceptance of that offer by another party (e.g. printmaker Susan Dean) and the subject matter must be definite or capable of being defined. When Mr Smith says "I will buy it" a contract is legally concluded and binding and if either person breaks their obligations, they could be sued for breach of contract.

Types of contract

Verbal contract

It is possible to sell work with or without a written contract of sale. If an artist receives money from a sale without any exchange of bills, it is called selling by verbal contract. If discussion takes place about a particular detail e.g. whether the price of the frame is included or that a piece of Selotape collaged to the print might

deteriorate with time, this specific agreement overrides the general law. But if nothing is said or written down the law imposes the following obligations on an artist who sells his work by verbal contract :

1 To sell the work to the buyer
2 To deliver the work to the buyer
3 To allow the buyer to alter, damage or destroy the work provided such alteration, damage or destruction is not a distortion or mutilation of the work or prejudicial to the artist's reputation.
4 To allow the buyer to reframe the work
5 To allow the buyer to restore and conserve the work without prior consultation
6 To pay the buyer cost of restoration/conservation necessitated by unreasonable deterioration of the work
7 To allow the buyer to exhibit the work anywhere in the world, under any circumstances
8 To allow the buyer to sell or give the work to any individual or organisation
9 To allow the buyer to prevent anyone seeing the work, including the artist

The only obligation which the buyer undertakes in a verbal contract is to pay the purchase price to the artist.

Bill of sale/invoice/receipt

To circumvent the obvious dangers of verbal contracts, a bill of sale should be used when selling work. It need not be a formal document in order for it to be accepted legally; an exchange of letters is fine. The bill of sale should contain the following points :

1 Name and address of artist
2 Name and address of buyer
3 Title, medium, edition number, etc. of work
4 Description of work
5 Selling price (state whether inclusive or exclusive of VAT)
6 Terms of payment
7 Who owns copyright (i.e. whether copyright is included in sale price)
8 Whether artist is to have the right of first refusal to repair the work if it should become damaged
9 That the artist hereby accepts his right to be identified as the author of work
10 Date of sale
11 Place of sale
12 Signatures of artist and buyer

Sale-or-return

Prints left on consignment with a gallery indicate that the artist is not selling outright to the gallery but merely leaving them in the gallery for sale. (See Chapter 2, Pricing Prints, p. 62.) The basis for leaving work with any gallery should be discussed thoroughly first (see list below) and then written out in duplicate with a copy for the gallery and for the artist. It should be signed by the artist and the gallery at the time of sending or delivering works to the gallery.

1 Name, address and telephone number of artist
2 Name, address and telephone number of gallery
3 Date
4 Full description of print(s) including title, process, size, edition number(s), framed or unframed, plus confirmation of perfect condition
5 Retail price plus details of VAT, inclusive of frame or not
6 Rate of commission that gallery will deduct from retail price on the sale of the print/s plus VAT deductions made clear.
7 Time when payment will be made to artist (i.e. at end of every month, three months, etc.) The print remains the property of the artist until the artist has

received all the monies owing under this agreement, in which case the ownership of the print passes to the buyer.

8 Length of time the gallery will keep the print/s available for sale; discussion of replacement and removal of prints when time limit lapses.

9 Agreement for gallery to contact artist if gallery uses print for display outside the gallery premises (e.g. in another exhibition).

10 The liability for damage, loss or theft of print in gallery care (e.g. gallery agrees to look after the work and inform the artist immediately any loss or damage occurs to prints and not to make repairs without consent of artist).

11 The artist hereby accepts his right to be identified as the author of the work(s).

12 An exchange of any change of addresses.

Commissions

In the print field, a commission usually means a contract for the making of a special print for a particular publisher, although printmakers are also commissioned to make murals, sculptures, etc.

If the artist is approached directly by the commissioner, it is his own responsibility to discuss the commission, see that contracts are set up, read, corrected if need be, signed and then to complete and deliver the work.

If a printmaker approaches a gallery with either drawings or proofs of new prints which are uneditioned then the publishers/commissioner may wish to buy them directly from the artist. This is not a full commission but as an edition is commissioned from the drawings/proof, the following guidelines may apply.

When an artist accepts a commission, it is necessary to make a timetable with definite dates and keep to it. Note that in a commission, regard should be paid to the commissioner's right to reject the completed work. If the commissioner requires this right it is best to be stated but the agreement could be structured for approval of work at various stages to avoid unnecessary rejection.

It is usual in commissions for the copyright to be owned by the commissioner although the law is changing (See Chapter 3, Copyright and prints, p.85).

Stages in a commission

When approached directly to make a print, you will need answers to the following questions: What is the commission to be used for ? What are the limitations ? How much time have you to complete it ? What does client expect ? What is the budget ? How much will the various stages be allocated in terms of the budget ? The amount of a rejection fee ? Discuss VAT. Who will print the edition ? Who will be the final owner ?

After the initial discussions, the second stage is the visual presentation of the proposed idea. This can take the form of a drawing, sketch or proof. At this stage also you may wish to be paid for the preparation work and draw up a contract for the making of the commission.

The third stage is the realisation or production of a BAT (see Chapter 2, Terms and marks on prints, p.52) that is agreed by both parties, i.e. artist and publisher.

The commissioners may then wish to take over the plates and produce the edition themselves, i.e. send it to an editioning studio. In some cases the commissioner may ask the artist to produce the edition him/herself, an option which is cheaper than using an editioning studio. It is not wise for the artist to agree to produce an edition of 200 copies if perfect print quality cannot be guaranteed on each print. For many artists producing the edition themselves is a time-consuming and difficult task and a waste of valuable time and effort, especially if a large edition (e.g. an

etching of 200 copies) is being produced; the problems of printing and drying are far better left to a professional studio than risking delivering a print that is, for example, not quite dry and consequently cockles in the frame, etc.

The final stage is the finishing, signing of the edition and delivery to the publishers. If the editioning has been done at an editioning studio, they will simply ask you to go and and sign on a particular date. They will then be responsible for delivery to the publishers.

In the case of an artist approaching a publisher with a drawing or proof for the commissioning of an edition, the same questions will need clarification. The stages will be the same, i.e. 1 Initial sketches or proofs, 2 Agreed BAT, 3 Editioning, 4 Delivery to publishers.

It is usual in a print commission for the commissioners to own the plates.

Payment schemes differ in many galleries. Talk to other artists before accepting the first offer you are made. For an agreement that is understood by both artist and the dealer/gallery, the following points should be thoroughly discussed and written down to avoid future conflict :

1 Identity of commissioner
2 Date for beginning and completion of work
3 Preliminary designs/sketches/proof
4 Proofing and agreement of BAT
5 Editioning, numbers and a/p's
6 Time schedules of 3, 4, 5 above
7 Scale of fees i.e. per print/per hour/per completion of section?
8 Terms and times of payment
9 Who owns/wants copyright - discuss infringements (Note new copyright law)
10 Delivery to whom and when of 3, 4, 5 above
11 Commissioner's right to terminate a contract or reject work

CCA Galleries in London are one of the biggest and most successful commissioners/buyers of print editions. Because of their highly efficient marketing structure, they have devised systems to suit both artist and dealer. It has become customary to document every print in their editions and consequently the artist's proofs are editioned in Roman numerals to allow public/dealer/artist to know exactly how many prints exist. Three extra insurance copies, unsigned and uneditioned, are often made to allow for damage (and consequent loss of revenue) in the CCA Galleries market that depends on mailing.

Problems with contracts

Before a dispute arises, it is wise to enter a clause in any agreement that an agreed third party will arbitrate and settle the dispute. All contracts should be read by an outside, knowledgeable person, preferably a specialist solicitor. If at any stage in your contract making something goes wrong, or even if you simply feel unsure about what you are doing or who you are dealing with, do not ignore your misgivings; seek advice from your local RAA, nearest printworkshop, fellow printmakers or a sympathetic, specialist solicitor.

FURTHER READING *Working to Commission - A Practical Guide for Craftsmen and Women* London, Crafts Council 1983
Refer also to 'Artlaw' articles by Henry Lydiate in *Art Monthly*
Artists Newsletter ' Aspects of Commissioning' June 1984

COPYRIGHT AND PRINTS

What is copyright?

Copyright is a property right and the right of the artist to prevent other people copying his/her work without the permission of the artist.

Protection of prints in copyright law

The Copyright Act 1956 is the current legislation which affords prints copyright protection, as at the time of writing this handbook. However reference must also be made to the new legislation covering copyright and other similar matters contained in a new copyright act namely the Copyright, Designs and Patents Act 1988 which received Royal Assent in November 1988. The provisions of the 1988 Act will be brought into effect by the Secretary of State by means of statutory instruments save for five sections which came into force on receipt of the Royal assent.

The provisions of the 1956 Copyright Act are therefore still applicable for most purposes until the provisions of the 1988 Act are brought into effect. It is therefore proposed to first explain the salient points of the 1956 Act in relation to prints and then to deal with the said provisions in the 1988 Act.

The Copyright Act 1956 gives copyright protection to 'artistic works' which it is stated to include 'engravings'. These are defined as including 'any etching, lithograph, woodcut, print or similar work not being a photography'. This definition causes problems for many printmakers who use a combination of the traditional printmaking methods and photographic processes. Each print must therefore be judged on its own merit and the practice that has developed amongst most printmakers for deciding whether the professional printmaker regards the final product as a print even if photographic and other processes may have been used in its making. This distinction is important under the 1956 Act as different rules apply for prints and photographs with regard to the length of ownership of copyright.

Under the 1988 Act the provisions relating to engravings have been radically altered. Artistic Works are defined to include 'engravings' and their treatment under the new act is the same as other artistic works regarding the period of copyright and ownership of the first copyright.

Ownership of copyright in prints

Under the 1956 Act, the creator is the first owner of copyright in all artistic works except in commissioned engravings and those executed by an employee. However under the 1988 Act the first owner of copyright even in commissioned work is *the artist* unless he/she is an employee in which case the 1956 rules still apply, i.e. the employer is the first copyright owner.

Length of copyright protection

Under the 1956 Act, the length of copyright protection depends on whether the print has been published. Exhibition of the print to the public does not constitute publication but issuing reproductions of the print to the public does. For example : The offering for sale of a limited numbered edition of one hundred screenprints is not publication but the offering for sale of one hundred postcard reproductions of the print is a publication. The difference between the two instances cited above is that each numbered print in the first case is an original work even though each print is derived from the same block or screen. In the case of the postcards however the postcard reproductions are copies of the original print.

Summary of copyright rules

Unpublished prints
Copyright protection lasts forever if the print is never published.

Prints published after the creator's death
If the prints are published during the creator's lifetime, the period of protection is the creator's lifetime plus fifty years after his death (starting at the end of the calendar year in which the creator dies) e.g. work made 4 July 1982; creator dies 4 January 1985; copyright runs from 4 July 1982 to the 31 December 2035. On the 1 January 2036, the copyright protection ends.

Commissioned prints
If the commissioner and artist make no agreement as to the ownership to copyright before the print is made, then the law makes the commissioner the first copyright owner under 1956 Act, but under 1988 Act, the artist is the first owner of copyright unless he/she is an employee. (See Chapter 3, Commissions, p.82)

Uncommissioned prints
The first copyright owner of an uncommissioned print is the artist. The first owner of copyright acquires the legal right to prevent anticipated infringements or indeed to authorise acts (usually for a fee) which would otherwise be infringements.

Infringements of copyright

The restricted acts and exceptions to them are the same as for portrait paintings under the 1956 Act and all of the artistic works under the 1988 Act. Some artists and buyers believe that to sell or give away a work automatically transfers copyright to the recipient of the work. Copyright can only be sold or given away if the 'assignment' (transfer of copyright) is made in writing and signed by the copyright owner. Most artists do not sell or give away their copyright when they sell or give away their work. It is a valuable asset, and should therefore be treated by artists as important personal property even to the extent of making provision for it to be left in their wills.

However, artists (during the artist's lifetime) and their heirs or legatees (after death) may give permission for works to be reproduced, published, filmed or broadcast, usually for a fee. This valuable source of income for artists involves the granting of a copyright licence to the would-be user of the image - please note, that a copyright licence is not an assignment/transfer of the copyright which would remain with the artist even after a licence is given for a limited purpose.

Moreover, and more obviously common knowledge, the copyright owner may take action against would-be or actual users of the copyright image who do not obtain permission .

International protection

In order to gain international copyright protection the artist must place the international copyright symbol on his/her work. The symbol comprises the following

© Artist's name and the year of creation of the work.
For example © Jonathan Ryder 1989

The length of the period of copyright protection of a British artist's work in another country will depend on the internal laws of that country. However, it can be said that in most European countries and other countries which are signatories to the Berne Convention, the British artist will receive copyright protection for his/her work in that country for the period of copyright given according to the country's internal laws or the period given under English law whichever is the lesser.

Some questions answered

Q. *Does the signature of the artist on an original print indicate his copyright of that print?*

A. If the signature of the artist is not accompanied by © (the international copyright symbol) the signature does not indicate the artist's copyright in that print. If the print was commissioned the copyright in it belongs to the commissioner subject to what has been said above. As it is possible for the artist and commissioner to vary this rule, the presence simply of the artist's signature does not indicate conclusively that he is the copyright owner.

Q. *What is the effect of a signature on artistic work?*

A. The signature will indicate the artist of the work but does not determine who owns the copyright which will depend on whether or not it has been commissioned subject to what has been said above.

Q. *How long does the copyright of an unpublished original print last?*

A. Indefinitely. If,however, it is published during the artist's lifetime copyright will last the lifetime of the artist and fifty years from the end of the year in which the artist died. If the print is published after the artist's death copyright will exist for fifty years from the date of publication.

Q. *Can copyright be taken away from the legal holder?*

A. Yes, in cases such as bankruptcy where the copyright holder has become bankrupt.The new owner can then use the copyright licence to gain income to pay off debts.

Q. *Clarify the current position of copyright - isn't it undergoing change?*

A. It is correct that various changes to the existing copyright law have been made. It is proposed to abolish the unlimited term of copyright and impose a provision that most unpublished works will attract a term of copyright of the life of the artist plus fifty years from the end of the year in which the artist died as is the normal provision under the current law.

Q. *What is droite de suite?*

A. This is the percentage fee that is paid to the artist of the difference between the original sale price and the new sale price (i.e. a percentage of the profits) and generally applies to public sales only, e.g. auctions. The government has not introduced droite de suite although the UK agreed in the Berne Convention to do so. The EEC is concerned to harmonise this throughout Europe and failure on part of the government to enact this is causing disruption of the European markets.

Q. *What are Moral rights?*

A. They are :

1 The right of the artist to be identified as the author of his/her work subject to the assertion of that right.
2 The right of the artist to object to derogatory treatment of his/her work, i.e. distortion or mutilation of the work or treatment that is prejudicial to the honour or reputation of the artist.
3 The right not to have a work of art falsely attributed to the artist as author.

Q. *Should an artist register a design or a piece of work?*

A. Under the law of the United Kingdom registration of a work is not required as a condition for obtaining copyright or enforcing the rights given by the law of copyright. The Copyright Act 1956 automatically confers copyright on artistic works, and artists can therefore protect their works from being plagiarised without the need for formal registration. Nevertheless, registration of certain designs is possible under the Registration Designs Act 1949 as amended by the Copyright, Designs and Patents Act 1988, and this Act gives rather different protection to such designs than the Copyright Act.

FURTHER READING

ABC of Copyright UNESCO
Collected Artlaw Articles Henry Lydiate, Editor Jenny Boswell, Artlaw Services 1981
Creating Your Own Work Micheline Mason, Gresham Books 1980. Useful on copyright, marketing, legal aspects for craftspeople
Law & Copyright Collected Artlaw Articles by Henry Lydiate in *Art Monthly* from 1976-79
Practical Law for Arts Administrators C. Arnold Baker
Guide to the Law J. Pritchard, Pengiun Books
The Visual Artist & The Law Artlaw Research Project
The Visual Artists Copyright Handbook Henry Lydiate, Artlaw Services 1983. Available from DACS
The Writers' and Artists' Yearbook 1989 Adam & Charles Black
Art Monthly 'The Next Moves Forward' Henry Lydiate Dec/Jan 1988
Artists Newsletter 'Copyright Law-The Basic Facts' Stephen B Cox April 1988
'Using Copyrighted Material' Stephen B Cox June 1988. Especially useful for looking at areas of collage, photomontage, etc. when making your own art work.

HELP AND ADVICE

British Copyright Council
29-33 Berners Street, London W1P 4AA Tel.01 580 5544

Design and Artists' Copyright Society (DACS)
St Marys Clergy House, 2 Whitechurch Lane, London E1 Tel. 01 247 1650. Information on all aspects of copyright nationally and internationally in the visual arts

Patent Office, Industrial Property and Copyright Department
Copyright Enquiries, Room 1504, State House, 66-71 High Holborn, London WC1R 4TP Tel. 01 829 6145

EXPORTING PRINTS

There are many advantages from sending work abroad; a sale to a foreign buyer, application to a biennale, sale-or-return to a foreign gallery, commission by a foreign dealer. It is reasonable to assume that an artist needs exhibition space and a totally new venue is often quite exciting not only in terms of space but also of new contacts - new collectors and buyers, a new viewing public. The possibility of meeting artists with similar interests in a different county may provide fresh stimulus, correspondence and even exchange of work place. So in the best of situations, exporting prints may provide an expansion of immediate horizons.

An important question to ask yourself before sending any work abroad is how much do you know about the person or organisation you are dealing with ? Once prints are out of the country it is very difficult to get them back if anything goes wrong. It is advisable to sort out all arrangements with responsible people before exporting any work.

Ways of travelling abroad with prints

Travelling with original prints that you intend to sell and leave in a specific country is a most complex way to sell work. When you enter any other country with a work of art you are liable in two main areas: 1) import duty and 2) VAT which varies in each country. These sums must be assessed and levies paid in any bona fide transaction.

If you wish to travel with original prints for display, i.e. to take to other countries and then return with the work, an ATA Carnet issued by the London Chamber of Commerce and Industry will assist greatly in providing temporary admission into each stated country. An entry and exit form will be stamped en route.

It is possible to travel with prints that are of little value, i.e. display copies, which can then come under the umbrella of duty free allowance (maximum £120) or be of no commercial value at all, e.g. unsigned prints. Many artists travel abroad with their own work as gifts or samples.

If you are carrying your own prints around galleries, it is worth considering various points: Take a small number of unframed drawings, prints or photographs in a stout portfolio that is easy to carry; if possible avoid rolled work as it is almost

impossible to show to its best advantage; take a good representative slide selection especially of larger or difficult-to-carry work; take a working slideviewer. Take several copies of a biography or recent catalogue and present everything very well. It is possible to take orders for sales on a travelling tour as good copies of prints can easily be forwarded by post with an invoice after you return home.

If you have been invited to exhibit or have sold pieces of work that are not able to navigate the postal system, or if you have any serious doubts about whether you could organise export expertly yourself, use an experienced packer and shipper.

Customs

Even though prints may not necessarily be sold abroad, foreign customs laws will nearly always require correct documentation to be presented before works are allowed to enter the state concerned. It is essential to be aware of the customs and VAT regulations of each and every country the work will pass through. Read them very carefully and do exactly what they ask.

In 1992 it is likely that many customs formalities will be relaxed but at present there are two accepted forms of documents widely used in the EEC. They are the T-form system and carnet system. Both require:
1 Accurate list of prints
2 Declaration of the prints' value
3 Declaration of the purpose of export (i.e. for sale, for exhibition, on consignment, etc.)
4 Details of insurance

The T-forms can be obtained from the Customs & Excise; the carnets from the Department of Trade. They must be correctly filled in. Should there be a discrepancy between the documents and the works there are bound to be problems if it is spotted by an alert customs officer. Make a list with dimensions of each work and take along a photograph if possible.

The return of work
If you need to bring the work back to this country then having the correct documentation is also essential. Unless you can satisfy a customs officer that it is your work that you are returning to this country then the officer may well take the view that you are importing into this country. VAT is payable on import.

Insurance

It is wise to minimise a potential financial loss by insuring your work. The insurance or work (particularly in transit) is highly recommended. Either insure the work yourself or ensure that others adequately effect insurance cover (See Chapter 4, Insurance, p. 101)

THE PRESS AND THE MEDIA

No one magazine in Britain is exclusively concerned with printmaking comment, criticism, debate, information, reviews, news, etc. Contact with a well-stocked art library is essential to the printmaker who wishes to keep informed. Below I have attempted to list a variety of international magazines that deal exclusively with printmaking topics plus those magazines in Britain that carry either regular or occasional printmaking articles.

Mailing list
Although this section in the book is basically a press and media listing, it can serve many purposes and one of them is as the basis of a mailing list. A mailing list is collection of contact addresses which is useful in your professional life (various

lists exist throughout this book). A mailing list could begin with any of the following : British press; British TV & Radio; critics; fine art magazines; museums; print galleries; print dealers; printworkshops; suppliers to the trades; important institutions e.g. ACGB, CC, RAA's, V&A, BC, etc.; personal collectors; friends; artists; miscellaneous e.g. bank manager, local education, officers, schools, libraries, local businesses, etc.

Job vacancies
The back pages of many papers and magazines also carry job advertisements. Arts vacancy information occurs in papers such as the *Guardian,Times, Times Educational Supplement, Times Higher Education Supplement; Daily Telegraph, Independent, Time Out, City Limits, Listener,* in the *Arts Council Bulletin* and magazines such as *Art Monthly, Arts Review,The Artist,* and especially *Artists Newsletter.* Remember also RAA's newsletters .

Publicity
Publicity is the material that you/others have designed to help promote yourself. It is concerned with establishing a relationship with a number of people and motivating them. When designing and producing any publicity, as mentioned many times before, make sure that first you identify your aims and intentions so that you can design appropriate publicity. Remember that the best promotion includes research and correctly identifying your audience.

A publicity campaign begins as soon as the title is chosen for your exhibition and continues with the design of the poster, the preview card, the information on the press release and adverts in the press, etc. All publicity work must be done well ahead of the date of the event - months at best, to allow the media to follow up and present their copy for their own deadline. Give your press release a good title and add in basic information on the event, the artist/s or the circumstances of the event with which the receiving journalist might establish a story but be prepared for the story to come out differently from the way you intended.

Much is free in terms of a line or so on local radio and even listings in some newspapers and magazines. Compile a free press listing. By sending details plus good quality colour slides to magazines such as *House and Garden, Homes and Gardens or The Artist,* free publicity may be forthcoming. Direct any mail at named programmes, journalists or columns. Use the telephone if you are able, to follow up on mailing. Where to use publicity to its best advantage? Browse through a good quality newsagent, bookshop in an art centre or local reference library and choose the most relevant periodicals.

International print magazines

The majority of international magazines listed below concentrate on printmaking; I have include several which are not specialist but worthy of a mention.

Small national printmaking magazines exist in many countries such as :
Bon à Tirer 28 rue du Chateau Landon, Paris 75010 *Editor* Michael Goldstein. The journal of French presses and published editions
Alpha Box 4922, Grand Central Station New York NY 10163Bi-monthly magazine of the American Printing History Association
Aktuel Grafisk Information Forlag Aktuel Viden AS, Fuglsevej 54,DK 4060 Holeby, Denmark, *Editor* Morgens Staffe
Prints (Alton) Box 1468, Alton, Illinois 62002 *Editor* G.Schmitz. Bi-monthly publication of Art on Paper Inc.
which are not listed as formal entries below.

AUSTRALIA **Imprint**
Print Council of Australia Inc.,172 Roden Street, West Melbourne 3003
Editors Maggie Mackie and Roger Butler
Began in 1966, this is the magazine of the PCAI. Contains national and some international news, views, criticism and information about printmaking activities.

BELGIUM	**Revue d'Art Contemporain** 15 rue St Jean, 1000 Bruxelles *Editor* Stephane Rona International magazine dealing with topical art issues including printmaking
BRAZIL	**Serigrafia (Rio de Janeiro)** Metodos Ltda, Rua Cardoso Marinho 42, Caixa Postal 15085,20220 Rio de Janeiro *Editor* Jan Lopez Barreto Began in 1976. 4 issues p.a.on the graphic arts.
DENMARK	**International Grafik** Box 109, 9000 Fredrikshaven *Editor* Helmer Fogedard and Klaus Roedel Began in 1969. International fine art magazine with text in Danish, French, German and English.
FINLAND	**SIKSI** Suomenlinna, 00190 Helsinki Launched in 1986, *Siksi* is a periodical for contemporary Nordic Art produced by Nordic Arts Centre.
FRANCE	**Nouvelles de l'Estampe** Comite National de la Gravure Français, 58 rue de Richlieu, Paris 75084 Began in 1963. Approximately 5 issues per annum. Text in French. National and international printmaking news, views, historical and contemporary articles. Listings of international exhibitions and opportunities.
WEST GERMANY	**Graphische Kunst** Editions Kurt Visel, Webestrasse 36, 8940 Memmingen *Editor* Kurt Visel
ITALY	**Serigrafia** Deta's, Via P.M. Kolbe 8, 20137 Milan *Editor* Ruggero Zuliani Began in 1956. Bi-monthly publication dealing with graphic arts.
SWITZERLAND	**Graphis** Graphis Press Corp., Dufour Strasse 107, 8008 Zurich Began in 1944. Bi-monthly publication. International journal of graphiic and applied art. **Xylon** Xylon International, Kirchplatz 14, CH 8400 Winterthur Began in 1961. Magazine of the Xylon International Society of Woodcutters
USA	**Fine Print** PO Box 3394, San Francisco CA 94119 *Editor* Sandra Kirshenbaum Began in 1975. Published quarterly. Deals with fine art book production mostly, occasionally includes articles about fine printmaking. **Print Collectors Newsletter** 72 Spring Street, New York NY 10012 *Editor* Jaqueline Brody Bimonthly publication covering all aspects of printmaking, news, reveiws, book listings, salerooms, published work, etc. **Tamarind Papers** Tamarind Institue, 108 Cornell Avenue, SE, Albuquerque, NM 87106 *Editor* Clinton Adams Founded in 1974 as Tamarind Technical Papers. New annual production begining with Vol II (1988). Moved from limits of publication of articles of technical aspects of lithography and broadened aim to include critical and historical studies. **World Print Courier** (Formerley Print News) World Print Council 1700, 17th Street, San Francisco CA 94103 USA *Editor* Anna Novalcov Newsletter for members of the World Print Council.

General British art magazines

Apollo
22 Davies Street, London WIY ILH Tel. 01 629 4331
Editor Anna Somers-Cocks
International arts news, reviews and criticism.

Art Monthly
36 Great Russel Street, London WC1B 3PP Tel. 01 580 4168
Editors Peter Townsend and Jack Wendler
Art magazine with news, reviews, criticism plus Artlaw by Henry Lydiate and artist's book reveiw by Cathy Courtenay. 10 issues p.a.

The Artist
102 High Street, Tenterden, Kent TN30 6HT Tel. 05806 3673
General art, reviews, information, news.

Artists Newsletter
Artic Producers Publishing Company Limited
PO Box 23, Sunderland SR4 6DG Tel. 091 567 3589
Editors Richard Padwick and David Butler *News Editor* Susan Jones.
Artists Newsletter is an information service and channel of communication for artists, craftspeople and photographers. Its objective is to support and inform artists' practice. It seeks the improvement of the artists' voice, status and economic position. Published monthly. Note six-monthly print supplements plus monthly PMC news column.

Artscribe
39/41 North Road, London N7 9DP Tel. 01 609 2339
Editor Stuart Morgan
International news, reviews and criticism.

Arts Review
62, Faroe Road, London W14 OEL Tel. 01 603 7530
Print Correspondent Guy Burn
Fine art criticism and reviews. Fortnightly publication.

Crafts
12 Waterloo Place, London SW1 Tel. 01 930 4811
Editor Martina Margetts
Magazine produced by the Crafts Council concerning crafts in Britain. Bi-monthly publication.

Design
28 Haymarket, London SW1 Tel. 01 839 8000
Editor James Woodhuysen.
Produced by Design Council with articles on all aspects of design - textile, industrial, interior, product and management.

Galleries
Barrington Publications, 54 Uxbridge Road, London W12 Tel. 01 740 7020
Editor Paul Hooper
Lists London and regional galleries and exhibitions. Monthly publication.

Modern Painters
Fine Art Journals Ltd., 10 Barley Mow Passage, London W4 4PH Tel. 01 995 1909
Editor Peter Fuller
Quarterly journal of the fine arts.

Print Quarterly
80 Carlton Hill, London NW8 OER Tel. 01 625 6332
Editor Paul Hooper
Monthly historical and critical art guide, London and county.

Studio International
Tower House, Southampton Street,London WC2E 7LS Tel. 01 379 6005
Editor Michael Spens
International magazine dealing with contemporary art and design.

British press

City Limits
8/15 Aylesbury Street, London EC1R OLR Tel. 01 250 1299
Arts reviewer Mark Curragh

The Daily Telegraph
135 Fleet Street, London EC4P 4BL Tel. 01 538 5000
Arts reviewer Terence Mullaly

Financial Times
Bracken House, Cannon Street, London EC4P 4BY Tel. 01 248 8000
Arts reviewer William Packer

The Guardian
119 Farringdon Road, London EC1 Tel. 01 278 2332
Arts reviewer Tim Hilton, Sacha Craddock

Harpers and Queen
National Magazine House, 72 Broadwick Street, London W1V 2BP Tel. 01 439 7144
Arts reviewer Bryan Robertson

The Illustrated London News
4 Bloomsbury Square, London WC1 2RL Tel. 01 242 5173
Arts reviewer Max Wykes Joyce

The Independent
Newspaper Publishing Plc, 40 City Road, London EIY 2DD Tel. 01 253 1222
Arts reviewer Andrew Graham Dixon

The Observer
8 St Andrews Hill, London EC4V 5JA Tel. 01 236 0202
Art reviewer William Feaver

The Observer Colour Magazine
8 St Andrews Hill, London EC4V5JA Tel. 01 627 0700
Arts reviewer Vick Kier

The Sunday Telegraph
135 Fleet Street, London EC4P 4BL Tel. 01 538 5000
Arts reviewer Michael Sheppard

The Sunday Times
1 Pennington Street, London E1 9XN tel. 01 481 4100
Arts reviewer Marina Vaizey

The Sunday Times Magazine
200 Grays Inn Road, London WC1 X 8E2 Tel. 01837 1234

Time Magazine
Time and Life Building, New Bond Street, London W1 Tel. 01 499 4080
Arts reviewer Robert Hughes

Time Out
Tower House, Southampton Street, London WC2 Tel. 01 836 4411
Arts reviewer Sarah Kent

The Times
1 Pennington Street, London E1 9XN Tel. 01 782 5000
Arts reviewer John Russell Taylor

The Times Educational Supplement
Priory House, St John's Lane, London EC1M 4BX Tel.01 253 3000
Arts reviewer Michael Church

Times Higher Educational Supplement
Priory House, St John's Lane, London EC1M 4BX Tel. 01 253 3000

Vogue
Vogue House, Hanover Square, London W1R OAD Tel. 01 499 9080
Arts reviewer William Feaver

FURTHER READING *Using the Media -How to deal with the Press,Television and Radio* Denis MacShane Pluto Press
The Artists Survival Manual-A Complete Guide to Marketing Your Work J&T Klayman Scribner & Sons New York 1984
Artists Newsletter 'Do You Sincerely Want to be Poor?' Alan Mitchell April 1984
Artists Newsletter Publicity No.1 April 84, No.2 May 84, No.3 June 84, No.4 August 84, No.5 Oct 84, No.6 Jan 85

Chapter 4 **A PRINTMAKER'S INCOME**

Unemployment

When you leave school or college after training as an artist and have no employment, it is necessary to register as unemployed at your local office of the Department of Health and Social Security. If you have had previous employment and have paid sufficient National Insurance contributions (and are not being paid at present in any job) then you should be entitled to unemployment benefit. Although unemployment benefit is theoretically taxable, in many cases it will not be taxed because it will be covered by your personal allowance (amount of income you can earn in a year without being taxed).

Self-employment

Most printmakers will fall into the category of being self-employed, i.e. working for yourself. This can take the form of being freelance (i.e. self-employed) or of setting up a workshop/studio. In either case technically you will not be eligible for unemployment or supplementary benefit. If you have no income it is worth going to the DHSS to check that you are not eligible for unemployment benefit.

Self-employed people setting up a business

Most people will start their business as sole traders (see also Chapter 1, Establishing your own printworkshop, Leases, p.16). This term covers self-employed people running their own businesses. As a sole trader you may employ others, but as sole proprietor you bear the full responsibility for running the business. It is no longer necessary for sole trader businesses or partnerships to register a business name. Notes on the new simplified requirements are available from the Small Firms Service.

Other forms of trading include partnership, limited liability company and workers co-operative. There are several new government schemes to assist people to start their own workshop businesses, such as the Enterprise Allowance scheme, Training for Enterprise, Graduate Enterprise Programme, Design Enterprise programme, etc. If they might be relevant or helpful to you apply to your local Job Centre or ask your Regional Arts Association for advice.

Taxation

The structure of the government taxation departments :
The *Treasury* controls two major tax departments -
1 *The Board of the Inland Revenue* 2 *The Board of Customs and Excise.*

Direct taxation controlled by the Board of the Inland Revenue (i.e.income tax) is split into three major functions :- 1a *The Inspectorate* headed by the Chief Inspector who manages 750 tax districts each with its own senior inspector from which your own personal taxation is dealt with; 1b *The Collectorate* which actually collects taxes and is very powerful and 1c *The Inquiry* which investigates fraudulent activity.

Remember that a tax inspector can deny or confirm your standing as a self-employed professional artist so make contact with your local Inland Revenue office and ask for information whenever you need it. To appeal against an inspector's decision seek assistance from your accountant or solicitor.

Schedules D & E
The tax status for self-employed people is in the Schedule D category. If you carry out your business on a commercial basis with a view to making profits, it is likely that you will be treated as self-employed with the advantage of being able to set off your business expenses against your business income. If you fail to convince the tax office that you are a professional printmaker and aiming to make money, the result will be that they will downgrade you to 'hobbyist' level (See Chapter 1, Working from home, p.15) although your profits will be taxed under Schedule D. It is important to note that losses from a hobby can only be carried forward and set against any profits which may arise in future whereas losses that arise from a trade or profession could be carried forward or offset against any other income you might have. Advice of an accountant is probably necessary to prepare accounts for printmakers being taxed under Schedule D.

If you are part-time employed (or full-time employed) you will be taxed under Schedule E.

As soon as you start your own business/workshop you should advise your local Inspector of Taxes by completing and sending form 41G. This form and full information about tax is contained in the Inland Revenue's booklet 'Starting in Business' which is available free from your local tax office.

Rates of tax
Taxable income for *individuals* is divided up into slices known as rate bands; each band is chargeable to tax at a different rate. Basic rate is charged on the first band i.e. 25% on the first £19,300 (1988-89)

The higher rate of 40% is charged on income which is above £19,300 (1988-89). Limited companies are taxed at a different rate. Check with your accountant.

Accounts

Individuals are normally assessed tax on the basis of profits earned in the accounts year ending in the previous tax year, but at the rates in force during the current tax year. The tax is generally payable in two equal instalments on 1 January in the current tax year and on 1 July following. However, there are special rules for dealing with the assessments for the tax year in which a business commences and for the second tax year's assessment. These rules can often work to the advantage of the taxpayer. The converse is the case when a business ceases. An individual is free to choose the annual date to which accounts are made up and it is usual, but not compulsory, for accounts to be made up to a calendar month end. Significant tax advantages may sometimes be obtained by careful choice of the date to which accounts are to be made up and the length of the first account. Professional advice is important at this point and the professional fees involved may be more than outweighed by a savings in tax.

Many self-employed people need an accountant to negotiate with the Inland Revenue on their behalf. An accountant will prepare your annual accounts and will

advise on the extent of the allowable business expenditure that the Inland Revenue will probably accept. The accountant will submit your accounts and taxation computations to the Inland Revenue and check any assessments raised and naturally charge a fee for this. It is not impossible for self-employed people to deal with their local tax office directly but many will find it difficult and may well miss out on opportunities to reduce taxation liabilities. The Inland Revenue are always more likely to accept accounts and computations submitted by a qualified and respected accountant than accounts drawn up by the taxpayer him/herself. It is always useful to seek the advice of an accountant before trading activities commence rather than after the first year of trading is completed.

Allowances

If you are being taxed as an individual you can initially claim personal allowances outlined in leaflets from your local IR office (e.g. A single person's allowance, married man's allowance, wife's earned income allowance, plus additional allowances for children). Note that after 1990 men and women will be taxed separately. If you are running a business or freelance you can claim all expenditure on normal business items.

If you are working from home, a deduction for the use of the home is allowed as a proportion of household bills (e.g. rent, rates, light,heating, cleaning, maintenance, insurance etc.) providing the amount claimed is reasonable. No room should be used exclusively for work as it may result in Capital Gains Tax Exemption being partially forfeited.

Great care should be exercised when claiming deductions for items where there is duality of purpose e.g. lunches or work clothing. Items may be claimed as expenses only when they are in total pursuit of your profession.

Where expenses include VAT and where the VAT is reclaimed from the IR, the VAT element cannot be treated as an allowable deduction. Where the VAT is not reclaimed the whole expense inclusive of VAT is allowable.

Capital expenditure i.e. typewriters, computers, cars, presses, etc. cannot be claimed for as a deductible expense but qualifies for 25% allowance in the the year of purchase and 25% balance p.a. in subsequent years. This can be wholly or partially disclaimed in any year that full benefit cannot be obtained.

Grants, awards and prizes

Persons in receipt of grants from the Arts Council or similar bodies should discuss carefully with the issuing body as to whether they are liable for income tax or not. Classifications such as art publishing grants, direct or indirect grants for commissions for a painting or sculpture, film and video bursaries, photography bursaries etc. are likely to be assessed for income tax. Non-taxable awards include bursaries for people retraining and/or attending full-time courses. Prizes are in a different category and may not be liable for income tax but advice should be sought.

This is an example of an annual accounts statement; most records should be kept for at least six years.

Statement of earnings & expenses for the year ended April 19—

Earnings (e.g. income)
Sales
Fees
Grants,Bursaries,Awards
Others _____
Total earnings

Expenses (e.g. allowances against income)
Upkeep of studio (proportion of rates, insurance etc.)
Repairs to studio and studio equipment
Studio lighting and heating
Cleaning and replacement of protective clothing
Art materials
Frames and framing charges
Other services
Photography
Small tools
Telephone (proportion)
Postage, stationery and printing
Newspapers, journals and periodicals
Books
Entrance fees and catalogues to exhibitions
Publicity and advertising
Exhibition charges
Travelling expenses (GB)
Foreign travel expenses
Motor vehicle expenses (proportion)
Accountancy charges
Bank charges
Miscellaneous expenses
Total expenses
Profit/loss for year _____

I certify that to the best of my knowledge and judgment the above is a fair and true statement of my earnings and actual or estimated expenses as Artist for the year ended April 19—

Signed _____ date _____

National insurance

If you are self-employed for all or part of the time you must arrange to make national insurance contributions unless your earnings in a year are less than £2,500 (1988/89 lower limit). As a self-employed person you must pay flat-rate Class 2 contributions and also Class 4 contributions. All contributions are payable in respect of years ending on 5 April.

The National Insurance contribution classes :

Class 1 These are payable by employees and their employers and are based on earned income.

Class 2 These are flat-rate contributions paid by the self-employed every week including holidays at the rate of £4.05 per week (1988/89 figure). You can either make payment by stamping a contribution card which is obtainable from your local social security office with National Insurance stamps which can be bought from the Post Office or by arranging for contributions to be automatically paid from your bank by direct debit. To arrange this you complete Form CF351 which is attached to the booklet 'National Insurance Guide for the Self-Employed' Ref NI41.

Class 3 These are weekly flat-rate contributions payable on a voluntary basis to provide or make up entitlement to certain social security benefits.

Class 4 contributions are paid in addition to Class 2 contributions if your income comes from your trade, profession or vocation. It is generally assessed and collected by the Inland Revenue. It is calculated as a percentage of those profits which fall between the upper and lower limits. The limits are set annually. In the tax year 1988-89, the lower limit is £4,750 and the upper limit is £15,860. The percentage limit is 6.3%.

For example -
1988-89 if your profits are £12,250, your class 4 contribution will be £12,250

<div align="right">

less lower limit £ 4,750
£ 7,500 x 6.3%
Total **£ 472.50**

</div>

Payment of Class 4 contributions is made as part of payment of your tax which in the case of self-employed people is in half yearly instalments. National Insurance Class 4 rate is also payable if you are on the Enterprise Allowance scheme. One half of the Class 4 contribution is an allowable deduction for income tax purposes.

Exemption from contributions can be applied for in respect of small earnings and in various other cases and you should apply for a deferment claim form CF 359 and send it directly to DHSS Class 4 Group, Newcastle on Tyne NE 98 IYX. Information is included in the leaflet 'People with small earnings from self-employment'. Do not leave your application too late.

If you are employed elsewhere for part of the time you will have to pay Class 1 contributions as well and these contributions will usually be deducted by your employer. However, there is an upper level to the amount of contributions you have to pay in any tax year and if your total contributions are more than this the excess will be refunded to you.

If you have employees you must deduct Class 1 contributions from their pay and pay an additional employer's contribution.

The Department of Health & Social Security issue a number of leaflets which explain these points in detail.

It is important to make sure that you do start paying national insurance contributions when you start up your own business/workshop as failure to do so can lead to prosecution and will certainly involve you in having to pay all the amount due in arrears if it is discovered that you have been operating as self-employed but not paying NI contributions.

Pensions

As a self-employed person you only receive the basic state pension on your retirement, not the earnings-related part. If you wish for more than this you will need to make arrangements with a life assurance company. There is income tax relief on payments towards a pension, subject to a maximum. Do not rush into signing up for a long-term pension policy with a life company, since contributions can usually be made at the end of your accounts year.

Book-keeping

It is necessary to keep some form of accounts for two main reasons: as a record of your income and expenditure in the year to enable the Inland Revenue to assess your tax and to enable you to have some financial control. Unless you know how much you have in your bank, how much you are owed and how much you owe others you will find it difficult to operate and you will be in danger of going out of business.

On setting up your workshop it is advisable to open a business account with its own cheque book and paying-in book immediately . Many people now use small personal computers for their accounting.

A simple system
The best piece of advice is to keep all accounting systems simple. All expenditure should be written down on monthly expense sheets (bought loose leaf from stationery shops). Expenses are classed into two types,direct and indirect. Direct

includes materials, framing, exhibition expenses, printing, publicity,etc.; indirect concerns telephone, car, travel, household (often a proportion of whole sum if you are working where you are living). For small payments, a petty cash book should record details such as tapes, paints, tea, etc. and receipts should be kept in each case to verify expenditure. This should be totalled and recorded each week/month. Larger payments should be made by cheque, meticulously recorded on your cheque book stub and a receipt or bill obtained for every payment. Paid invoices should be filed in monthly order and marked with date paid and cheque stub number. Income should be recorded in the same way. By adding all the paying ins and deducting all the cheques issued out, it is possible to keep informed about your position.

This system is perfectly adequate if your turnover is small and should enable your accountant to draw up annual accounts. However there are disadvantages. It does not allow you any cash control and it is weak in credit control which is basically watching that payments due to you do not take too long to be paid.

The DIY System
These are normally hardback, bound books with several sections to them, each part ruled and already laid out for the entries. Each one has a set of instructions and examples for each section. The advantages are that they offer the small business person some measure of financial control, especially over bank and cash balances. They almost all include VAT sections and profit and loss sections. They aim to cut down what you will have to pay your accountant. The main disadvantage is that none will work unless kept up regularly, which means weekly at a minimum and daily at best.

Stationery
It is important to have a simple letterhead printed which states who you are, your address and what you do. A business card with the same information can also be useful. You can use your letterheaded notepaper as a basis for many purposes. If you are registered for VAT, your VAT registration number will need to appear on your stationery.

Order For purchasing goods, it should state the date, the quantity, description of goods, price, delivery details.
Delivry note This accompanies goods, whether despatched or delivered. It should state the customer's name, his order number, the quantity, price and description of goods delivered. If you deliver personally always get a signature on your copy.
Sale-or-return record For recording work left on sale-or-return. Should be dated and state the retailer's name, (see Chapter 3 Contracts, p.81 and Chapter 1 Pricing prints, p.62). Make sure that the retailer signs your copy.
Invoice This is a request for payment and should normally be sent separately from the goods when supplying a firm although with private clients it can be handed over with the goods. It requires the same information as carried on the delivery note or sale-or-return record plus the number of that document, the total cost, any discounts, VAT and VAT number where applicable.
Credit note If goods are returned for any reason make sure that you record it as otherwise there may be a dispute at a later stage as to whether you delivered the prints or not. When the returned prints are received send the customer a credit note stating his order number, quantity, type and price of each print and the reason for return. If and when the prints are replaced a fresh invoice is sent.
Statement This is a reminder to the client/gallery that they have not yet paid your invoice. It should quote any unpaid invoices, total and deduct any credit notes issued in the period. When using it, be sure to take a carbon copy or photocopy of the original and file it. Include a date (day posted) and number each category consecutively to help in your book-keeping and to guard against loss.

It is sensible to have running at the same time an *address filing system* so that addresses and telephone numbers can be quickly found; a *correspondence file* in alphabetical order will establish a neat way of keeping letters from galleries, publishers etc. and a *print book* (see Chapter 2 Documentation and record keeping, p.64) will enable you to record the production and financial history of each edition.

Banks

High Street banks offer many facilities and it is wise to shop around to discover the cheapest way of operating accounts,etc. It is advisable to maintain a good relationship with your bank by keeping your account in credit whenever possible and by asking for an overdraft/loan before going into debit. It is likely that at some point you will ask your bank to lend you some money. You may feel nervous about approaching the bank manager but his business is lending money. Go prepared with facts and figures. Some form of security is necessary for sizable loans and the simplest form is to have the loan guaranteed by a friend or your family; other types of security include property, other funds such as a building society account, stocks and shares, etc. Even if you do not have much security it is worth approaching your bank. If you can show commitment, both financial and personal, there is a good chance that they will consider your request for funding sympathetically.

Employing people

A guide 'Employing People' is available from the Small Firms Service which sets out the basic information (Dial the operator and ask for Freefone 2444 to obtain a copy).

Value Added Tax

The activities of all printmakers come within the scope of VAT to a greater or lesser degree. Artists are obliged to register immediately for VAT with the Customs and Excise if their income exceeds £22,100 (with effect from 15 March 1988) in any one year or £7500 in any one quarter (this sum usually increases every year).

Although this is a tax which is largely self assessed, it is not optional. Any delay in registering at the proper time will result in the Custom & Excise claiming VAT from all income received from the date when registration should have been made. This will mean that it comes directly out of your own pocket.

VAT is a sales tax and applies to most goods and services but, for example, UK books (at the present time) are zero-rated. If the turnover of a self-employed person or a business is such that it should be registered for VAT then that business is obliged to charge VAT on its output, i.e. on sale of prints (plus hire or loan) and sel- initiated printmaking services such as lectures, workshops, demonstrations, and can reclaim it on its inputs i.e. goods and services used in carrying out the business.

(See Chapter 2,Print pricing, p.59, also p.103 local Custom & Excise office.)

VAT supply rates
Standard rated supplies (taxable at 15%) are the general rule. This rate applies unless the law specifically provides otherwise.

Zero-rated supplies (taxable at 0%) are a form of relief for socially or economically important items, including, for example, books and newsprint.

Exempt supplies (not taxable at all) are also free of tax and include land insurance, postage, finance, education and health.

VAT registration

Since 1985 penalties arising from late registration are extremely harsh and are imposed automatically. Note also that equally harsh penalties are to be introduced concerning late submission of returns and under-declarations of VAT. If earnings have reached the above stated levels, then registration is obligatory.

Voluntary Registration This is important for new businesses which have not perhaps reached the stated turnover limits but which have costs with high VAT levels. If voluntary registration is made it will also be necessary to charge VAT on outputs.

Deregistration This is only possible if taxable supplies cease or fall demonstrably below registration thresholds.

VAT accounting details

VAT returns are important and in this system it is necessary to send in prompt and accurate returns. Various bookkeeping systems can be bought which will facilitate record-keeping. Advice of an accountant should be taken. The usual interval between returns is three months with one month allowed to submit them.

VAT and Customs & Excise

Unlike the payment of income and other taxes, it is more usual for the artist to deal directly with the Customs & Excise. This may involve visits by the Customs & Excise after registration for the inspection of records and it is necessary for all VAT invoices to be kept for six years. Discussion can take place with the Customs & Excise at the very beginning when your local VAT office can help with advice on many issues.

Insurance

Insurance is an area that artists often find they forget about and its only when the worst happens, e.g. that you discover to your cost that you are inadequately insured or not covered when all your work is soaked overnight by water from a burst tank in the studio above yours, that you begin to think about getting adequate cover.

The object of insurance is to offset financial loss in the event of damage or loss in areas that concern buildings, property or persons. It is advisable to discuss your requirements with a registered insurance broker before deciding on a specific company's policy. It is possible to be insured against most occurrences. To protect yourself against particular risk it is worth seeking out a specialist art broker.

Persons

It is possible and often necessary to take out life insurance, health insurance and even a specific personal accident policy against a risk or injury to yourself which may render you temporarily unfit to carry on your business. If you are employing other people it is necessary by law to have adequate cover for injury, disease and property liability resulting from your trading activities. Failure to do so may lead to prosecution. Cover is also available for injury, damage or loss caused by your goods.

Property

Whether you have a separate studio or are working from home it is necessary to insure both the premises and the contents. It is essential to look around in order to make sure that you get the best policy for your particular requirements and circumstances. Most companies have a wide range of policies. All risks should be considered however remote or unlikely they may seem. It is better to cover all eventualities than to be underinsured. If you insure against damage by fire and the premises are damaged by water you will not be able to claim under the fire policy. (See also Chapter 2, Premises, p.15.)

If you are working from home and your house is mortgaged, it is very important that you check the policy as it is unlikely to include cover for a business. The insurance company may refuse to pay out on the policy if you have not disclosed the fact especially if your house burnt down because the inflammable materials used in your workshop caught fire. It is also important to realise that if you do not tell the building society or bank that you are working from home, problems will arise in relation to claims.

Usually, if you are a leaseholder and only rent part of the building, the landlord insures the building as a whole, including your premises, and each tenant pays a proportion of the cost of insurance. It is important that the landlord knows what you are doing and that you have read a copy of the policy before signing the lease.

The usual risks normally covered by an insurance policy are:-
Fire, theft, lightning, earthquake, explosion, storm or flood, water or oil leakage, burst pipes, impact, subsidence, landslide, riot and civil commotion and malicious acts. There may also be risks which you should consider because of the nature of your work, or the area in which the premises are situated, such as storage of flammable liquids, corrosion by acids, etc.

The type of insurance cover should include damage, demolition of existing premises and site clearance, the cost of rebuilding including architects' and surveyors' fees, the cost of renting alternative temporary accommodation, accidental damage to glass, pipes, cables, drains, etc., and if your workshop is visited by the public, your legal liability to members of the public on the premises. There may be additional items to be covered (depending on the nature of your work) such as extending the workshop and adding new machinery. It is always wise to keep the insurance company fully informed about your work activities especially if these represent a hazard. Some types of machinery are required by law to be covered by insurance.

It is possible to reduce the amount of premium by installing adequate fire protection, by making the property as thief-proof as possible (bolts to door and windows) etc. Policies are often index -linked and worth checking each year whether to increase or decrease the premium because of changes in workshop. Some insurance companies give discounts for no smoking premises.

Your own work
It is essential to insure your work and your work materials for all risks anywhere in GB and it should include work in transit. If necessary specifically name certain items which constitute a special risk, e.g. acid and other inflammable materials

Vehicle
The law compels everyone owning a vehicle to carry insurance covering loss, damage and injury to others in the case of an accident. If you use a vehicle specifically for your business (or even your domestic vehicle for carrying frames to an exhibition), it is important to consider special risks that an ordinary vehicle insurance does not cover and consult a broker.

Sources of finance, information and advice

Crafts Council
12 Waterloo Place, London SW1Y 4AU Tel. 01-930 4811
The Crafts Council operates a number of grant schemes for the benefit of individual makers in England and Wales and has a range of information services. The following leaflets giving details are available : Grants & Loans (details of all schemes); List of Selected Craft Shops & Galleries in England & Wales; Guide to the Council's Information Services; List of Group Workshops; Recommended publication *Running a Workshop - Basic Business for Craftspeople* published by Crafts Council at £4.95.

Regional Arts Associations
Regional Arts Associations within England (except Greater London Arts) run their own grant schemes and you should contact the association for the area in which you live and work for details. In London,

Greater London Arts and the Crafts Council operate grants schemes. Most Regional Arts Associations also run regional indexes of craftspeople within their area and will give help and advice where required.

(List of addresses see Chapter 5, p. 107 ff)

Council for Small Industries in Rural Areas (COSIRA)

Head Office - 14 Castle Street, Salisbury, SP1 3TP Tel. 0722 336255
This is the main agent within England of the Development Commission whose aim is to encourage small rural businesses. Rural areas are defined as anywhere with a central population of under 10,000. COSIRA can provide information, training and finance. Capital grants of up to 35% of the total cost of converting redundant buildings in specified rural areas are available. Loans towards buildings and/or equipment are available. Contact your local COSIRA office (address in you telephone directory) or the Head Office for details. In Wales contact the Welsh Development Agency, in Scotland the Scottish Development Agency /Highland and Islands Development Agency and in Northern Ireland the Local Enterprise Unit (see below for details).

Welsh Development Agency

(Small Business Section), Treforest Industrial Estate, Pontypridd CF37 5UT Tel. 044 385266
Information and advice for small businesses in Wales.

Scottish Development Agency

(Small Business Division), 102 Telford Road, Edinburgh EH4 2NP Tel. 031-343-1911
As well as assisting small businesses, the SDA has a number of grant schemes for individual craftspeople within Scotland.

Highland & Islands Development Board

Bridge House, 27 Bank Street, Inverness 1VI 1QR Tel. 0463 234171

Local Enterprise Development Unit (LEDU)

Lamont House, Purdy's Lane, Belfast BT8 4TB Tel. 0232 6910310
LEDU will assist small businesses within Northern Ireland with information and finance. The Crafts Industry Scheme has small capital grants available.

Small Firms Service

To contact your nearest centre dial 100 and ask the operator for Freefone Enterprise
This service is sponsored by the Department of Employment and operates through a nationwide network of Small Firms Centres. Information and counselling service for owners and managers of small businesses is available. One of the most useful functions is that it can put the prospective business person in touch with a range of specialist advisors of every sort.The information is free, the first counselling session is free and after that a small charge is levied. Although they do not give grants or loans they can help with advice on possible sources of finance. Operates in Scotland through Scottish Development Agency, in Wales through Welsh Development Agency and in N.Ireland through Dept. of Commerce by the Local Enterprise Development Unit.

Local Citizens Advice Bureau

Range of information and advice to help you connect to various services

Local Enterprise Agencies /Enterprise Zones /other Council agencies

There are a number of agencies throughout the country which have the common aim of encouraging small businesses to set up in local areas. Some local councils have also developed policies aimed at assisting small businesses and the government has set up a number of special zones which offer financial help and freedom from planning controls. Contact your local council for details of any such help within your locality.

Insurance

In considering all insurance it is best to consult a qualified insurance broker who will be able to advise you on your needs and the cost. Use recommendations from colleagues or friends or contact British Insurance Brokers Association 10 Bevis Marks, London EC3 7NY Tel. 01 623 9043

Dept. of Health and Social Security

Information Division, Room D513/5, Alexander Fleming House, Elephant and Castle London SE1 6BY Tel. 01 407 5522

Local Inland Revenue Office

List of personal allowances and leaflet 'Starting a Business'. Notes to help you an your assessment (64D CODA) are issued each year to everyone liable for income tax.

Local Custom & Excise Office (VAT)

Custom & Excise (look in the telephone book for your nearest office) leaflets such as The Ins and Outs of VAT; Should I be Registered for VAT; The VAT General Guide (Notice 700); VAT leaflet 712 (sale of secondhand works of art); VAT leaflet 361 (VAT and museums and galleries.

Accountants and Solicitors

Anyone thinking of engaging an accountant is recommended to meet two or three and consider whether a good working relationship could be established. Ask how long the practice has been in existance, whether the accountant has similar clients and what the hourly charge out rates are of the partner and senior members of staff : do not be put off by the 'it is difficult to estimate without completing the work' answer. Find accountants through personal recommendations, citizens advice bureaux, Institute of Chartered Accountants in England and Wales, Chartered Association of Certified Accountants (membership books can be found in most reference libraries) and Yellow Pages. For solicitors, contact The Law Society 113 Chancery Lane, London WC2A 1PL Tel. 01 242 1222 or Law Centres Federation Duchess House, 18-19 Warren Street London W1P 5DP Tel. 01 387 8570

Legal Aid

It is possible to consult a solicitor free of charge if you are eligible to receive legal aid. Under what is called the Green Form or Advice and Assistance Scheme, you are entitled to receive approximately one and a half hours worth of a solicitor's time to advise you on any aspect of the law provided that your income satisfies certain limits. If you need to take court proceedings and you satisfy the financial criteria you can apply for a Legal Aid Certificate to cover all or part of the costs of the proceedings.

FURTHER READING

Art, Design & Craft: A Manual for Business Success E. Arnold Hodder & Stoughton London, 1988
Charitable Status London, Interaction Imprint 1982
Ecomonic Situation of the Visual Artist London, Calouste Gulbenkian Foundation 1985
The Greatest Little Business Book Peter Hingston 1987-88
The Guardian Guide to Running a Small Business Clive Woodstock London, Kogan Page 1988
Money Which A Tax Saving Guide Look in local reference library; issued annually in March
Running a Business from Home Alan Terry London, Sphere Books 1985
Running A Workshop - Basic Business for Craftspeople London, Crafts Council 1987
Small Business Finance Raiser- Better Business Guides Stan Mason London, Hutchinson Business 1986
Sources of Free Business Information Michael J Brooks London, Kogan Page 1986
Successful Marketing for the Small Business Daily Telegraph Guide Dave Patten London, Kogan Page 1985
The Pitfalls of Managing a Small Business and How to Avoid Them Leaflet written by Dunn & Bradstreet 26-32 Clifton Street London EC2P 2LY (available free on request)
Small Business Guide - Sources of Information for New & Small Businesses Colin Barrow London, BBC 1984 contains perhaps the most comprehensive list of local enterprise agencies and is the directory of sources of information and advice
Working for Yourself in the Arts & Crafts Sarah Hosking London, Kogan Page 1986
Artists Newsletter 'Employment & Tax ' Stewart Young March 1988
 'Tax & the Visual Artist' Peter Haveland December 1987
 'Are You Covered?' August 1987

Chapter 5 OPPORTUNITIES FOR PRINTMAKERS

For the artist who wishes to make his/her living from the direct practice of printmaking, life is not necessarily easy. Problems encountered by printmakers early on in their careers can often be described as stemming from a lack of facilities, cash, patronage or sponsorship. The would-be artist who leaves art college without any professional or business studies, suddenly finds that s/he has to learn very quickly a great deal which is not directly related to the degree of artistic talent s/he might possess.

This chapter provides the beginning of a list of opportunities. Each opportunity requires a degree of organisational skills from the artist; a printmaker has to be able to write competent letters, to be skilled and practised at interviews, and be able to pursue an opportunity through difficulties until it reaches fruition. This calls for many attributes - vision, patience, endurance, perseverance, a sense of humour! It requires confidence in yourself as an artist and your work especially when 'no thanks' is the recurring answer.

According to the figures provided by the Gulbenkian report (1985) over 50% of those who describe themselves as 'professional' are under 33, and 71% are under 44. This over representation in the younger age group may be due to the failure of many artists to continue practising as they get older. This cannot be explained in terms of lack of commitment or seriousness of approach, rather perhaps of aspirations which cannot be fulfilled in monetary terms or of stresses of young families and buying homes.

Many opportunities are available for the enterprising and outward looking printmaker in the next few pages. As Sandy Linan, ILEA art careers officer, points out artists have talents and skills that are applicable in many areas of employment and a typical career path can contain several changes in direction. People with art training are valued by employers in retailing, marketing, publishing, computing, manufacturing, buying, etc. There are of course careers which utilise 'art' directly such as museum work, conservation, arts administration, teaching, commercial design, retail (craft shops, art galleries, etc.) art therapy, exhibition design, theatre, television, propmaking, computer aided design, etc. Printmakers especially have a number of markets for their work in addition to the fine art print - greetings cards, posters, textiles, wrapping paper, book illustration are all areas where work can be sold and commissions obtained. Each area involves a different list of companies as prospective purchasers and has different rules and common practices in the way art work is bought and sold.

Sponsorship

According to the Arts Council most recent (43rd) report, arts sponsorship has grown from about £0.5 million annually ten years ago to nearly £30 million today. A new incentive with the catch phrase 'we are selling art skills to business instead of the other way round' is quoted at the beginning of the Arts Council's special report on business and the arts which optimistically looks at their future relationships. This perhaps describes one of the key points of sponsorship - that it is an equal business in which there are advantages to both parties.

To effect successful sponsorship is time-consuming and hard work and careful consideration must be given to the decision to try to find a sponsor yourself - it is not an immediately responsive operation; it may take months before a decision is reached and that might be negative. Professionals who deal in the business of connecting artists with sponsors could be the first avenue to try before embarking yourself. It's worth remembering not to use sponsorship for a main source of income and not to use it for capital projects (e.g. the purchase of a studio) which cannot be written off against tax. Sponsorship is best used for single projects such as exhibitions where cash can be used on printing catalogues, etc.

FURTHER READING

Directory of Social Change
Radius Works, Back Lane, London NW3 1HL
Publishers of a large number of books and leaflets concerned with grants and fund-raising including *A Guide to the Major Trusts, A Guide to Company Giving, A Guide to Grants for Individuals in Need, Survival Without a Grant, Corporate Donors Handbook, Raising Money From Industry, Grants from Europe, Charity Trading Handbook, Charitable Status:A Practical Handbook, Raising Money From the Arts, Raising Money from Trusts, Raising Money from Industry, Raising Money from Government, Industrial Sponsorship and Joint Promotions,* etc.
Practical Sponsorship Stuart Turner London, Kogan Page
Artists Newsletter 'Sponsorship' Tony Warner August 1988. A very informative and thorough article directed particularly at artists seeking sponsorship.

HELP AND ADVICE

Association for Business Sponsorship of the Arts (ABSA)
2 Chester Street, London SW1X 7BB Tel. 01 235 9781
ABSA is the independent national organisation promoting and facilitating business sponsorship of the arts, with offices in London, Edinburgh, Belfast and Cardiff. ABSA also administers the Government's Business Sponsorship Incentive Scheme which matches new sponsorship money with public funds, on behalf of the Minister for the Arts.

Sponsorship Database
Tim Shaw 52 Poland Street, London WIV 3DF Tel. 01 439 8957
An information system covering entire sponsorship market. Subscriber's fee (around £500) provides information on current deals, new legislation, guidelines, etc. plus listing of projects looking for

ARTS COUNCILS AND REGIONAL ARTS ASSOCIATIONS

The Arts Council of Great Britain is the central agency for funding the arts in Britain and delegates responsibility to the Arts Councils in Scotland, N. Ireland and Wales. Other craft activites in England are the responsibility of the Crafts Council and in Scotland the Central Development Agency. In England the Regional Arts Associations are funded through the Arts Council, local authorities and others to support the work of arts in the regions. Information from them concerning printmaking awards and activities is listed in each area. Further details should be obtained directly from the associations themselves.

Independent and local arts associations exist in many areas, such as the Yorkshire Contemporary Art Group which organised the impressive 'Tradition and Innovation in Printmaking Today' in 1986 sponsored by Rank Xerox.

ENGLAND
London

Arts Council of Great Britain
105 Piccadily, London, W1 Tel. 01 629 9495
Contact Director of Visual Arts Sandy Nairn, Art Officer Sarah Wason

The Arts Council of Great Britain is the central grant-making organisation for the arts throughout Britain. It works closely with the RAA's in providing advice and financial assistance for the visual arts. The principal criterion for determining whether to apply to the AC or relevant RAA is whether the project has a national (AC)or a regional importance (RAA). Write to AC for special Visual Art Projects Guidelines. There is no media distinction in the awards. Project areas include Exhibitions and Events, Publications, National conferences, Research, Pilot, and Feasibility Projects and National Fellowships. Specific printmaking projects given awards in 1987-88 include this handbook and Spirit of Carnival In Print:Paddington Printshop.

Greater London Arts
9 White Lion Street, London N1 9PD Tel. 01 837 8808
Contact Visual Arts Officer Alan Hayden.
Founded in 1966. Covers the area of thirty-two boroughs and City of London. GLA is the strategic development agency for London. It provides not only money but also advice, specialist arts expertise, encouragement and support. Write to above for policy and funding guidelines.

Regions
Buckinghamshire Arts Association
55 High Street, Aylesbury, Bucks HP20 1SA Tel. 0296 434704
Contact Director Shaun Hennessy.
Covers the area of Buckinghamshire. Funded by East Midland Arts. Many awards open to printmakers e.g. starter grants, exhibition grants, education grants to encourage workshops, seminars, etc., venue grants (priority often given to non-gallery spaces to participate), setting up grants for non-gallery venues, project grants, etc.The association's advisers feel able to provide specific information and advice about many aspects of professional life. Contact above for further information.

Eastern Arts Association
Cherry Hinton Hall,Cherry Hinton Road, Cambridge CB1 4DW Tel. 0223 215355
Contact Visual Arts Officer Jane Heath.
Covers areas of Bedfordshire, Cambridgeshire, Essex, Hertfordshire, Norfolk.

East Midland Arts
Mountfields House, Forest Road, Loughborough, Leics LE11 3HU Tel. 0509 218292
Contact Visual Arts Officer David Manley.
Founded in 1969. Covers areas of Derbyshire(except High Peak District), Leicestershire, Northamptonshire, Nottinghamshire, Milton Keynes.East Midlands Arts publication 'Artfacts' details guidelines to schemes, awards and services within their area.(Also funds Buckinghamshire AA)

Lincolnshire and Humberside Arts
St Hugh's, 23 Newport, Lincoln Tel. 0522 33555
Contact Principal Visual Arts Officer Alan Humberstone.
Covers areas of Lincolnshire and Humberside. No annually awarded grants or residencies. Any opportunities advertised through *Artists Newsletter*. Note biennial Humberside Printmaking Competition organised by Humberside College of Education.

Merseyside Arts
Graphic House, 107 Duke Street, Liverpool L1 4JR Tel. 051 709 0671
Covers areas of Knowsley, Liverpool, St Helens, Sefton, West Lancashire, Ellesmere Port and Halton Districts of Cheshire.

Northern Arts
10 Osborne Terrace, Jesmond, Newcastle upon Tyne NE2 1NZ Tel. 091 2816334
Contact Visual Arts Officer Peter Davies
Founded in 1961.Cleveland, Cumbria, Durham, Northumberland, Metropolitan districts of Newcastle, Gateshead, North and South Tyneside and Sunderland. NA grant aids Northern Print (5 Charlotte Square, Newscastle NE1 4XF) and Lowick House Printmaking Workshops (Lowick Green, Nr Ulverston, Cumbria). Lowick House offers a specialist annual printmaking bursary to enable an artist to print at Lowick House workshops. All artists are encouraged to apply for NA awards which comprise funding for projects, creating opportunities and establishing practice. Also Interest-free project loan scheme. Northern artists' bursary £6,000 to an artist not engaged in full-time teaching also open to printmakers. Visual Arts index. Also travel and training scheme designed to help individuals develop their practice. Many other schemes.

North West Arts
4th Floor, 12 Harter St, Manchester M1 6HY Tel. 061 228 3062
Contact Visual Arts Officer Virginia Tandy.
Covers areas of Greater Manchester, district of St. Helens, Cheshire except Ellesmere Port & Halton, Lancashire except West Lancashire, High Peak District of Derbyshire. Not very active in terms of printmaking, 'little to report in terms of printworkshops or residencies'.

South East Arts

10 Mount Ephraim, Tunbridge Wells, Kent TN4 8AS Tel. 0892 515210
Contact Visual Arts Officer Frances Smith.
Founded in 1973. Covers areas of East Sussex, Kent and Surrey. The chief way of helping printmakers is through the Selected Register which includes printmakers. In addition occasional residencies have an emphasis on printmakers and a recent example is the current Ritual and Relics residency.

Southern Arts

19 Southgate Street, Winchester Hants SO23 7EB Tel. 0962 55099
Contact Visual Arts Officer Hugh Adams.
Founded in 1968. Covers areas of Berkshire, Hampshire, Isle of Wight, Oxfordshire, West Sussex, Wiltshire and Bournemouth, Poole and Christchurch.

South West Arts

Bradninch Place, Gandy Street, Exeter, Devon EX4 3L Tel. 0392 218188
Contact Visual Arts Officers Christine Ross/Valerie Millington.
Founded in 1956. Covers areas of Avon, Cornwall, Devon, Dorset (excluding Bournemouth, Poole and Christchurch), Gloucestershire and Somerset. Supports a series of residencies and artists in schools schemes which are open to printmakers as is the Annual Fine Art Photography Award Scheme. Details in their bi-monthly newsletter. Printworkshops in the region include Avon: South West Branch of Printmakers Council ('Crofton', 8 Chapel Lane, Old Sodbury Lane, Old Sodbury, Bristol BS17 6NG), Bath Artists Printmakers (11a Broad Street, Bath). Cornwall: Penwith Printworkshop (Back Road West, St Ives); Balwest Studios Printmaking Workshop (Lower Balwest Farm, Ashton, Helston, TR13 9TD), Pomery's Printworkshop (St Mawes). Devon: The Appledore Press (2 Meeting Street, Appledore, Nr. Bideford), Wilkey's Moor Workshop (Wilkeys Moor Farm, Cornwood, Ivybridge), Tavistock Community Print Workshop (Chapel Street, Tavistock). Somerset: Moorland House Workshop (Burrowbridge TA7 ORG), Nettlecombe Studios (Nettlecombe, Nr Williton, Taunton). Glos.: Rosanna Mahoney (Poppy Cottage 22 Driffield, Nr. Cirencester).

West Midlands Arts

82 Granville Street, Birmingham B1 2LH Tel. 021631 3121
Contact Visual Arts Offcer Julie Seddon-Jones.
Founded in 1970. Covers areas of Hereford, Worcester, Shropshire, Staffordshire, Warwickshire, Districts of Birmingham, Coventry, Dudley, Sadnwell, Solihull, Walsall and Wolverhqmpton. No specific awards to printmakers. Borderline Printworkshop (Knighton,Staffs) is a self supporting and non-profitmaking workshop and offers multi-faceted programme of exhibitions, commumity and education work and some placements and residencies. Also Birmingham Print workshop (Unit P, Glover Street, Digbeth B9 1EN).

Yorkshire Arts

Glyde House, Glydegate, Bradford. West Yorkshire BD5 OBQ Tel. 0274 723051
Contact Visual Arts Officer Yvonne Deane
Founded in 1969. Covers Districts of Barnsley, Bradford, Calderdale, Doncaster, Kirklees, Leeds, Rotherham, Sheffield, Wakefield and North Yorkshire. All grants and schemes open to printmakers but no specific print awards. Printmakers are in particular demand for education and community placements. YA supports a number of client organisations who have public printing workshops including Crescent Arts Workshop (Art Gallery Basement, The Crescent, Scarborough;screen and etching) and Kirklees Art Space (Easthorpe Gallery, Huddersfield Road, Mirfield WF14 8AT; relief printing, photo screenprinting and etching). YA also supports two community printworkshops Bradford Community Printshop (127 Thornton Road , Bradford) and York Printshop (The Basement, 2 The Crescent, Blossom Street, York YO2 2AW). YA are also assisting in the setting up of a multi media printworkshop in Rotherham. Bradford College of Art offers an open access policy for graduates wishing to use its facilities. Leeds Polytechnic established a print fellowship with financial support from Henry Moore Foundation. Note also British International Print Biennale held at Cartwright Hall, Bradford.

SCOTLAND

Scottish Arts Council

19 Charlotte Square, Edinburgh Tel. 031 226 6051
The Art department offers offers a number of different awards and bursaries for artists which includes printmakers. The SAC assists The Printworkshop in Edinburgh, Glasgow Print Studio, Inverness Printworkshop, Peacock Printmakers Dundee with annual revenue funding. Solisquoy Printworkshop also receives a grant. Printmaking bursaries are offered through work at Dundee Ediburgh and Aberdeen workshops amounting to £1000 to artists in 1987-88. SAC supports the Scottish Print Open and some artist-in-residence schemes such as Peacock Printmakers exchange with French workshop and Dundee workshop exchange with a organisation from Finland.

Scottish Development Agency

Rosebery House, Haymarket Terrace, Edinburgh EH12 5EZ
Crafts setting-up schemes, workshop and equipment schemes, training schemes, exhibition grant schemes, crafts fellowship schemes.

WALES **Welsh Arts Council**
Museum Place, Cardiff Tel. 0222 394711
Contact Director of Visual Arts Peter Jones, Artists and Commissions section Amanda Loosemore.
The two major awards offered by WAC are the travel awards and the master class/apprenticeship
awards. The first is a substantial grant to any practitioner in the arts (living or working in Wales) to
travel abroad to have an inspirational experience. The second is a grant to study with a master. The
most recent printmaker to receive one of these grants was Julian Schwartz in 1986-7. Note also the
National Eisteddfod which holds frequent competitions for printmaking. WAC also has a computerised,
non-selective slide and information library holding an index of 1400 artists living and working in Wales;
printmaking is the second largeest category in this library after painting.The slide library is essentially a
public resource and two interesting outcomes recently included CADW commissioning five
printmakers to produce limited editions and an exhibition of the work of contemporary printmakers in
Wales. Seven galleries in Wales have been elected to have Welsh Arts Council support and are worth
contacting :- Newport Museum and Art Gallery (*Contact* Robert Cricksey, Gwent); Sawnsea Art
Gallery & Museum (*Contact* Glyn Vivian, Alendria Road, W. Glam); Aberystwyth Art Centre (*Contact*
Yve Ropek, Penglais, Dyfed); Mostyn Gallery (*Contact* Sue Beardmore, Llandudno, Gwynett);
Wrecsam Library Art Centre (*Contact* Steve Brake, Clwyd); Davies Memorial Gallery (*Contact*
Michael Nixon, Newtown, Powys); Ffotogallery (*Contact* Chris Coppeck, Chances Street, Cardiff).
Note also biggest art centre in Wales at Chapter Art Centre, Cardiff (*contact* Sewart Cameron) in
which a host of art activites take place and includes a three space gallery.

West Wales Association for the Arts
Dark Gate, Carmarthen, Dyfed Tel. 0267 234248
Founded in 1971. Covers areas of Dyfed and West Glamorgan

North Wales Arts Association
10 Wellfield House, Bangor, Gwynedd Tel. 0248 353248
Contact Director D.Llion Williams
Founded in 1967. Covers areas of Clwyd, Gwynedd and Montgomery in Powys. This organisation
organises annually a programme of six/seven residencies within visual arts and crafts lasting about
twelve weeks each and printmaking has featured in these in the past, on average one per year.

South East Wales Arts Association
Victoria Street, Cwmbran, Gwent Tel. 063 33 67530
Contact Arts Development Officer Richard Cox
Covers areas of Gwent, Mid Glamorgam,South Glamorgan, districts of Brecknock & Radnor in Powys.
Under their artist- in-residence scheme they frequently appoint printmakers e.g. a screenprinter-in-
residence required in Cardiff for September 1989. At Chapter Arts Centre there is a major
screenprinting workshop called U-Print(Market Road, Canton Cardiff CF5 1QE). ADDW has a print
workshop (Gaskill Buildings,Collingdon Road, Cardiff). There a number of small print collectives
e.g.Two By Two (90 St Mary Street, Cardiff). A Welsh branch of the Printmakers Council was formed
in Cardiff in 1988 (*Contact* Exhibitions Officer I.Khanna, 4 Despencer Street, Riverside, Cardiff).
SEWAA also runs a print purchasing scheme.

NORTHERN IRELAND **Arts Council of Northern Ireland**
181a Stranmillis Road, Belfast Tel. 0232 663591
An annual Printmaker-in-residence scheme is offered jointly by ACNI with Belfast Printworkshop (Jim
Allen, BPW, 181A Stranmills Road, Belfast BT9 5DU) for one year's duration valued at £6500 (1988)
plus rent-free accomodation.

USEFUL BRITISH ASSOCIATIONS

ENGLAND **Arlis /UK & Eire (Art Libraries Society of UK & Eire)**
Secretary, c/o Library, Central School of Art, Southampton Row, London WC1
National society for everyone interested in art libraries and librarianship. Publishes newssheet and
quarterly journals plus directory of members.

Artists Union
9 Poland Street , London W1 Tel. 01 437 1984
TUC-affiliiated union for artists. Seeks to organise, represent and defend visual artists regardless of
style or medium.

British Council
10 Spring Gardens London SW1 Tel. 01930 8466
Art Division: 11 Portland Place London W1 Tel. 01 636 6888
Founded in 1934, the British Council exists to promote wider knowledge of Britain and English
language abroad and to develop cultural relations between Britain and other countries. The British
Council's main objective in its arts work overseas is to encourage a wider appreciation of British
achievement in the visual arts within the general context of diplomatic and cultural relations.This is

principally effected through the provision of exhibitions of British art of the past or present day. Generally these are organised in response to requests from institutions abroad or invitations for British participation in international events such as Venice or Ljubljana biennales. Selection of artists for participation is normally based on the criteria of their intrinsic merits, both in achievement and potential, and for their significance in relation to current developments in this country and internationally. Many exhibitons are composed of prints and a significant proportion of purchases for the collection are graphics bought for specific exhibition projects. Although financial constraints limit the purchasing power of the department, over the last five decades the collection has acquired over 4,000 prints. Artists who have had a firm invitation to exhibit overseas may apply for assistance in meeting some of their costs. Assessment of applications is made by a small sub-committee of the Council's Visual Arts Advisory Committee which meets quarterly.

Crafts Council

12 Waterloo Place, London SW1 Tel. 01 940 4811
The Crafts Council provides an enormous and comprehensive range of opportunities and facilities for craftspeople. The Grants & Services section administers all grants & loans schemes; Education section provides a range of facilities and liasons with teachers, lecturers and administrators to further understanding of crafts; it purchases work from crafts people for its collection; it runs a gallery with extensive crafts exhibitions; it runs a shop in V&A Museum and a bookshop in its headquarters which includes its own publications; it publishes *Crafts Magazine*; it runs an information service and a register of craftspeople, a slide library , enquiry service , slide presentations and offers advice on many areas of business and publicity.

Design & Artists Copyright Society Limited (DACS)

St Mary's Clergy House, 2 Whitechurch Lane, London E1 7QR Tel. 01 247 1650
Created in 1983 for the protection of British artists' copyright and collection of dues in the UK and throughout the world. Part of an international copyright organisation. Membership open to any visual artist and also the estate of an artist up to fifty years after death. Also represents foreign artists in UK.

Fine Art Trade Guild

192 Ebury Street, London SW1 el. 01 730 3220
Contact John Mountfield, Clerk of the Guild
The Fine Art Trade Guild is the trade association representing and promoting the interests of all those involved professionally in the fine art trade. The Guild was formed in 1910 as a development from the Printsellers Association, itself founded in 1847. The establishment of high standards continues to be a primary aim, and to this end the Guild publishes codes of practice and publishing regulations. The latter include strict rules for limited edition prints, and reproductions, which must meet high quality standards before they can be stamped with the Guild emblem, which gives the trade and public confidence in the integrity of the edition. The Guild provides its members with a wide range of services, including advice, information, specialised insurance, valuable discounts and a quarterly magazine.

International Association of Art (IAA)

c/o Robert Coward, Valentine-Ellis Accountants, Charterhouse, London EC1M 6AS
Association representing practising artists internationally, operating under auspices of UNESCO.

INTERNATIONAL PRINTMAKERS' ASSOCIATIONS

AUSTRALIA **Print Council of Australia Inc**
172 Roden Street, W.Melbourne, Victoria 3003
Contact Wilma Tabacco (Hon. Secretary). Founded in 1966.
Aims To promote printmaking as an art medium and promote printmakers via exhibitions (both nationally and internationally); to produce their quarterly magazine *Imprint*; to liaise with print collectors and commercial galleries.
Membership Over 900 members. Open to all printmakers; 5 levels of membership; payment of annual subscription.
Activities Exhibitions in Council's gallery; organises national and international touring exhibitions; publishes *Imprint* and exhibition catalogues plus *Directory of Australian Printmakers;* commissions member and patron prints.

AUSTRIA **Berufsvereinigung der Bildenden Künstler Österreichs**
(Austrian Professional Artists Association)
Schloss Schönbraun, Ovalstiege 1130, Vienna
Contact: The secretary. Founded in 1912.
Aims To promote the co-operative,economic, social and legal interests of professional Austrian artists.
Membership Over 2000 artist members
Activities Lectures on contemporary art and professional matters. Organises exhibitions of members' work in Austria and abroad each year.

BELGIUM **Centre de la Gravure et de l'Image Imprimée**
Gravures Tandem, 10, rue des Amours, 7100 La Louvière
Contact Gabriel Belgeonne, 42, Place d'Hymiée, 6280 Gerpinnes
This organisation has been established with the aim of creating a printmaking centre in the widest
sense - an information, promotional and documentation centre which supports new initiatives in
printmaking and where meetings, lectures can take place; it encourages special research and study
into printmaking and exhibits and collects work on a regional, national and international level.

CANADA **Canadian Artists Representation (CARO)**
183 Bathurst Street Toronto M5T2R7

Print and Drawing Council of Canada
Department of Art & Design, University of Alberta, Edmonton, Alberta T6G 2C9

FRANCE **Trace Association of Engravers**
54 rue Daguerre, 75014 Paris

FINLAND **Taidegrafikot**
Finlands Grafiska Sällskap,Pohj Rautatiekatulla 5,SF-00100 Helsinki 10

Nordic Arts Centre
Suomenlinna, SF 00190 Helsinki
Produces Nordic arts magazine. A centre from which many exhibitions and cultural events are
organised.

GT. BRITAIN **Association of Printworkshops in GB**
Chairman Ken Duffy, Treasurer Michael Green, Secretary Nick Arber
This association was formed in 1979 as a grouping together of publicly accessible printworkshops with
the aims of furthering printmaking, increasing international contacts and understanding of the issues
that unite workshops. Several bi-annual conferences were held with funding support by various art
councils. When funding was withdrawn the association was terminated, holding its last meeting in1984.

Greenwich Printmakers Association
1A The Market,Greenwich, London SE10 9HZ Tel. 01 858 1569
Contact Gallery manager. Founded in 1979.
Aims To promote sale of members work; to further interests of printmakers, printmaking and public
awareness of printmaking. To combine wherever possible for bulk purchasing of materials.
Application procedures Members are elected as vacancies occur. Application to membership
secretary, elected by subcommittee. Members man gallery, pay fees, take active role in association.
Number of members 41 (restricted to artist printmakers only).
Activities Run own full-time gallery; hold many exhibitions elsewhere.10th anniversary February 1989.

National Society of Painters, Sculptors and Printmakers
122 Copse Hill, London SW20 ONL Tel. 01 946 7878
President A.N. Schle
Contact Hon. Sec. Mrs G. Spencer. Founded in 1930.
Aims To advance the aesthetic education of the public by promoting, demostrating or teaching
painting, sculpture or printmaking.
Application procedures Membership is open to practising artists, with selection by panel of jurors.
Associate and full membership levels.
Activities Includes annual exhibition at Smiths Galleries in London.

Printmakers Council of Gt. Britain
31 Clerkenwell Close, London EC1 Tel. 01 250 1927
President Stanley Jones
Contact The secretary. Founded in 1965
Aims To promote the cause of printmaking in Britain, to bring the work of contemporary printmakers
before the general public and to encourage a greater understanding and knowledge of all forms of
printmaking. PMC is keen to help young and unestablished artists and to promote new and
experimental techniques.
Application procedures 700 members. Membership is open to all practising printmakers on payment
of annual fee plus associate membership for galleries, colleges, etc.
Activities Artist-run organisation. Arranges a programme of exhibitions of members' work. Educational
services include demonstrations, lectures and slide information service. Central organisation
headquarters in London plus regional branches in South West, South of England and in Wales.
Regular column for members in *Artists Newsletter*.

Royal Society of Miniature Painters, Sculptors and Engravers

15 Union Street, Wells. Somerset BA5 2PU Tel. 0749 74472
President Mrs. Suzanne Lucas
Contact Admin. Sec. Mrs. S. M. Burton
Aims: To encourage and promote painters, sculptors and engravers who work in miniature.
Application procedures Approximately 130 members. Open to any artist who works in miniature. Size limit. Selection jury for admission. Annual subscription. Associate and full membership levels.

Royal Society of Painter-Etchers and Engravers

Bankside Gallery, 48 Hopton Street, London SE1 9JH Tel. 01 928 7521
President Harry Eccleston.*Secretary* Malcolm Fry
Contact The secretary. Founded in 1880.
Aims To provide a permanent exhibition forum for printmakers of original prints in all media and in line with its charitable status; to provide an educational service to the general public (particularly in respect of the nature of an original print, its worth and the varying media used).
Membership 190 members. Application by annual election. Apply direct to gallery for details.
Activities Annual exhibitions at the Bankside Gallery. Cultivating links abroad including a Moscow exhibition 1989. Educational events, demonstrations, open studios.

Society of Wood Engravers

PO Box 355, Richmond. Surrey TW110 6LF Tel. 01 940 3553
Contact Hilary Painter

WEST GERMANY

Bundesverband Bildender Künstler

Professional Organisation of Visual Artists, Poppelsdorfer Allee 43, 5300-1 Bonn
Contact The secretary. Founded in 1971.
Aims Representation of the professional, fiscal, legal and artistic interests of visual artists in West Germany.
Membership 8,000 artist members. Open to all professional painters, sculptors, photographers, printmakers and video artists in West Germany.

ICELAND

Icelandic Printmakers Association

Freyjugata 41, lol Reykjavík
Contact Valgerdur Hauksdottir, Chairman
Aims To protect interests in common between Icelandic printmakers; to introduce Icelandic printmaking in Iceland and to further its development; to hold membership exhibitions; to introduce international printmaking in Iceland and Icelandic printmaking abroad.
Membership This association is a member of the Icelandic Artists Association. There are six different associations within the Artists Association depending on technique. The Association has regulations governing applications.
Activities Membership exhibitions; organises extensive exhibitions in Iceland and in Europe and USA plus Graphica Atlantica, a survey of contemporary printmaking on both sides of the Atlantic. Established first Nordic Triennale to take place in Iceland, artists by invitation only.

S. KOREA

Korean Contemporary Printmakers Assocation

Tae Ho Kim, Seodae Moon Ku, Chang Chun Dong, 62-4 Seoul

NORWAY

Norwegian Graphics Association

c/o Norke Grafikere,Youngsgt.6, 0181 Oslo 1

Billedkunstfaglig Sentralorganisation

Wergelandsveien 17, 0167 Oslo 1
Norwegian Artists Organistaion

PHILLIPINES

Phillipine Association of Printmakers

595 San Andres, St.. Malate, Manila

PORTUGAL

Sociade C-operative de Gravadores Portugeses

c/o Gallery Gravura, 4 Una Sequeiros, Lisbon 2

SPAIN

Asociación Difusora Obra Gráfica Internacional (ADOGI)

Apartado de Correos 9319, Barcelona 08080
Created for purpose of collaboration with Taler Galeria Fort and organises Mini Print International, Cadaques. Non-profitmaking organisation which plans to create a mini print museum, house a large experimental print workshop and publish a specialised print magazine. Artist printmakers are invited to become members on payment of an annual fee which includes participation in the next mini print international.

SWEDEN **Grafiska Säskapet**
Röbodtorget 2, S-111 52 Stockholm
Swedish printmakers' association and union.

Swedish Association of Printworkshops
c/o Copperworkshop, Fiskgarten 1, 116 45 Stockholm

USA **Print Consortium**
1725 Crescent Drive,St Joseph, Missouri 64506
Contact Dr William S. Eickhorst, Executive Director
Aims Promotion of printmaking as a fine art; exposure of members to wide audience; providing low cost, high-quality print exhibitions.
Application Membership by jury or invitation only. 125 USA members, 30 foreign.
Description of activities Works by members are assembled into theme exhibiitions, advertised and rented to museums, galleries, etc.; artists are kept informed ; consortium retains 25% commisssion.

Print Club
1614 Latimer Street, Philadelphia, Pennsylvania 19103
Contact The secretary. Founded in 1915.
Aims Encouragement of contemporary printmaking.
Membership 1500 members, 500 others. Open to printmakers and photographers.
Activities Lectures; exhibition programmes; sales of limited edition prints; reference library; competitions; archives; programmes for children; variable number of awards annually to Print Club members, annual international print and photography competition for members.

World Print Council
1700-17 Street,San Francisco CA 94103

INTERNATIONAL PRINT BIENNALES AND TRIENNALES

Biennales and triennales offer international opportunities for contact and exchange. Work seen in these competitions often reflects the variety and excellence of international contemporary printmaking. Only in the printmaking field (perhaps with the exception of drawing competitions) can such a large world perspective be seen due to the ease with which prints from many countries can arrive by post and be assembled together. The most recently formed biennales follow a new trend in small-format prints which are less costly to send and to exhibit. The presence of British printmakers in invitational exhibitions abroad is frequently unrepresentative and limited. Artists could do more to promote themselves and after putting together a pack comprising a CV, a set of slides and press cuttings, send this as application to biennales of their choice.

Some guidance on application procedures

Prints Most entries to international competitions are of rolled prints. Make sure your tube is stout enough to stand up to overseas postal treatment. A recommended diameter is of at least 4" with fitting caps which will allow customs officers to open and close without much trouble. Do not send part of an edition if possible. Send a/p's or h/c's. Prints in some cases are never returned and many are damaged in transit.
Insurance Read the information sheet carefully. Many biennales do not cover insurance of work whilst in transit, but usually insure whilst on exhibition. If your print is valuable take out special insurance.
Records It is easy to forget details of prints once they have been sent abroad. Keep carbon copies or photocopies of application forms.
Slides Few biennales are open. Many need application via a CV and slides of work. Keep a detailed list of what you send and accept the possibility that your slides may never be returned.
Invitations Many competitions are by invitation only. This means that either they have various advisors in European countries or that you can send slides to apply. Send a packet with CV, slides and documentation well in advance of the exhibition.
Reurn of prints Prints are normally returned at the organiser's cost up to a year after the event. Write frequently if you have not received your work back.
Entry fees These should be sent in foreign currency of the country if at all possible.Your own bank will supply a banker's draft. Read the application form carefully. Traveller's cheques and cash are possible.
Customs This is probably the most difficult area which causes much confusion. It is most important to fill in the necessary forms issued by the post office and keep copies of them. Customs requirements vary considerably. Adhere to the instructions given. It is vital to fill in VAT Export forms at the post office and be sure to have them stamped - if not you may run risk of paying VAT for the return of your

own unsold prints. This can make entry to biennales very expensive. Send work Registered Air Mail. Parcels to USA can be marked Duty Free -T.S.U.S.765 or labelled Printed Matter or Sample of Merchandise.

Prize money In some eastern countries, e.g. Yugoslavia and Poland, prize money must be spent in the country of origin and will be kept for a number of years if necessary. Look carefully at the details in the application form.

Catalogue Every exhibitor is normally sent a free exhibition catalogue.They provide an excellent guide to international artists and addresses are often listed. The V&A reading room has a collection of some international biennale catalogues. Few biennales automatically re-invite participants.

Europe1992 It is difficult to assess what the benefits of no trade barriers will be but hopefully it will mean that prints can be more easily sent/taken/carried to and from Europe.

BELGIUM	**Internationale de Gravure Européene Contemporaine**

Internationale de Gravure Européene Contemporaine
Musée de Beaux Arts de la Ville de Liège, Parc de la Boverie, 4000 Liege
Over 500 works from 20 countries. Last held 1987.

Petit Format de Papier (Biennal of Small Prints)
Cuts des Sarts, Couvin
First held in 1981. By invitation only. Send CV and slides. Last held 1987.

BULGARIA

International Print Biennale
65 Lenin Blvd, 9000 Varna
First held 1981. Invitation only. Works of foreign participants who have been invited by organising committe are not subject to selection. Other application by slides. Submission of up to 5 prints.Prize money must be used in Bulgaria. Last held 1987. Next held 1989.

CHINA

Republic of China (Taiwan)International Print Biennial ROC
Council for Cultural Planning and Development, Executive Yuan, 102 Ai-kuo East Road, Taipei, Taiwan
First held 1983. Three sections - open international, invited international, historical chinesewoodcuts. Prizes. Last held 1987. Free entry. Size limit. Excellent two part colour catalogue.

Biennale de Gravure
Museum d'Art Moderne, Directrice des Affaires Culturelles, Wejian hui de Taiwan
Last held 1987-88.

CZECHOSLOVAKIA

Biennale of Graphic Design, Brno
Moravska Galerie, Brno 2, Husova 14
Last held in 1988. International exhibition of illustration, book and graphics inlcuding many prints and monoprints. Open and invited sections.

EIRE

The First Irish Miniprint Exhibition, Dublin
Contact Black Church Print Studio, Ardee House, Ardee Street, Dublin 8
First held December 86/January 87. Open competition. Prizes. Size limit. Next held 1989.

Graphica Creativa Triennial
Alvar Aalto Museum, PO Box 761, 46101, Jyvaskyla
First held 1974. Ivitation only. Variable theme.Prizes. Last held 1987

FINLAND

4th International Triennial of Graphic Art by Young Artists
Vaasan Taidegraafikot, PL 229, 65101 Vaasa

FRANCE

Trace Biennale of Engraving
Trace Association of Engravers, 54 rue Daguerre, Paris 75014
 Open entry for copperplate and wood engravings. Size limit. Next held 1989.

Première Triennale Mondiale d'Estampes 'Petit Format'
Association Musée d'Art Contemporain de Chamalières, 3 Ave de Fontmaur, 63400 Chamalières. Auvergne
First held in 1988. Entry by invitation and juried slide selection. Size limit. Good catalogue. Prizes.

GT. BRITAIN

British International Print Biennale
Cartwright Hall, Lister Park, Bradford BD9 4NS
Contact Biennale secretary
First held 1968. Conditions subject to change and variation with each biennale. Currently two sections - British and Foreign. British Open aspect being considered. Next entry Autumn 1989 for Spring 1990.

WEST GERMANY

Intergrafik Triennale of Engaged Graphic Art
Triennale engagierter Grafik , Berlin
Contact Ronald Paris, Präsident der Intergrafik
First held 1966. Invited artists selected by jury. Prizes. Last held 1987.

WEST GERMANY	**International Grafik Triennale, Frechen** Kunstverein zu Frechen, Johann-Schnitz Platz, 9-M. Postfach 1564, 5020 Frechen *Contact* Eva Middelhoff First held 1972. Open entry juried from slides. Prizes awarded by special jury. Last held 1989. Moved from biennale status (1972-80) to triennale(1983-).
	The Biennial of European Graphic Art, Heidelberg Sophienstrasse 3, D-6900 Heidelberg *Contact* General Secretary Milos Lukes First held 1978. Invitation only. Very large biennale. Last held 1988.
	Landesbank Druckgrafik Kunstpreis Sekretariat, Postfach 1060 49, Lautenschlagerstrasse 2, D-7000 Stuttgart 10 First held in 1981.European artists only. Size limit. Submission of transparencies for selected invitation. Next held 1989.
ICELAND	**Norrænt Graphí-Príár. Nordic Graphic Triennale** Islensk Grafík, Freyjugata 41, 101 Reykjavík or The Nordic House at Hrinbraut, 107 Reyjavík First held August 1988. By invitation only. The first triennale established in Iceland. Aims to represent well established artists in the field of printmaking. Next held 1991.
ITALY	**Premio Internazionale Biella per l'Incisione** Via Torino 56, 13051 Biella *Contact* Segreteria Sig. Lucio Migliardi First held 1963. Invitation only. Last held 1987, next in1990. Invitation only by prize giving committee. Limitations. Large prizes. Good catalogue.
	Triennale Europa d'ell Incisione Grado First held in 1981. Selected works. Last held 1987.
JAPAN	**International Independent Exhibition of Prints - Kanagawa** Kanagawa Prefectural Gallery, 3 - 1 Yamashita-cho, Naka-ku, Yokohama-shi, Kanagawa-ken, Japan T231 First held 1974. Open entry. Held annually. Work received each October. All entries displayed.
	Wakayama Biennial Exhibition of Prints Takushi Hamada, Curator, The Museum of Modern Art, Wakayama, 1-1 Momatsubara-dori, Wakayama-shi, Wakayama, Janapn 640 First held 1985. Open entry selected by jury. Next held 1989.
S. KOREA	**Seoul International Print Biennale** Promotions Department, The Dong-A Ilbo, PO box 307, Kwang Wha Moon, Seoul *Contact* Mr. Chung Woong Kim, Secretary General First held 1970. Open entry. Prizes. Last held 1987.
	International Miniature Print Biennale Space Group Korea, 219 Wonseo-Dong, Chongno-gu, Seoul First held 1980. Open entry. Prizes. Last held 1988.
LATVIA (USSR)	**Miniature Graphics Triennale** Riga, Kulturas Ministrija, Latvijas Last 1986.
NORWAY	**Norwegian International Print Triennale** Herman and Ulla Hebler, Postbos 1118, Gamleyben, 1600 Fredrikstad First held 1972. Invitation only. Prizes. Last held 1986. Changed from biennale.
POLAND	**Cracow International Print Biennale** Miedzynarodowe Biennale Grafiki, pl. Szczepañski 3a, 31-011 Kraków First held 1966. Open and invited sections. Prizes must be spent in country of origin. Last held 1988.
	Small Graphic Forms 'Male Formy Grafiki' Lodz Male Formy Grafiki, Biuro Wystaw Artystycznych, ul. Wolczanska 31, 90-607 Lodz First held 1979. Open entry. Last held 1987.
	Mezzotint '85 - An International Exhibition of Graphic Arts Bureau of Exhibitions, Commissioner Felix Chudzynski, ul. Bitwy pod Plowcami 6A 32, 81-775 Sopot First held 1985.

SPAIN	**Cadaques Miniature Print International** Taller Galeria Fort, Apartado de Correos, 9319, Barcelona 08080 *Contact* Snr. Pascual Fort First held 1981. Open entry selected by jury. Size limit. Prizes. Last held 1988.
	Ibizagrafic Musée d'Art Contemporain, Apartat 251, Evissa. Balears
SWITZERLAND	**International Triennial of Original Graphic Prints** Kunstgesellschaft Grenchen, Postfach 341, CH-2540 Grenchen First held 1958. Open entry and submission also by slides. Prizes. Last held 1988.
	Xylon International Triennial Exhibition of Woodcuts Gewerbemuseum Winterthur, Kirchplatz 14, CH-8400 Winterthur First held 1954. Condition for entry formulated by Xylon. Relief printing only. Prizes. International jury selects prizes. Artists write to above address for inclusion on the mailing lists for entry forms.
USA	**Annual International Competition of Prints and Photographs** The Print Club, 1614 Latimer Street, Philadelphia, PA 19103 *Contact* Anne Schuster (Director) First held in 1925. Open entry to all print club members. Membership is open to all interested artists.
	IGAF Miniature Print Biennial John Szoke Gallery, 591 Broadway, New York NY10012 First held 1985. Open entry. Maximum image size 2 sq. ". Prizes. Next held 1989
	International Print Biennale, Miami, Florida PO Box 145158, Coral Gables, Florida 33114, First held 1972. Open entry selected by jury. Prizes. Possibly discontinued.
	Silvermore Guild/ IGAF International Print Biennale Silvermore Print Galleries, 1037 Silvermore Road, New Canaan, CT 06840 First held 1986. Open to all artists making prints. Initial selection from slide application. Awards. Last Held 1988. Next held 1990.
	Somerstown Gallery Biennial International Juried Print Exhibition Somerstown Gallery, Box 301, Somerstown, NY 10589 *Contact* Lisa Breznak First held 1986. Open to all printmakers. Selection by slides. All printmaking methods. Minimum dimmensions. Purchase awards. International jurors. Small catalogue.
YUGOSLAVIA	**Ljubljana International Biennial of Graphic Art** JGLC Mednarodni Graficni Likovni Center, Grad Tivoli, Pod Turnom 3, 61000 Ljublijana *Contact* Zoran Krzisnik (Organiser) First held 1955. Open and invited sections. Prizes in Yugoslav currency. Large catalogue. Last held in 1987

PRINTMAKERS' AWARDS, PRIZES AND OPPORTUNITIES

The majority of awards are advertised in the press. *Artists Newsletter* is a central focus for awards (monthly magazine; annual subscription; PO Box 23, Sunderland SR1 1EJ Tel. 091 510 9144). An information service which offers to provide individuals with current details of competitions and exhibitions throughout UK for an annual fee is run by Philip Saunders at Artifact (Fine Art Consultants,163 Citadel Road, The Hoe, Plymouth. DevonPL1 2HU Tel. 0752 228727)

Arts Associations

These bodies represent a prime source of funding and support. The list of projects in the most active is impressive. These range from interest-free project loan schemes, travelling schemes, master class awards, funds for creating opportunities and establishing practices, retraining schemes, bursaries (usually open to all disciplines), artists' placement in schools , etc.. In most of these schemes there is no medium distinction and printmakers are eligible to apply. (See British Arts Councils and Regional Art Associations section, p. 107ff.)

Bursaries

These are awards often given by the Arts Council or local RAAs to enable artists (often with established careers) to take time off (mid term) for a new project, training, etc. The tendency for bursaries and fellowships to occur on a repetitive annual basis is declining . Any individual organisation can apply to set up a new bursary. Contact your local RAA.

Workshop Awards

Printworkshops in UK offer a number of opportunities. Lowick House Print Workshop offers a special annual printmaking bursary to enable an artist to print in the workshops (Lowick Green, Nr Ulverston, Cumbria LAIZ 8DX Tel. 0229 85 698); Essendine workshop in London offers artist-in-residence schemes (Essendine Road, London W9 Tel. 01 289 3255); Borderline Printworkshop (Old Post Office, Knighton, Market Drayton, Shrops. Tel. 063 081 225). Scottish printworkshops in association with SAC offer various exchanges and awards. Look through printworkshops list. Contact workshops direct.

Belfast Printworkshop
181A Stranmillis Road, Belfast BT9 5DU Tel. 0232 381591
Contact Jim Allen. BPW offers a Printmaker-in-residence fellowship, tenable for a period of one year beginning early January valued in 1987-88 at £6,500 and includes rent-free accomodation.

Workshops often have contact with art schools e.g. Staffordshire Polytechnic has contact with Borderline Printworkshop; Duncan of Jordanstone College of Art has links with Dundee Printmakers Workshop, Bristol Poly technic has links with Nettlecombe Court Printworkshop, Northern Print has links with Newcastle Polytechnic, etc.

Awards in art schools, polytechnics and universities

Residencies, assistanceships and awards are often held in conjunction with facilities at an art school but these awards are changing. Colleges such as Exeter College of Art (Exeter Fellowship), Cardiff College of Art, Cheltenham College (Cheltenham Fellowship), Manchester Polytechnic (Granada Fellowship), Norwich School of Art (John Brinkley Fellowship), etc.have been awarded in the past and should be checked. Middlesex Polytechnic offers a number of apprenticeships each year. Fine art departments in some colleges e.g at Leeds Polytechnic, offer short-term residencies to local artists (See Directory of British art schools, p. 34ff).

Henry Moore Foundation Printmaking Fellowship
Contact Mrs H.Cale, Staffing Officer, Leeds Polytechnic, 25 Queen Square, Leeds LS2 8AF for further information.

Cambridge Artist Fellowship
Kettles Yard Gallery, Castle Street, Cambridge CB3 OAQ Tel. 0223 352124
An annual award for one academic year duration. Funded jointly by the University of Cambridge who provide meals, accomodation and studio and Arts Council who pay salary direct. This scheme is a sabbatical year for a mid-career artist. No printmaking facilities as such. Scheme administered by Kettles Yard Gallery.

Summer schools and short courses although well-established at some art colleges e.g. Falmouth, are a relatively new introduction to many. The revenue from the courses is used to increase the capital of the various departments in which they are held. These courses, often run by well-established artists, offer many opportunites including brushing up an old skill or learning a new one. They are usually advertised widely in the art press.

Awards in galleries

Many awards, bursaries, residencies and placements are offered or administered by enterprising galleries.

For example, the Kew Gardens Bursary, sponsored by CCA Galleries initially with the hope that different sponsors can be found to make it an annual award. The Whitechapel Art Gallery (London) has offered artist-in-residence schemes and the Air Gallery (London) has offered schools fellowships. Watch press for details.

The Joseph Webb Commemorative Fund Award
Bankside Gallery, 48 Hopton Street, London SE1 9JH Tel.01 928 7521
Royal Painter-Etchers and Engravers offer an annual bursary of £250 mainly to assist students in the art of etching. Usually in Autumn of each year. For details contact the Bankside Gallery.

Other awards

Calouste Gulbenkian Foundation (Lisbon), UK Branch
98 Portland Place, London W1N 4ET Tel. 01 636 5313
This branch of the Foundation deals with proposals for projects in UK and Republic of Ireland and the work of the Foundation is organised around programmes in Arts, Education and Social Welfare. Past awards have included printmaking projects.

Elizabeth Greenshields Foundation
1814 Sherbrooke Street West, Montreal. Quebec. Canada H3H 1E4
Approximately 50 awards made annually to assist study. Applicants may be nationals of any country and must have a good knowledge of their craft. Purpose to aid talented young artists in early stages of their careers.

The Fulbright Commission
UK Education Commisssion, 6 Porter Street, London W1 M2HR Tel. 01 486 7697
Major awards in various media; enables Fellow to spend time in USA, return air fare and grant.

Kennedy Memorial Trust
16 Gt College street, London SW1P 3RX Tel. 01 222 1151
12 Scholarships each year from Britain to USA. Tenable for one year at Harvard or MIT Boston.

Leverhulme Trust
Lintas House, New Setter, London EC4
Major awards to artists for in-depth study of special areas. Awarded annually.

Rome Scholarship in Printmaking
The British School at Rome, Tuke Building, Regents College, Inner Circle, Regents Park, London NW1 4NS
Rome Scholarship offered in printmaking is intended to give a few emergent artists of distinction and exceptional promise the opportunity to further their studies whilst residing in Italy based at the British School at Rome. Tenure for one academic year. Offered annually. All entry forms have to be returned by early February.

Winston Churchill Memorial Trust
15 Queensgate Terrace, London SW7 5PR Tel. 01 584 9315
Annual, major awards to artists with a specific project for travel anywhere in world. Details usually available in July/August.

Useful addresses for study or research abroad

There are large guides in most reference or art libraries detailing offers and awards for research and travel abroad. (See also Chapter 1, Degree courses, Further reading, p. 43, p. 46.)

Foreign Embassies
If it is your wish to visit and work in another country, then the arts section of a foreign embassies may be able to help you. Some foreign embassies also offer scholarships, e.g. Greek Government has offered a printmaking scholarship in the past .

Art Information Center
280 Broadway,Suite 412,New York, NY 10007 USA
Association that compiles information about arts organisation that are found all over USA

Association of Commonwealth Universities
36 Gordon Square, London WC1H OPF 01 387 8572
Publication and information service and advice

British American Arts Association
49 Wellington Street, London WC1 01 379 7555
Information exchange to aid professional artists' work in UK/USA

British Council (See also Useful associations section, p. 110)
10 Spring Gardens, London SW1A 2BN
Annual directory of foreign goverment scholarships

CAFE (Creative Activity for Everyone)
23-5 Moss Street, Dublin 2. Ireland
Irish funding handbook 1989. Lists 127 sources of funding for artists in Ireland.

Central Bureau for Educational Visits & Exchanges
Seymour House, Seymour Mews, London W1H 9PE 01 486 5101

Commonwealth Scholarships
c/o Arts Dept., Commonwealth Institute, Kensignton High Street, London W8 6 NQ
Aims to foster cultural co-operation. Open to all artists from Commonwealth countries to apply.

US/UK Educational Commisssion
6 Porter Street London, WC1M 2HR 01 486 1098
Free leaflet on post-graduate art & design courses in USA.

NATIONAL PRINTMAKING COMPETITIONS

British International Print Biennale
The Secretary, Cartwright Hall, Lister Park, Bradford BD9 4NS
First held in 1968. Normal practice for an open British section plus invited foreign and British section.
Last held 1988. Submission in 1989 for 1990 exhibition. Application forms from above.

Humberside Printmaking Competition
Humberside College of HE, School of Fine Art, Queens Gardens, Hull HU1 3DH
First held 1981 and then biennially. Run by Humberside College of Higher Education.
Aims to promote innovation and experiment in printmaking. Open to all printmakers in UK. Contact organisers for future details

Impression
Spanish Arch Gallery, Long Walk, Galway, Ireland
Contact Leonie King (Galway 091 94256 after 5pm)
Annual national print exhibiton. First held 1988. Open to Irish nationals and Northern Ireland. Due to poor funding from the Arts Council, Spanish Arch Gallery are unable at present to open it to UK.
Workshop adjoins gallery, all printmakers welcome.

LLoyds Bank Young Printmakers Awards
Royal Academy of Arts, Burlington House, Piccadilly, London W1V ODS
LLoyds Bank have terminated their sponsorship of theses awards after ten years of support. The RA is looking for a new sponsor who at the time of this handbook going to press has not been forthcoming.

Open To Print
Sunderland Polytechnic, School of Art & Design Backhouse Park, Ryhope Road, Sunderland SR2 7EE
National student printmaking competition organised by Sunderland Polytechnic.

Open British Printmaking Exhibition
Royal West of England Academy, Queens Road, Clifton, Bristol BS8 1PX
First held in 1988. Aim of exhibition to encourage printmaking. It is the plan of RWEA to hold this competition every two years. It is open to all British printmakers, with an emphasis on young printmakers' work. All sizes and media are considered. Awards.

Open Annual Print Exhibition
Royal Society of Painter-Etchers & Engravers, Bankside Gallery, 48 Hopton Street, London SE1 9JH
First held in 1985. Entirely open print competition with aim of offering students and artists an opportunity to exhibit in a major London gallery. Artists must be resident in UK. Selection. Awards.
Held annually in the Spring.

Prints with a Point
Off-Centre Gallery, 13 Cotswold Road, Windmill Hill, Bedminster, Bristol BS3 4NX
First held June 1987. Organised by Peter Ford. An international exhibition of drypoints and polemical prints. Open competition but juried for selection. Touring show. Next held September 1989.

Royal Academy Summer Exhibition
Royal Academy of Arts, Burlington House, Piccadilly, London W1V ODS
Annual exhibition held each summer. Open entry to all media including printmaking. Notice to artists in January of each year. Juried selection.

Society of Wood Engravers
PO Box 355, Richmond. Surrey TW1 6LF
Annual open exhibition.

SCOTLAND **Scottish Print Open**
c/o Glasgow Print Studio,128 Ingram Street, Glasgow G1 1EJ
Printmaking competition open to artists born, resident or trained in Scotland.. Juried selection. Organised in past by one of Scottish printmaking workshops. Prizes. Catalogue.

ART FAIRS

Art fairs provide opportunity mostly for established dealers and galleries to display and trade in a representative selection of their artists' work at locations around the world. The booklet *Exhibition Bulletin* (the trade handbook of national fairs) gives details of trade fairs and also where to get equipment , stands, etc. (Available monthly from London Bureau 266-272 Kirkdale, Sydenham, London SE26 4RZ Tel. 01 778 2288.) Consult also a new directory *Art Festivals in Britain & Ireland* edited by Sheena Barbour (Rhinegold Publishing Ltd., Book Sales Dept., Freepost, London WC2 8BR). Look out for art fairs which are locally organised often around a particular theme or event, e.g. Bristol Print '89, a Festival of Printmaking,

Bath Art Fair
Artsite Pierrepont Place, Bath BA1 IJY Tel. 0225 61659/60394
An annual art fair held in conjunction with the Bath Festival (usually in May).

Chelsea Crafts Fair
Normally held at Chelsea Town Hall, Kings Road, London SW3.
Run by the Crafts Council 12 Waterloo Place, London SW1 Tel. 01 930 4811.
Many other craft fairs around the country. Consult 'Exhibition Bulletin' or Crafts Council.

International Contemporary Art Fair (ICAF)
11 Manchester Square London W1M 5AB Tel. 01 486 1951
Largest contemporary art fair held in Britain. ICAF is organised by Interbuild Exhibitions Ltd. part of an international group of exhibition organisers, managers and consultants. ICAF next held in Britain in 1989.

London Original Print Fair
Royal Academy of Arts,'Burlington House, London W1 Tel. 01 439 7438
Annual print fair limited for space. Now includes a limited number of dealers in contemporary living artists. Stands are by invitation only.Selection of international English, American, Belgian, French, etc.) prints for sale. Housed at Royal Academy but not organised by them.

International art fairs
Art fairs occur in many major cities around the world at varying times of the year but for the individual showing small publications it is probably not worthwhile even applying for a stand. Most are booked far in advance and cost large sums of money. They are held regularily in cities such as Bologna, Adelaide, Los Angeles, Stockholm, Chicago, Stuttgart, Madrid, etc. Consult 'Exhibition Bulletin' for times and dates, etc.

Print Symposium
AUSTRALIA Print Council of Australia Inc.
172 Roden Street, West Melbourne. Victoria 3003
Contact Diane Soumilas
A national print symposium will be held in 1989. Contact PCAI for details.

BIBLIOGRAPHY

GENERAL

Adams, C. *American Lithographers 1900-1960 :The Artists and Their Printers* University of New Mexico, 1983

Baro, Gene *Thirty Years of American Printmaking* New York,Brooklyn Museum, Universe Books1976

Blum, André *The Origins of Printing and Engraving* New York, Scribner 1940

Dyson, Anthony *Pictures to Print* London, Farrand Press 1984

Eichenberg, Fritz *The Art of the Print* New York, Abrams 1976

Gilmour, Pat *Ken Tyler:Master Printer and the American Renaissance* Hudson Hills Press & Australian National Gallery, 1986

- *Modern Prints* London, Studio Vista Dutton 1970

- *Understanding Prints* London, Waddington Galleries 1979

Goldscheider, Irena *Czechoslovak Prints from 1900-1970* London, British Museum

Hayter, S.W. *About Prints* Oxford, OUP 1962

Ivens, W.J.Jnr. *Prints and Visual Communication* New York, Da Capo 1969

Lambert,Susan *The Image Multiplied:Printed Reproductions of Paintings 1480-1980* London, Trefoil 1987

Spencer, Charles *Decade of Printmaking* London, Academy Editions 1975

Sottfrifer, Kristian *Printmaking:History and Technique* New York, McGraw Hill 1968

Zigrosser, C. and C.M. Gaehde *A Guide to the Collecting and Care of Original Prints* New York, Crown 1966

TECHNIQUE

Antresian, G. and C. Adams *Tamarind Book of Lithography* New York, Abrams 1971

Brunner, Felix *A Handbook of Graphic Reproduction Processes* Taufen, Arthur Niggli Ltd. 1975

Carr, Francis *A Guide To Screen Process Printing* London, Vista 1961

Chieffo, Clifford T. *Silkscreen as a Fine Art* New York, Reinhold 1967

Daniels, Harvey *Printmaking* London, Hamlyn1971

Edmonson, Leonard *Etching* Van Nostrand Reinhold1973

Gross, Anthony *Etching, Engraving and Intaglio Printing* London, Oxford 1970

Hayter, Stanley *New Ways of Gravure* New York, Pantheon 1949

Heller, Jules *Printmaking Today* New York, Holt Reinhart and Winston 1972

Jones, Stanley *Lithography for Artists* London 1967

Knigin, Michael and Murray Zimiles *The Contemporary Lithographic Workshop Around The World* New York, Reinhold 1974

Man, Felix *Artists' Lithographs* New York, Putnam 1971

Mara, Tim *Thames & Hudson Manual of Screen Printing* London, Thames & Hudson1979

Newman, Thelma R. *Innovative Printmaking* New York, Crown Publishers Inc 1977

Peterdi, Gabor *Printmaking* London, Macmillan 1959

Ramusen, H. *Printmaking with Monotypes* Philadelphia, Chilton 1960

Ross, John and Clare Romano *The Complete Printmakers* New York, The Free Press 1972

Rothenstein, Michael *Frontiers of Printmaking* London, Studio Vista 1962

- *Linocuts and Woodcuts* London, Studio Vista 1962

Saff, D. and D. Sacilotto, *Printmaking: History and Process* New York, Holt, Reinhart & Winston 1978

Simmons, R. and K. Clemson *The Complete Manual of Relief Printing* London, Dorling Kindersley Ltd. 1988

Trevelyan, Julian *Etching : Modern Methods of Intaglio Printing* New York, Watson Guptill 1964

CATALOGUES

American Prints:Process and Proofs Judith Goldman, New York, Whitney Museum 1981-2

Artist and Printmaker:Printmaking as a Collaborative process New York, Pratt Graphics Center 1981

L'Arte della Stampa Rome, Galleria Nationale d'Arte Moderna 1974

Artists at Curwen Pat Gilmour, London, Tate Gallery 1977

Czechoslovak Print from 1900-1970 Irena Goldscheider, London, British Museum Publications 1986
Final Proof Cardiff, Welsh Arts Council 1981
Gemini GEL, Art & Collaboration Ruth Fine, Washington, Abbeville1984
A Graphic Muse:Prints by Contemporary American Women USA, Mount Holyoake College Art Museum, 1987
Kelpra Prints Pat Gilmour, London, Tate Gallery 1980
Kelpra Prints London, Arts Council of GB 1970
Mechanised Image Pat Gilmour, London, Arts Council of GB 1978
Oxford Printmakers Santa Barbara, Clio Press 1985
Photography in Printmaking Charles Newton, London, V&A Museum, Compton Pitman 1975
Prints of the Twentieth Century Riva Castleman, New York, Museum of Modern Art 1976
The Print in Germany 1880-1933 London, British Museum, 1984
Printworkshops in Camden:A Post-war Survey Silvie Turner, London, Camden Arts Centre 1985
Printed Art: A View of Two Decades Riva Castleman, New York, Museum of Modern Art 1980
Technics and Creativity Riva Castleman, New York, Museum of Modern Art 1971
Tradition and Innovation in Printmaking Today Yorks. Contemporary Art Group and Rank Xerox 1986
Under Cover of Darkness-Night Prints David Alston, London, Arts Council of GB 1986

DIRECTORIES *Artists Directory* Heather Waddell & Richard Layzell, London, Art Guide Publications
Art in America Annual Guide to Galleries, Museums&Artists 980 Madison Ave New York NY 10021
Arts Review Yearbook Starcity Ltd., 69 Faroe Road, London W14 OEL
Artists Studio Handbook Liz,Lydiate, Artic Producers PO Box 23 Sunderland SR1 IEJ
Catalogue of Fine Press Printers in British Isles Inky Parrot Press 1986
Directory of Art Centres Arts Council of GB, 105 Piccadilly London W1
Directory of Exhibition Spaces Editors Neil Hanson & Susan Jones, Sunderland, Artic Producers 1989
The Economic Situation of the Visual Artist Calouste Gulbenkian Foundation, London 1985
The Economic Importance of the Arts in Britain John Myerscough, Policy Studies Institute, 100 Park Village East, London NW1 3SR
Facts About Arts John Myerscough, Policy Studies Institute 1986
International Arts Directory St James Press, 3 Percy Street London W1P 9FA 1985
International Directory of Arts Vol. I&II Art Address Verlag, Frankfurt
Printing is Easy Community Printworkshops Directory 1970-86 Greenwich Mural Workshop, Mcbean Centre, Mcbean Street, London SE18 6LW
The Printworld Directory Printworld Inc., Post Office Box 785, Bala Cynwyd, Pennsylvania 19004
Small Press Directory Small Press Group, 308c Camberwell New Road, London SE5 ORW 1988
Whose Who in Art Management Editor N. Pritchett-Brown, London, Rhinegold Publications Ltd 1986
Writers'& Artists' Yearbook London, Adam & Charles Black

ADVERTISER'S INDEX

modbury engineering

Printmakers' engineering and machinery removals.

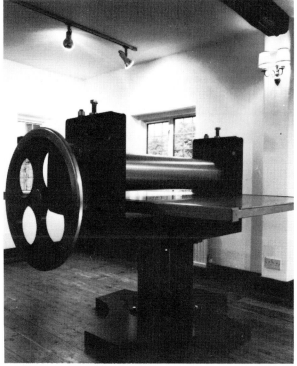

Modbury Press. 48ins width

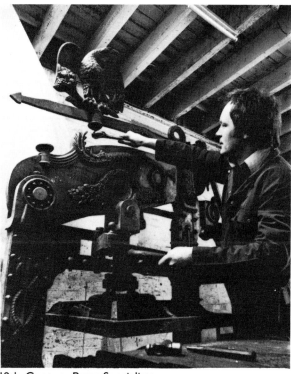

19th Century Press Specialists

REMOVALS - From single presses to complete printmaking departments
ON SITE REPAIRS AND MAINTENANCE

PRODUCTION

Prices at April 1989. VAT extra

Hot Tables. Cast iron, electric. Guaranteed 5 years. 20x26x7 and 25x30x7 ins	£510/£620
Aquatint Box. 26x30 ins inside, 48x28x34 outside.	520
Mezzotint tool holder and assembly.	61
Levigator. 10 ins dia. Cast iron or stainless steel.	78
Litho tympans, scrapers, offset blankets.	To order
Patent Intaglio/Relief Press. To order. 48 ins width.	c. £10000

SECONDHAND PRESSES. Litho stones and other equipment as available

CHRIS HOLLADAY is the proprietor of Modbury Engineering, a small specialised business working for printmakers since 1969. He makes frequent tours around the U.K. on contracts for schools and art colleges. When considering the requirements of printer, press and budget his experience can help you make the best decisions. Call him any time on 01-254 9980 (Beware answering machine).

311 Frederick Terrace, London E8 4EW

somerset
FINE PRINTMAKING AND PUBLISHING PAPER

A mould made paper developed in response to printmakers demands for a strong and versatile paper that can cope with the variety of techniques employed by the modern printer.

Made from the finest, purest cotton fibres, Somerset is internally sized and buffered with calcium carbonate against atmospheric pollution and acidic degradation. Experience has shown Somerset to be an extremely strong paper, suitable for blind embossing and deeply bitten plates, while remaining sensitive to mezzotint, engraving and relief techniques. Lithography, silkscreen and typographic printing produce excellent results on this paper.

How Somerset is made:

Mould made from 100% cotton rag fibres. Acid free and buffered with calcium carbonate to give a pH of 8.5.
Free from optical brightening agents.
Each sheet is watermarked 'Somerset, England' in the bottom right and top left corner and has four deckled edges.

What this means to the Printmaker:

Stable non-directional paper for multi-colour printing in perfect register. Durability and long life unaffected by atmospheric acidity.
Paper is colour stable, having a wool scale reading of 5 and will not change colour when exposed to light.
A material of great character and visual appeal.
The choice of paper for any printmaking medium.

SPECIFICATIONS

- *100% cotton fibre*
- *Cylinder mould-machine made*
- *Buffered with calcium carbonate*
- *Acid-free*
- *pH 8.5 (Hot Extract)*
- *Watermarked*
- *4 deckle-edges*
- *Available in 2 weights*
- *Available in 2 finishes*
- *Available in sheets and rolls*

APPLICATIONS

- *Etching*
- *Direct lithography*
- *Offset lithography*
- *Typographical printing*
- *Screenprinting*
- *Relief printing*
- *Pastel, gouache etc.*

The following items are available from stock.

Sheet Size		Weight g/m^2	Finish	Colour
Inches	cms			
22 × 30	56 × 76	250	Satin	White
22 × 30	56 × 76	250	Textured	White, TP (Soft White)
22 × 30	56 × 76	300	Satin	White
22 × 30	56 × 76	300	Textured	White, TP (Soft White)
30 × 44	76 × 112	300	Satin	White
30 × 44	76 × 112	300	Textured	White, TP (Soft White)

Other colours are available for special makings of 1000kg (2000lbs) and above.

DISTRIBUTORS

Atlantis Paper Company — *Tel: 01-481 3784*
R.K. Burt & Company Ltd — *Tel: 01-407 6474*
John Purcell Paper — *Tel: 01-737 5199*

ιcpmcpmcpmcpmcpm

President: Stanley Jones

The Printmakers Council has been at the heart of a tremendous growth in printmaking over the past 20 years. Founded in 1965 to promote printmaking as an art form, it aims to help all printmakers, especially young, unestablished artists, & tries to foster a greater public awareness & understanding of prints.

The PMC works mainly through programmes of print exhibitions, keeping the work of contemporary printmakers in the public eye. Many of these exhibitions include demonstrations, the most effective way of explaining print techniques. The Council organises educational services, a slide library, publications, lectures, & holds a planchest containing a wide variety of members' prints, which is available for consultation by galleries, dealers, exhibition organisers & buyers.

The Printmakers Council is open to all practising printmakers, & to organisations & individuals interested in printmaking.

For full details please contact PMC, 31 Clerkenwell Close, London EC1R OAT, tel. 01-250 1927

CCA GALLERIES
LONDON NEW YORK TOKYO

Europe's Leaders in Original Prints

CCA's policy is to search for and encourage new talent

Contact

Gerry Farrell
CCA Galleries Ltd, 8 Dover Street
London W1X 3PJ

01–499 6701

INDEX